Reconsidering G⌐⌐⌐⌐e

RECONSIDERING GÉRÔME

Edited by
SCOTT ALLAN and MARY MORTON

The J. Paul Getty Museum, Los Angeles

© 2010 J. Paul Getty Trust

Published by the J. Paul Getty Museum, Los Angeles

Getty Publications
1200 Getty Center Drive, Suite 500
Los Angeles, California 90049-1682
www.gettypublications.org

GREGORY M. BRITTON, Publisher

EDWARD WEISBERGER, Editor
KATHLEEN PRECIADO, Manuscript Editor
STUART SMITH, Designer
SUZANNE WATSON, Production Coordinator

Color Separations by Professional Graphics, Rockford, Illinois
Printed in Canada by Friesens

Cover: Jean-Léon Gérôme, A Greek Interior, 1850. Oil on canvas,
64.5 x 88.9 cm (25.4 × 35 in.). Private collection

Library of Congress Cataloging-in-Publication Data
Reconsidering Gérôme / edited by Scott Allan and Mary Morton.
 p. cm.
Includes index.
ISBN 978-1-60606-038-4 (pbk.)
1. Gérôme, Jean Léon, 1824-1904—Criticism and interpretation. I. Allan,
Scott Christopher, 1975- II. Morton, Mary G. III. J. Paul Getty Museum.
ND553.G5R43 2010
759.4—dc22

 2010007066

Contents

Introduction

SCOTT ALLAN

Jean-Léon Gérôme (1824–1904) was an undisputed professional success during his lifetime. Crowds flocked to see his paintings at the Paris Salon, and official recognition quickly followed. From his debut in 1847, he was repeatedly awarded medals, eventually triumphing at the 1867 Exposition universelle with one of only four Medals of Honor given to French artists. He benefited early on from several notable state commissions and, in a further mark of favor under Napoléon III's Second Empire, was appointed professor at the newly reorganized École des beaux-arts in 1863, to be followed by his ascension to a seat in the Institut de France in 1865. Through his position at the École, which he held for the rest of his life, he became one of the most influential art teachers of the nineteenth century, his pedagogical reach extending to thousands of students from the United States to the Ottoman Empire. And thanks to the savvy mass marketing of his work through mechanical reproduction by his father-in-law, the entrepreneurial dealer Adolphe Goupil, Gérôme reached audiences on an unprecedented scale. Commensurate with his resounding popularity were the fabulous prices commanded by his original paintings and autograph replicas, which in the 1860s, 1870s, and 1880s frequently sold for ten to a hundred times more than works by his Impressionist contemporaries. Having progressed up the ranks of the Legion of Honor, Gérôme was nominated *grand officier* in 1898 — a rare distinction among French artists.

From the outset, however, Gérôme's success met with critical hostility, countered by a relatively small handful of champions like Théophile Gautier, one of the more indulgent critics of the era. For conservative *salonniers* — who saw themselves as educators of the public, guardians of humanist values, and defenders of artistic standards — Gérôme's work, particularly his representations of historical subjects, not only was symptomatic of the modern triumph of "genre" over high-minded history painting but also actively debased its source material by playing to the crowd, to whom was imputed an insatiable desire for sensational or saucy anecdotes. Critics from all quarters lambasted Gérôme for the triviality of his conceptions and ignoble characterizations of his protagonists. High drama

seemed hopelessly beyond Gérôme's reach, and his natural inclination toward the petty and vulgar seemed all too evident in his shamelessly irreverent takes on antiquity and in a string of indecorous compositions—including *A Greek Interior* (see cover) and *Dance of the Almeh* (fig. 25)—apparently calculated to pander to viewers' basest instincts.

With regard to style, Gérôme fared not much better with his critics. A *petitesse*, or smallness, of means was thought to match the *petitesse* of his conceptions. Identified as first and foremost a genre painter, Gérôme allegedly privileged superficial imitation over profound expression and appeared myopically drawn to accessory, material details at the expense of the moral and dramatic heart of a story. However conscientious or laudable they might be considered in themselves, his "archaeological" tendencies seemed misguided in the sacrosanct arena of history painting. More fundamentally, his meticulous, polished technique appeared to have virtually no painterly value at the level of facture and to have been made to order for the passive consumption of his subject matter and for his work's mass reproduction through graphic or photographic means.[1]

This critique was most witheringly formulated by Émile Zola on the occasion of the 1867 Exposition universelle.[2] Targeting Gérôme as one of the lions of the official art world, Zola dismissed him out of hand as a cynical manufacturer of anecdotal images for mass reproduction and popular consumption—a critique that historians of modern art have repeatedly echoed. On the wrong side of modernism and the heroic avant-garde, Gérôme's name became convenient shorthand for a vulgarly "anecdotal" art, a bankrupt academic system, and a reactionary bourgeois establishment. The triumph of Impressionism and Post-Impressionism swiftly effected Gérôme's consignment to the dustbin of history, his reputation tarnished for the vociferous stances he had taken against these movements—opposing, for example, the Édouard Manet retrospective at the École des beaux-arts in 1883 and the Gustave Caillebotte bequest to the French state in 1894. In the years leading up to and following Gérôme's death in 1904, his market value dropped precipitously, and his paintings were unceremoniously relegated to museum storerooms. The aftereffects of the modernist reaction were felt well into the second half of the twentieth century. When Thomas Hoving decided to display paintings by Gérôme at New York's Metropolitan Museum of Art in 1973, John Rewald, the preeminent scholar of Impressionism, decried the move in a combative article in *Art in America* entitled "Should Hoving Be De-Accessioned?"[3]

Just one year before, however, Rewald's "insufferable...dreary" Gérôme had been the subject of a serious monographic exhibition in Baltimore, Dayton, and Minneapolis.[4] A few art historians like Gerald Ackerman and Albert Boime

had begun to devote serious attention to Gérôme in the 1960s. Ackerman, the curator of the 1972 show, would indeed dedicate his entire career to the artist, publishing the indispensable catalogue raisonné and monograph in 1986, followed by a revised edition in 2000,[5] already in urgent need of updating given the continual movement of Gérôme's work on the market.

If revisionist trends in 1970s scholarship were beginning to counter the exclusive modernist narrative with a more pluralistic picture of French art—one that accommodated "The Other Nineteenth Century"[6]—new postmodern critiques were also mounting against Gérôme. In the wake of Edward Said's landmark book *Orientalism* (1978), with its ambitious Foucauldian analysis of the West's discursive construction of the "Orient,"[7] art historians set about the critical deconstruction of Orientalist painting. In "The Imaginary Orient" (1983), Courbet expert and pioneering feminist scholar Linda Nochlin brilliantly took aim at Gérôme, and particularly *The Snake Charmer* (plate 3), arguing that the purported ethnographic realism and photographic verisimilitude of his work were complicit with imperialist ideology and helped naturalize the racial and cultural stereotypes endemic to the period.[8] In the decades since Nochlin's essay, however, the postcolonial critique has gained considerably in complicating nuance, and lingering modernist prejudices against Gérôme have become increasingly outmoded.

Coming at a time of ferment in Gérôme studies, when a predominantly younger generation of scholars is busy discovering the artist and approaching his work with refreshing seriousness and creativity, the present volume goes a long way in challenging old critical biases as well as laying out productive new avenues of inquiry and research.

The cross-fertilization of literary theory and art history over the past four decades has sensitized contemporary scholars to painting's narrative potential in ways not entertained by modernist formalism, which dismissed Gérôme as a facile "literary" or "anecdotal" artist. By way of redress, several essays here intently explore the narrative strategies and compositional mise-en-scène of his work. It becomes apparent that we are just beginning to learn how to "read" Gérôme's paintings in their full complexity; that they are not simply geared to passive consumption; and, indeed, that they reward close looking. As Gülru Çakmak emphasizes, Gérôme allows for an absorptive visual experience that unfolds meaningfully in time and space.

Close attention to the narrative and compositional structure of Gérôme's work suggests that his image as a bastion of academic conservatism is reductive if not wholly false. Indeed, the essays published here show him to have broken decisively with traditional models of history painting, the sacred cow of academic

art theory. His place in the "new art history" will evidently be in the emerging genealogies of modern mass culture, whether it be in connection to popular nineteenth-century fiction, the focus of Nina Lübbren's compelling essay, or twentieth-century cinema, as Marc Gotlieb provocatively argues.

With a renewed investment in carefully "reading" Gérôme comes a heightened attention to the commentaries of his works' first viewers. As Peter Cooke reminds us, the Academy and École were far from monolithic institutions, and some of Gérôme's harshest critics—such as the unclassifiable Gustave Moreau, upon whom Cooke focuses—came from within academic ranks. And as Claudine Mitchell shows, more attention needs to be paid to Gérôme's contentious reception in the public arena, particularly in connection to his more politically sensitive subjects. Her exploration of the various rhetorical strategies deployed by critics with regard to *December 7, 1815, 9 O'clock in the Morning* (plate 7) has the useful effect of rendering a seemingly straightforward, transparent scene ideologically opaque. The question of Gérôme's own politics, only indirectly addressed by Mitchell, and the knee-jerk alignment of his work with an "official" rather than "avant-garde" realism[9] are topics that demand serious reevaluation.

Historically of a piece with Gérôme's alleged literariness was his commercialism, critics quickly dismissing him as a painter who compromised his art to sell stories to an untutored audience. If the present essays are any indicator, however, that commercialism no longer invites strong value judgments. Gérôme's highly involved relationships with Goupil, the market, and mass reproduction are no longer seen as signs of a compromised artistic integrity but rather as telling indices of his modernity. This commercialism might even be said to anticipate certain postmodern artistic practices in which replication and marketing are taken to be integral elements if not the very founding premises. At the same time, however, we should be wary of making Gérôme over in our contemporary image. As a few of the authors argue in this book, the artist's relationship to mass culture may in fact have been more fraught than is often assumed. Emily Beeny compellingly suggests that Gérôme was deeply ambivalent about the mass reproduction and consumption of his work and that this ambivalence found covert expression in the artist's construction of spectacle and spectatorship within his paintings. Taking a deconstructionist tack, Emerson Bowyer suggests how a publishing project reliant upon modern reproductive technologies profoundly undermined the artist's, and his biographer's, lingering investment in values of authenticity and originality.

The image of Gérôme as a lowbrow, commercial artist has traditionally been reinforced by the overt, many would say crass, eroticism of some of his

work. From the early 1850s, with paintings like *A Greek Interior*, it was a common perception that he catered to prurience rather than disinterested aesthetic contemplation. Decisively shifting focus, Allan Doyle's essay considers the sexual and gender politics of Gérôme's work, which is presented as a vehicle of self-fashioning through which the artist positioned himself critically against art historical and academic tradition. Here it becomes evident that Gérôme's sense of humor and ironic wit call for a great deal more attention, indecorous or kitschy as these traits have traditionally seemed in the hallowed precincts of "high art."

Finally, with regard to Gérôme's Orientalism, the forceful but broad-brush critiques of the early 1980s are being challenged by new archival research. Peter Benson Miller revisits the vexed question of the artist's realism. Typed as escapist, artistically reactionary, or ideologically false, his Orientalist work has typically been excluded from mainstream histories of realism, which have privileged the French, homegrown practices of Gustave Courbet and others. As Miller demonstrates, however, "realism" was highly contested terrain in the criticism of the late 1850s and early 1860s, and Gérôme's ethnographic project—as he developed it in Egypt—could be and was in fact vaunted as a progressively modern enterprise. Far from being identified a conservative practice, the artistic exploration of the East was encouraged as a viable way out of stale academic convention.

For her part, Mary Roberts describes and documents the wide extent of Gérôme's activities in Istanbul and the Ottoman Empire and convincingly argues that his Orientalist genre paintings were able to serve the goals of Ottoman statecraft and conceptions of empire in ways utterly distinct from their reception in western Europe and America. Gérôme's audience, like his network of pedagogical influence, was truly international, and the varying reception of his work in different national and cultural contexts—the ways in which that work accommodated ideological perspectives other than that of the "West"—is a subject that scholars have only just begun to explore. It is a particularly pertinent issue given the current high level of interest in collecting Gérôme's art in the Middle East.[10]

It will be noted that the sequence in which I have discussed the essays here does not match their order in the book, an order that nevertheless has been designed to highlight points of connection, resonance, and critical difference between the texts; I leave it to the reader to discover these. Above all, it is the intention of this volume to provide a representative sampling of new critical approaches to Gérôme's work, foster an appreciation of its richness, complexity, and variety, and ultimately help galvanize future scholarship.

Notes

1. For further discussion of Gérôme's critical reception in the Paris Salon, see Scott C. Allan, "Gérôme before the Tribunal: The Painter's Early Reception," in the catalogue being published in 2010 by the Musée d'Orsay for the Gérôme exhibition organized by the Musée d'Orsay, Paris, and J. Paul Getty Museum, Los Angeles, in association with the Museo Thyssen-Bornemisza, Madrid. The present volume was conceived in conjunction with this exhibition.

2. See Émile Zola, "Nos peintres au Champ-de-Mars," in *Écrits sur l'art* (Paris, 1991), pp. 183–85.

3. John Rewald, "Should Hoving Be De-accessioned?" *Art in America* 61, no. 1 (January–February 1973), p. 28.

4. See Gerald M. Ackerman, *Jean-Léon Gérôme (1824–1904)*, exh. cat. (Dayton, 1972).

5. Gerald M. Ackerman, *The Life and Work of Jean-Léon Gérôme, with a Catalogue Raisonné* (London and New York, 1986); and Ackerman, *Jean-Léon Gérôme: Monographie révisée, catalogue raisonné mis à jour* (Courbevoie, 2000).

6. See, for example, Louise d'Argencourt and Douglas Druick, *The Other Nineteenth Century: Paintings and Sculpture in the Collection of Mr. and Mrs. Joseph M. Tanenbaum*, exh. cat. (Ottawa, 1978).

7. Edward W. Said, *Orientalism* (New York, 1978; Vintage Books Edition, 1979), which incidentally reproduces Gérôme's *The Snake Charmer* (plate 3) on its cover.

8. Linda Nochlin, "The Imaginary Orient," *Art in America* 71, no. 5 (May 1983), pp. 119–31, 186–90.

9. On the association of Gérôme with "official" realism, see Albert Boime, "The Second Empire's Official Realism," in *The European Realist Tradition*, ed. Gabriel P. Weisberg (Bloomington, 1982), pp. 31–123.

10. Recently, for example, Gérôme's *Le barde noir* (1888) and *Femme circassienne voilée* (1876) sold above estimate at auction for $1,172,500 and £2,057,250 ($4,107,107), respectively. Both paintings now belong to the Qatar Museums Authority in Doha. See Sotheby's New York, *19th Century European Art Including the Orientalist Sale*, October 23, 2008, lot 168; and Christie's London, *Orientalist Art*, July 2, 2008, lot 42.

Groping the Antique
Michelangelo and
the Erotics of Tradition

ALLAN DOYLE

One is not quite certain what to make of Jean-Léon Gérôme's *Michelangelo Showing a Student the Belvedere Torso* (plate 1); as Gerald M. Ackerman has noted, the 1849 canvas is one of his "strangest" pictures.[1] Gérôme shows Michelangelo bowed and sightless, being led through his gloomy studio by a pubescent assistant. Hands outstretched, they creep together toward the Belvedere Torso.[2] Despite the loss of its head, arms, and lower legs, the antique sculpture had long been admired for its ability to embody brute power in a seated pose. While still whole, it was thought to have represented Hercules bound with his arms behind his back.[3] The Torso's lack of sensitive appendages underscores its inability to refuse the touch or return the gaze of its admirers. Its oblique position animates the colossus, lending the impression that it is struggling to avoid the master's advances. Brought before Michelangelo for his personal delectation, this mound of heroic muscle has been rendered a passive object of desire.

The painting is strange not only for the unlikely encounter between Michelangelo and the Torso it depicts but also for the unsympathetic portrayal of its celebrated subject. Surrounded by untouched blocks of marble, Michelangelo's tools lie idle; his closed drawing portfolio leans against the Torso's base. The young assistant's lithesome physique contrasts sharply with that of his aged, hunched master, whose famous broken-nosed profile likens him to the dismembered trunk he longs to feel. Stacked one on top of another, the three bodies present the viewer with what appears to be a single male figure in progressive stages of ossification. Gérôme depicts the Renaissance master in a pitiful state of aesthetic impotence and physical infirmity.

The close atmosphere of the atelier, coupled with the assistant's taut costume, hints at tactile pleasures of a nonaesthetic kind, raising the question of

Michelangelo's sexual orientation.[4] The artist's biographers described his deep attachment to a succession of young men who functioned as servants, students, and beloved friends. Ackerman has interpreted the suggestion of same-sex desire in *Michelangelo*, along with the playful homoeroticism found elsewhere in Gérôme's early oeuvre, as evidence of the influence of a group of Jacques-Louis David's students who were known for their effete brand of late neoclassicism. Noting that the use of homoerotic themes within the group of artists that surrounded Gérôme ended with his marriage in 1863, Ackerman suggests that their alignment with the Davidian legacy may have reflected the group's personal "proclivities."[5] I would argue, however, that Gérôme's use of homoerotic motifs may be more productively understood as an aesthetic strategy intended to position the artist within the complex aesthetic politics of his time. The fact that *Michelangelo* shows a perversion of the proper master-student relation, one in which the latter guides the former instead of vice versa, calls for a recoding of the Davidian legacy rather than providing evidence of its emulation or the erotic tastes of the author and his friends.

In the original description of the anecdote that Gérôme illustrates, Michelangelo is described as passionately embracing the Torso and even kissing it; the story seems intended to testify to the artist's excessive attachment to the antique rather than to his homosexuality.[6] The anecdote was invented by Joachim von Sandrart in the seventeenth century.[7] Sandrart describes Michelangelo going blind late in life and having the Torso brought to his studio so that he could reacquaint himself with it through touch. Anecdotal scenes involving the old masters grew popular with nineteenth-century painters. Rather than documenting historical studio practice, such stories allowed artists to use their predecessors in a manner that served their current aesthetic agendas. Francis Haskell has observed that these works usually offered an optimistic view of the artists' social relations with their peers and patrons.[8] While hardly optimistic, Michelangelo's encounter with the Torso was usually interpreted in a sympathetic manner. An article from 1847, which appeared in the journal *L'Artiste*, is typical in its empathetic language. After describing how the "touching figure" of the blind sculptor has "profoundly moved him," the author expounds: "The sadness of humanity, the regret of the past, the hope of a better life, all this is symbolized in this unique situation."[9]

Gérôme's mordant wit takes aim at such sentimental rhetoric: his Michelangelo is not likely to touch anyone. Gérôme found Florentine art "excessive" and, during a visit to the Italian city, tried to convince his artist friends that "all of it was bad."[10] This may explain why, despite a fastidious attention to historical accuracy in his archaeological works, he chose to illustrate an anecdote that French commentators had already exposed as a fiction.[11] Gérôme's *Michelangelo*

is, however, more than a sardonic attack rooted in personal taste. The painting paradoxically juxtaposes two modes of production in order to interrogate the complex intertwining of tactility, vision, and desire in the making of art objects derived from antique models.[12] For Gérôme, Michelangelo's touch signifies a studio practice that aspires to direct, physical contact with its source materials. *Michelangelo* exhibits a smooth, nearly invisible method of paint application that flatly opposes manual tactility. This opposition between form and content ironizes the sentimental, touching view of Michelangelo's sad end by evoking tactile values in a purely optical register. Jacqueline Lichtenstein's recent summary of Denis Diderot's analysis of the relation between tactility and blindness provides a useful antecedent to Gérôme's position. According to Lichtenstein, Diderot holds that "visual pleasure entails an impulse to touch that must never be fulfilled: the subject must keep his distance, content with wanting but never attempting to touch."[13] *Michelangelo* denigrates artists who violate this demand for contemplative distance while subtly recommending its author's distanced method as the appropriate means of access. Where Gérôme's early view into Michelangelo's studio figures a homoerotic relationship to the antique as outmoded, in a group of late self-portraits, the painter returns to the theme of the artist-in-the-studio in order to offer a positive model of studio practice in ostensibly heterosexual terms.

Traditionally the Belvedere Torso was viewed more in relation to production and pedagogy than appreciation, and plaster casts of it could be found in ateliers across the continent.[14] Its bulging musculature was known to have inspired many of Michelangelo's most celebrated nudes, which, like the sculpture itself, were admired and copied by artists for centuries. One of these derivations was the central figure of Saint Bartholomew in the Sistine *Last Judgment*, a copy of which was installed in Paris in 1837 as part of Adolphe Thier's plan to import copies of Italian masterworks for the benefit of aspiring French artists. The Torso would also be included in the *Cours de dessin*, a drawing manual consisting of a series of lithographic drawing models Gérôme and his student Charles Bargue published in the 1860s and 1870s.[15] In Michelangelo's hands, the Torso was believed to have provided him access to the secrets of the ancient masters. William Hogarth echoed a widely held belief when he declared it was here that the artist had "discover'd a certain principle...which gave his works a grandeur of gusto equal to the best antiques."[16] The Torso was also unique in bearing an original inscription identifying its author, Apollonius. Gérôme omits the original inscription and signs his painting by carving his name on the wooden block beneath the Torso, a conceit that would make the painter literally bear the weight of the classical tradition.

When French artists first took up the theme in the early decades of the nineteenth century, they presented Michelangelo's enthusiasm for the

sculpture as exemplary. Paintings from the second decade of the nineteenth century used metaphors evoking pedagogy and lines of aesthetic patrimony rather than explicit allusions to pederasty. The troubadour painter Pierre Révoil, for example, set his *Michelangelo Blind* in a public space in which he carefully placed the Torso between the artist and his youthful guide.[17] Michelangelo reaches out to touch the sculpture while his assistant takes the master's free hand. The boy holds a leash in his other hand, at the end of which a dog sits patiently. Révoil therefore forms a sequence of relationships of training and obedience that moves from canine servitude to Michelangelo's tactile intuition of Greek mastery. The outstretched arms of student and master form a near-circle that neatly frames the sculpture's broken phallus, carefully positioned to appear just above their overlapping hands. The Torso here functions not only as the favorite muse of an individual artist but also as the source of an aesthetic tradition that was passed from hand to hand, originating with the master's direct contact with the classical body.

The individual artist's relationship to antiquity became more problematic for succeeding generations of French artists who felt a growing need to distance themselves from the mannered neoclassicism practiced by the school of Jacques-Louis David.[18] By this time depictions of sensual male nudes produced by students who emerged from the homosocial environment of the Davidian atelier were viewed with distaste.[19] Gérôme identified the decadent phase of David's career with his *Intervention of the Sabine Women* (1796–99) and blamed its cold, frozen figures on a poor choice of antique sources. He claimed that although David "created a new school, that is to say, another manner of seeing and feeling…unhappily, he drew his inspiration from the works of the Greek decadence instead of going back to Phidias and his precursors."[20] Gérôme in his *Michelangelo* attempts to break with the Davidian lineage by stemming the influence of an artist whose relationship to antiquity Gérôme finds equally problematic in its literal embrace of male sensuality.

Darcy Grigsby has argued that Eugène Delacroix used his atelier trysts with female models to negotiate the problem of post-Davidian production and thereby "heterosexualized the formerly homosocial studio space as well as the act of painting."[21] This insight casts Delacroix's melancholic portrait of Michelangelo of 1849–50 in a new light. The painting shows the sculptor sighted but in a state of profound inactivity, having forsaken his hammer, chisel, and books of poetry.[22] Michelangelo broods alone in his studio seated between his *Medici Madonna* and *Moses*, whose bases have been altered to amplify their unfinished appearance.[23] Although he criticized Michelangelo's unfinished manner, Delacroix in his writings and canvases also testified to his identification with the artist, and

his loose style may be viewed as a painted analog of Michelangelo's sculptural *non-finito*.[24] Lee Johnson has argued that a painting by Joseph-Nicolas Robert-Fleury that appeared in a lithograph the same year Delacroix began his canvas may have inspired Delacroix's portrait of the old master.[25] The print shows a desperate-looking artist seated on a roughed-out male torso in what looks to be the Medici Chapel. He grasps a *modello* of the Night figure between his legs with near-fetishistic intensity.[26] Although he is sighted, Michelangelo is given a blank stare that suggests he is blind to the viewer's presence. Both Robert-Fleury and Delacroix paint Michelangelo in a state of absorbed distraction, caught in a moment of nonproduction while positioned between sculptural models. The sculptor is made to embody the dilemma faced by the painters themselves: how to recode the erotic connotations of the atelier. Gérôme's variation on the theme refuses sexual difference. Where his contemporaries positioned Michelangelo caught between male and female bodies, Gérôme shows him sandwiched between ephebic immaturity and a mutilated totem of hyperbolic masculinity. Gérôme thereby pictures Michelangelo as being enthralled by the now outmoded paradigm of eroticized male bodies found in the Davidian atelier.

When French sources retold the tale of Michelangelo and the Torso they often emphasized the artist's sensual enjoyment by describing how he ran his hands over and around its bulging forms.[27] Gérôme, however, focuses the viewer's attention on what he implies is the real object of Michelangelo's interest, his young helper. It is easy to imagine that Gérôme may have identified with the young man, having himself only recently emerged from the ateliers of his teachers Paul Delaroche and Charles Gleyre. Seeing the assistant from behind, the viewer is encouraged to put himself in the boy's shoes, as both share the same orientation to the canvas's designated subject. Stepping into the painting, the boy leads the viewer into its dark, central knot of limbs and hands. Curiously, he holds both his master's hands when surely one would suffice, as was the case in the Révoil painting. The attractive, geometrical design of his tights propels the eye rhythmically across their horizontal spread while sweeping it up their length. Their smooth surface contrasts markedly with the wrinkled flesh of the aged master and the pitted surface of the Torso. In carefully detailing the lacing of his hose to the bottom of his vest, Gérôme conveys the pull of the fabric being stretched over the youth's delicate frame. Taken together, these details liken the garment to the canvas itself, another piece of colored cloth stretched across a rigid structure. The boy is, therefore, the lure, which brings the viewer into Gérôme's painted atelier. His outfit is intended to catch not Michelangelo's eye—he is, after all, blind—but the viewer's. He can only be recognized as a potential object of Michelangelo's tactile desire by first appealing to the viewer's retina.

Rather than the rude blows of hammer and chisel, *Michelangelo* demonstrates the licked, porcelain-like surface its author learned from Delaroche and Gleyre. Gérôme's flawless technique argues that the best means of propositioning the viewer's tactile desire is predicated on the removal of any trace of the author's hand. Ackerman has playfully observed that the boy's smooth backside solicits a desire to "pat" it.[28] The tension between Gérôme's self-effacing paint handling and Michelangelo's longing for touch reaches its climax at what may be described as the painting's punch line. At first it seems that the pair have come too close to the Torso. The hem of Michelangelo's coat nearly grazes the massive thigh of the sculpture while their interlaced arms hover above its lap. Given their proximity, it is unclear what part of the body the boy is aiming for or if they would make contact before running into its base. This uncertainty suggests that, despite his hesitant air, the young man has misled the master in a cruel variation on blindman's buff. The mystery is resolved, however, when one recognizes that Gérôme has carefully positioned their arms such that the shadow cast by Michelangelo's left hand falls squarely on the Torso's crotch. Michelangelo's homoerotic desire is here aligned with a longing for physical contact that is doomed to remain unconsummated. This redoubling of the master's blindness at his fingertips drives home the notion that vision and actual touch are essentially opposed.

The relationship between tactility and antiquity found in Michelangelo had precedent in Gérôme's oeuvre. Following an unsuccessful attempt for the Prix de Rome, the artist decided that he needed to improve his abilities at rendering the nude. To this end, he sought the advice of Delaroche, who suggested he attempt a figure painting that would make good the missing skills.[29] Gérôme showed the results to Delaroche who encouraged him to submit the painting to the Salon where it was a popular and critical success. *The Cockfight* (fig. 1) earned the young artist a bronze medal and a glowing review by Théophile Gautier.[30] Gautier christened Gérôme leader of the Néo-Grecs, a group of young artists many of whom had recently emerged from Gleyre's atelier and with whom Gérôme worked and lived in a somewhat bohemian atmosphere.[31]

Gérôme's inaugural effort exemplifies the Néo-Grecs' preference for viewing antiquity through the ludic and everyday. His painting shows a pair of nude adolescents and a cockfight. The motif was borrowed from an ancient relief depicting two boys facing off against one another.[32] The original work illustrated the same pun on the words for rooster and the vernacular for male genitalia in ancient Greek that is found in modern English. Gérôme's classical education and ironical sensibility undoubtedly allowed him to appreciate the joke. Adult males gave youths cockerels as part of a courting ritual, a popular motif with vase painters.[33] Gérôme's adaptation of the relief involved the pictorial equivalent of

13

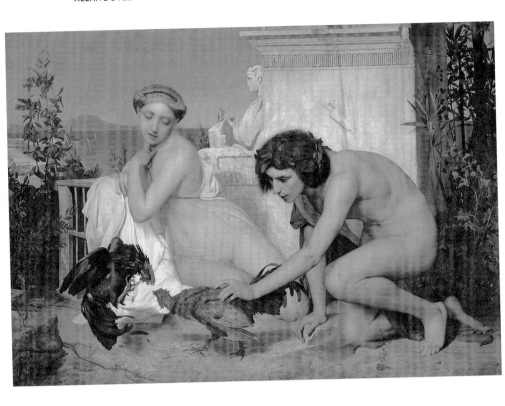

FIGURE 1
Jean-Léon Gérôme, *The Cockfight*, 1846. Oil on canvas, 143 × 204 cm
(56¼ × 80¼ in.). Paris, Musée d'Orsay (RF 88)

sex-reassignment surgery. He cropped out one male, on the left, and replaced him with a young girl. The remaining boy urges his bird on against the darker one which, suspended in midair, seems to have gained the advantage. In his review, Gautier ascribed ownership of the airborne cock to the girl. Other critics have seen her merely as a spectator, an impression generated by her somewhat awkward placement and demure response to the violent contest. Fully exposed to the viewer's gaze, the nude girl is positioned as a feminine object of desire in a composition that ambivalently endows her with a borrowed cock. In contrast to Michelangelo's failure to achieve his desired end, the young man firmly takes hold of his bird. Herbert Hoffmann discusses *The Cockfight* in his archaeological survey of the cockfight motif in ancient art and argues that the boy's rooster functions symbolically as his phallus and concludes: "In 1846 the official interest was precisely not homo-eroticism, but—in its sublimated double standard—the woman as an object of desire."[34]

Not all reviewers were as enthusiastic as Gautier with Gérôme's debut. After noting the painter's young age, the realist critic Champfleury named the Néo-Grecs the "School of Gérôme" in a review entitled "L'École du calque." Making Gérôme synonymous with the verb *calquer* (to trace), he disparaged him and his "school" as servile imitators whose unoriginal efforts would thoroughly gratify their former masters.[35] The critic also accused them of being too precious for the dirty work of the studio, claiming "that brush nor palette has never dirtied the hands of [Gérôme's] followers."[36] Whether these remarks stung or not, when Gérôme returned to the theme of the artist in the studio in a small group of late self-portraits he pointedly portrayed himself as having gotten his tools dirty. In sharp distinction to the critic's caricature and to Gérôme's unflattering portrayal of Michelangelo, these canvases assert their maker's enduring aesthetic virility by showing him in the process of producing a statue of a nude female.

The End of the Session (plate 2) depicts the artist at work on the clay model for his Omphale group shown at the Salon of 1887. According to legend, Hercules was punished for a murder by being enslaved to the Lydian queen Omphale. Interpreters of the myth emphasized their exchange of gender roles. Hercules was often shown spinning for Omphale while wearing women's clothing and holding a distaff and thread. Omphale was depicted having taken his lion skin and club. Since the Renaissance, painters and sculptors had modeled Omphale's pose on the Farnese Hercules and that of Hercules on the Belvedere Torso, whose submissive position suited the theme. This is the case in *Hercules and Omphale*, Peter Paul Rubens's 1606 canvas, which Gérôme would have seen at the Louvre, where it was on display during the first half of the nineteenth century.[37] In addition to the widespread presence of casts of the Torso in academic ateliers, the

sculpture had itself resided in Paris between 1798 and 1815, having been brought there by Napoléon as spoil from his Italian campaign. In 1810, Alexandre Lenoir, director of the Musée national des monuments français, recommended French artists take the opportunity to emulate Michelangelo's manual investigation of the Torso, which he identified as a representation of Hercules while in Omphale's service. In his *Histoire de l'art en France*, Lenoir associated Omphale, the Torso, and Michelangelo, predicting that "men who are researching the production of Fine Arts" would be inspired by the opportunity to stroke the antique booty:

> One [artist], the torch of Prometheus in hand, would animate the Venus de Medici, the other, fixated by the male forms of the beautiful statue of Hercules spinning for Omphale (referred to as the ancient Torso), palpates the skillfully rounded muscles of the subduer of the hydra of Lerna, and searches with his hand over all the parts of his body, to discover the secrets of art. As we saw in the past when blind Michelangelo had this masterpiece moved, and enjoyed, despite his blindness, the pleasure of touching it before going into his tomb.[38]

Gérôme's *Michelangelo* was a riposte to those who, like Lenoir, viewed as exemplary Michelangelo's tactile relationship to the Belvedere Torso's "male forms." If this canvas presents a negative model of atelier practice, Gérôme's self-portrait with his statue of Omphale is its positive complement. Both paintings depict a perverse reversal of social hierarchies. Contra *Michelangelo*, Gérôme's later canvas promotes the female life model as the commendable route to the antique. The temporary reassignment of gender roles involved in the Omphale myth is used here to argue for a mode of manufacture, which is ultimately as thoroughly heterosexual as it is optical.

Like Rubens, Gérôme adopts the queen's pose from the Farnese Hercules.[39] The artist's bent-over stance makes him seem small in comparison to the statue. This diminishing effect is amplified by the viewing angle, which monumentalizes what was in reality a smaller than life-size painting. His life model casts a dampened sheet over her clay double to keep it moist until the next session. One cloth already covers the sculpture's head and shoulder, denying the viewer facial clues as to the sex. The muscular leg that thrusts forward reinforces this initial impression of androgyny. When the sculpture *Omphale* was unveiled at the Salon, the masculine appearance of the figure was viewed as appropriate to the gender-bending motif.[40] Hercules' absence from the sculptural group casts Gérôme in the role of the indentured hero. Although his deep bend displays an impressive athleticism for his age, showing himself washing his tools in a bucket of

water also hints at domestic servitude. The sponge he holds echoes the task asso-
ciating him with the administration of the queen's nightly moisturizing regime.[41]
Given Jean-Léon's delight in visual jokes and word play, it is no surprise that lions
were a favorite motif. Omphale's borrowed *lion* skin implies she has adopted not
only Hercules' attribute but her maker's as well.

The End of the Session puts Gérôme's authorial power on display while
alluding to its faux undoing. The Omphale group included a blindfolded prepu-
bescent boy representing Eros peeking out from behind her left leg. This inclu-
sion reconfigured the original punitive story line of the myth to suggest that it
is only because love is blind that Hercules has surrendered his trophies and his
pride. By reassigning Omphale's triumph to Eros, Gérôme returns to a male body
the power that could lay a hero low. Omphale's function now becomes like that
of the girl in *The Cockfight* whose phallic endowment was similarly placed in
suspension. Draping Eros in the painted version, however, blinds the viewer to
his symbolic function. With two heads covered and two turned, the four bod-
ies depicted in *The End of the Session* consistently refuse the viewer's eye. The
nearest one comes to visual contact occurs in the form of Gérôme's averted gaze,
which directs the viewer's attention to the single red flower that has been placed
on the model stand. This touch of color strongly contrasts with the canvas's oth-
erwise subdued, cool palette and introduces a moment of enlivening intensity
to its uninflected surface. The morbid effect produced by shrouded bodies is
underscored by the flower, which may be read as a funerary offering or a token of
romantic affection. The flower generates a moment of sentiment that pierces the
painting's airless, uncanny atmosphere. This emblem of sexual sublimation helps
defuse any implication of impropriety. Unlike Michelangelo's rubble-strewn
grotto or Delacroix's libertine playhouse, Gérôme's well-lit, tidy atelier is that of
an established bourgeois painter, and his relationship to the nude is figured here
as decidedly chaste.[42] The painted flower attests to the fact that Gérôme has not
manhandled his model as Michelangelo longed to do. She remains on her model
stand as an object to be viewed and measured, touched only with calipers that lie
on the wooden step.

This is not to say that the glowing, pearlescent flesh of the model's back-
side is not intended to solicit tactile desire. The soft blush of the woman's skin
rhymes subtly with the flower whose contrasting green stem and red blossom
evoke a brush dipped in crimson paint. The overlapping poses of the model and
statue slur their bodies into a single entity that moves from living flesh to inan-
imate material. By placing the flower on the near side of the stand, the artist
includes the viewer in the circle of its potential owners. It offers itself as a grasp-
able tool that could be passed over the work's surface and, at least in Gérôme's

ALLAN DOYLE

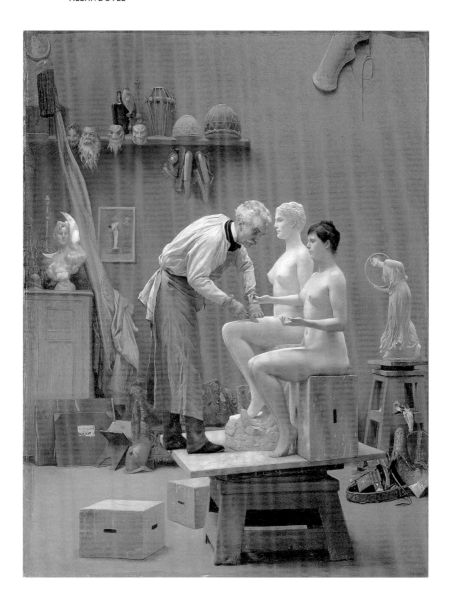

FIGURE 2
Jean-Léon Gérôme, *Working in Marble*, 1890. Oil on canvas, 50.5 × 39.5 cm (19 ⅞ × 15 ½ in.).
New York, Dahesh Museum of Art (1995.104)

imaginary, empower an artist to bring life to dead material while keeping one's distance. Seen together, *The End of the Session* and *Michelangelo* form a painted rebuttal to the Michelanglesque confusion of tactility and opticality. As opposed to the *non-finito* adopted by romantic peers like Delacroix, Gérôme pictures himself in pursuit of art objects that are excessively finished. A second late-atelier self-portrait, *Working in Marble* (fig. 2), shows the artist, tool in hand, polishing the already-smooth surface of his *Tanagra* while placing his other hand on its inner thigh. His gaze is, however, directed between the legs of the life model sitting beside the work. Given the sculpture's advanced state of completion, it is unclear what this focused looking is to be understood as accomplishing. *Working in Marble* seems again to be in conversation with *Michelangelo*, having replaced the master's feeble hand with the artist's penetrative vision.

While *Michelangelo* exploited a tension between form and content, Gérôme's atelier now becomes a space of washing and burnishing that aligns itself with his Ingriste manner. Michelangelo's illicit desire for materiality has been exchanged for a fetishistic attachment to the transparent picture plane. Gérôme's late, self-conscious studio posturing appears here as a disavowal of the fragmented, homoerotic origins of neoclassicism. *Working in Marble* and *The End of the Session* testify to the belief that in a post-Davidian age, all hope for an unbroken, exclusively male link to antiquity must be abandoned. Sexual difference is now admitted into the studio but kept at a distance. This is perhaps most pointedly demonstrated by the fact that in *Working in Marble* Gérôme shows himself wearing gloves. This prophylactic against direct contact with his faux-antique sculpture figures Gérôme as a promoter of safe-studio practice for would-be lovers of the antique; concisely put, his advice for Lenoir's "men who are researching the production of Fine Arts" is, to use a current catchphrase, "no glove, no love."

Notes

I thank Ljubomir Milanovich whose Herculean efforts on my behalf in the Marquand Library of Art and Archaeology at Princeton University were indispensable to the writing of this essay.

1. Gerald M. Ackerman, "The Néo-Grecs: A Chink in the Wall of Neoclassicism," pp. 168–96, in *The French Academy: Classicism and Its Antagonists*, ed. June Hargrove (Newark, 1990), p. 187.

2. The literature on the Belvedere Torso is vast; useful guides are Francis Haskell and Nicholas Penny, *Taste and the Antique: The Lure of Classical Sculpture, 1590–1900* (New Haven, 1981), pp. 312–14; and Raimund Wünsche, *Der Torso: Ruhm und Rätsel*, exh. cat. (Munich, 1998). For the Torso and other archaeological finds in the Renaissance, see Leonard Barkan, *Unearthing the Past: Archaeology and Aesthetics in the Making of Renaissance Culture* (New Haven, 1999).

3. Gösta Säflund has argued that it represents Marsyas bound. See "The Belvedere Torso: An Interpretation," *Opuscula romana* 11 (1976), pp. 63–84.

4. Michelangelo's sexual orientation and his relationships to his male assistants have been the subject of much recent scholarship; see, in particular, James M. Saslow, *Ganymede in the*

Renaissance: Homosexuality in Art and Society (New Haven, 1986); Lene Østermark-Johansen, *Sweetness and Strength: The Reception of Michelangelo in Late Victorian England* (Ashgate, 1998); and Robert S. Liebert, *Michelangelo: A Psychoanalytic Study of His Life and Images* (New Haven, 1983). On the wider social context of sodomitic practices in Renaissance Italy and their meaning, see Michael Rocke, *Forbidden Friendships: Homosexuality and Male Culture in Renaissance Florence* (Oxford, 1996); and Leonard Barkan, *Transuming the Passion: Ganymede and the Erotics of Humanism* (Stanford, 1991).

5. Ackerman (note 1), p. 177.

6. Wünsche (note 2), p. 36.

7. "Der fürtressliche Michaël Angelo, als er schon wegen hohen Alters ganz blind ware und nicht mehr laboriren konte hat dannoch zur ergötzung seines Tugend-gewidmeten Geistes sich vielmals zu diesen Figuren führen lassen: da er dann dieselben wegen der auserlesnen Vollkommenheit mit seinen Händen von oben bis unten wie auch rund umher betastet in seine Arme genommen und geküsset" (Joachim von Sandrart, *Teutsche Akademie*, 2 vols. [Nuremberg, 1675], 1, bk. 2: pp. 34–35; www.sandrart.net [accessed August 2009]).

8. Francis Haskell, "The Old Masters in Nineteenth-Century French Painting," pp. 168–95, in *Past and Present in Art and Taste: Selected Essays* (New Haven, 1987), p. 104. Haskell also describes the majority of artists as presenting a "kindly" Michelangelo (p. 96).

9. H. Acquier, "Michel Ange et la Marquise de Pescaire," *L'Artiste*, ser. 4, vol. 10 (1847), pp. 163–67. Unless otherwise noted, all translations are my own.

10. Charles Moreau-Vauthier, *Gérôme, peintre et sculpteur, l'homme et l'artiste, d'après sa correspondance, ses notes, les souvenirs de ses élèves et de ses amis* (Paris, 1906), pp. 63–64.

11. The earliest French translation of the anecdote I have located is found in P. J. B. Nougaret's *Anecdotes des beaux-arts* of 1776. This text does not mention Michelangelo kissing the Torso but does claim that he touched it for "several hours" and was only willing to leave after having "tenderly embraced" the sculpture (Nougaret, *Anecdotes des beaux-arts* [Paris, 1776], vol. 1: p. 297). In his notes for Anne-Louis Girodet-Troison's *Oeuvres posthumes*, however, Pierre Alexandre Coupin casts doubt on the episode (see Coupin in *Oeuvres Posthumes de Girodet-Trioson, peintre d'histoire*, 2 vols. [Paris, 1824], 1: pp. 281–82).

12. Haskell (note 8), p. 109, has discussed this issue in regard to Gérôme's *Rembrandt Etching a Plate with Acid* (1861).

13. Jacqueline Lichtenstein, *The Blind Spot: An Essay on the Relations between Painting and Sculpture in the Modern Age*, trans. Chris Miller (Los Angeles, 2008), p. 56.

14. Haskell and Penny (note 2), p. 312.

15. Charles Bargue, with the collaboration of Jean-Léon Gérôme, *Cours de dessin*, trans. Christian Diebold (1867–69; Courbevoie, 2003), pp. 82, 90.

16. William Hogarth, quoted in Haskell and Penny (note 2), pp. 312–13.

17. It appears to be set in the Belvedere Palace, as is described in the account of the anecdote in Nougaret (note 11). This painting is reproduced in Marie-Claude Chaudonneret, *Fleury Richard et Pierre Révoil: La Peinture troubadour* (Paris, 1980), p. 136.

18. Marie-Pierre Chabanne argues that Michelangelo was seen as a "herald of Neo-classicism" for artists under the Restoration. See her *Michel Ange romantique: Naissance de l'artiste moderne de Winckelmann à Delacroix* (Villeneuve d'Ascq, 2003), pp. 174–75.

19. For the homoerotic pedagogy and politics of David's atelier, see Thomas Crow, *Emulation: Making Artists for Revolutionary France* (New Haven, 1995).

20. Jean-Léon Gérôme, quoted in Fanny Field Hering, *Gérôme: The Life and Works of Jean Léon Gérôme* (New York, 1892), p. v.

21. Darcy Grimaldo Grigsby, *Extremities: Painting Empire in Post-Revolutionary France* (New Haven, 2002), p. 255.

22. For more on Delacroix's view of Michelangelo's inactivity, see Marc Gotlieb, "Creation and Death in the Romantic Studio," in *Inventions of the Studio: Renaissance to Romanticism*, ed. Michael Cole and Mary Pardo (Chapel Hill, 2005), pp. 147–83.

23. Charles De Tolnay, "Michel-Ange dans son atelier par Delacroix," *Gazette des beaux-arts*, ser. 6, vol. 59 (1962), pp. 43–52.

24. On Delacroix's ambivalent identification with Michelangelo, see Jack J. Spector, "An Interpretation of Delacroix's *Michelangelo in His Studio*," *Psychoanalytic Perspectives on Art*, *PPA*, ed. Mary Mathews Gedo (Hillsdale, NJ, 1985), pp. 107–31; André Joubin, "Delacroix vu par lui-même," *Gazette des beaux-arts* 6, no. 21 (May–June 1939), pp. 305–18; Théophile Silvestre, "Michel-Ange dans son atelier," in Alfred Bruyas, *La Galerie Bruyas* (Montpellier, 1876), pp. 296–306; and Marie-Pierre Chabanne, "Michel-Ange, Stendhal, Delacroix, et Dumas: Portraits de l'artiste en romantique," in *De la palette à l'écritoire: Actes*, ed. Monique Chefdor, 2 vols. (Nantes, 1997), 1: pp. 187–95. Lee Johnson is skeptical of the connection; see his *Paintings of Eugène Delacroix: A Critical Catalogue, 1816–1831*, vol. 3, *1832–1863, Movable Pictures and Private Decorations: Text* (Oxford, 1986), pp. 126–28.

25. Johnson (note 24).

26. Charles de Tolnay has interpreted the Night figure as signifying a restless, dream-filled sleep and as a symbol of female fertility. See his *Michelangelo*, vol. 3, *The Medici Chapel* (Princeton, 1948), p. 67.

27. Alexandre Lenoir, *Histoire des arts en France, prouvée par des monuments, suivie d'une description chronlogique des statues en marbre et en bronze, bas-reliefs, et tombeaux des hommes et des femmes célèbres, réunis au Musée impérial des monuments français* (Paris, 1810), pp. 30–31.

28. Ackerman (note 1), p. 187.

29. Gerald M. Ackerman, *Jean-Léon Gérôme: Monographie révisée, catalogue raisonnée mis à jour* (Courbevoie, 2000), p. 27.

30. Théophile Gautier, *Critique d'art: Extraits des Salons, 1833–1872*, ed. Marie-Hélène Girard (Paris, 1994), pp. 237–44.

31. One report claimed that they petitioned the government for the elimination of marriage. See C. H. Stranahan, *A History of French Painting from Its Earliest to Its Latest Practice* (New York, 1888), p. 313.

32. Ackerman (note 1), p. 173. For a reproduction of the relief see Herbert Hoffmann, "Hanenkampf in Athen: Zur Ikonolgie Einer Attischen Bildformel," *Revue archéologique* (1974), 1: pp. 176–77.

33. See Saslow (note 4), p. 33; K. J. Dover, *Greek Homosexuality* (1978; Cambridge, MA, 1989), p. 92.

34. Hoffmann (note 32), p. 209.

35. Champfleury, "L'École du calque," reprinted in *Le Réalisme* (1857; Paris, 1973), pp. 129–30.

36. Ibid., p. 130.

37. For Jacques Foucart's rediscovery of the Rubens, which had languished for more than a century in the Louvre reserves, see Jacques Foucart, "Les Retrouvailles d'un grand Rubens du Louvre," *La Revue du Louvre et des musées de France* 35 (1985), pp. 387–96. Foucart insists that the work was placed in storage as late as 1850.

38. Lenoir (note 27), pp. 30–31.

39. For a Freudian reading of Rubens's Omphale as a phallic woman, see Lisa Rosenthal *Gender, Politics, and Allegory in the Art of Rubens* (Cambridge, 2005), p. 141.

40. See George Lafenestre, "Salon of 1887 II: Sculpture," *Revue des deux mondes* 3, no. 81 (May 1887), pp. 886–87.

41. This same sponge was prominently placed at the base of the completed clay figure when it was photographed for a photogravure included in Fanny Field Hering's 1892 monograph on the

artist. Sponges soaked in white soap suds are also used by servants to wash passive female bodies in a series of late Orientalist bathing scenes the artist executed in the latter half of his career. For the photogravure, see Hering (note 20), pp. 168–69. For bathing scenes, see Ackerman (note 29), pp. 93, 129.

42. For a fascinating discussion of Michelangelo's afterlife in the romantic period and the paradox of the chaste nude, see Patricia A. Emison, *Creating the "Divine" Artist from Dante to Michelangelo* (Leiden, 2004), pp. 303–48.

Monographic Impressions

EMERSON BOWYER

In 1898 American artist Henry Wolf produced a portrait of Jean-Léon Gérôme (fig. 3). Wolf's print is a facsimile wood engraving hand-cut from a photographic image that had been developed on a sensitized block. The technical term for this mind-bending, counterintuitive process—photoxylography—immediately betrays its hybridity. A member of the controversial "New School" of engraving, Wolf found in photography a "powerful auxiliary."[1] Yet, for some critics, his practice was a monstrous adulteration, the bastard child of art and industry.[2] Forsaking the supposedly natural syntax of his métier, the engraver performed an artisanal pantomime of automated reproduction. This oddly violent act of media mimicry shredded the photographic image, only to reconstitute it in the cleaving crush of the printing press. No longer a photograph and not entirely an engraving, Wolf's transvestite image seeks to enchant the viewer with immediate presence.[3] But of what? The sitter or the photograph?

Examination of a test print for the portrait compounds the provocation (fig. 4). Here the image is ensnared midtransmission, exposing a fractured, fragmented Gérôme—three pre-Warholian impressions of the same face.[4] Decapitated, ungrounded and untethered, the painter has been relayed through a series of reproduction technologies. This is a portrait of the artist as simulacrum. Both copy and model are obliterated by the circulation of the image, its libertine commerce thwarting long-policed boundaries between media. These floating, repeating, at times overlapping forms were eventually tamed. But here they remain, ghosts in the machine.[5]

How, then, to construct Gérôme as a monographic subject? This question is more difficult than one might first imagine. It strikes at the very heart of the artist's creative practice, highlighting his problematic position within the phantasmagoric visual regime of the nineteenth century. Throughout the last century his critical fortune has been tenuous at best, reflecting the continued currency of that

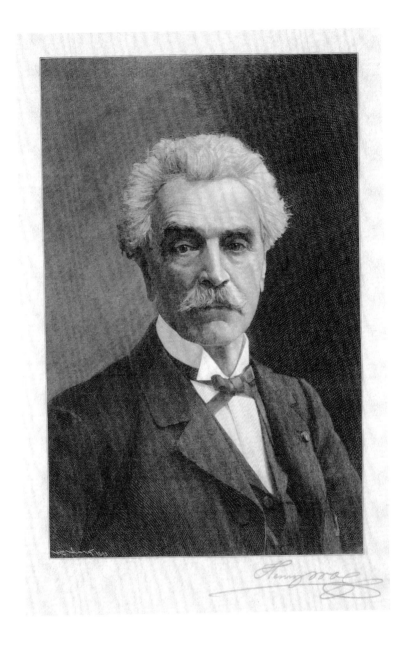

FIGURE 3
Henry Wolf (American, 1852–1916), *Portrait of Jean-Léon Gérôme*, 1898. Wood engraving on china paper, sheet: 12 x 9.5 cm (30 ½ x 24 ⅛ in.); image: 7.4 x 4.8 cm (18 ⅞ x 12 ¼ in.). Williamstown, Massachusetts, Sterling and Francine Clark Art Institute (1976.46)

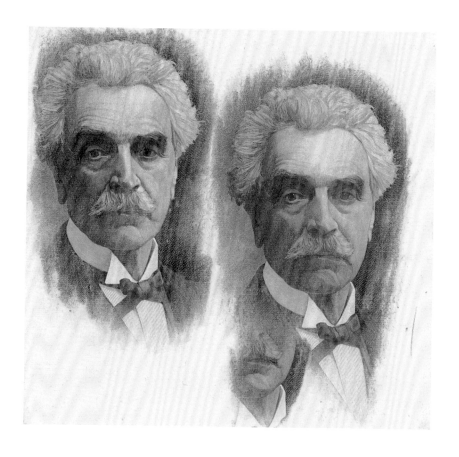

FIGURE 4
Test print for **Henry Wolf**'s *Portrait of Jean-Léon Gérôme* (1898; fig. 3). Fine Arts Museums
of San Francisco, Achenbach Foundation for Graphic Arts (1963.30.26148)

jealous idol, the origin. Gérôme's status as "originary author" is complicated by his entangled relationship with mechanical reproduction. In his test print Henry Wolf unwittingly stumbled across this issue, only to veil its wounding presence in a fine mesh of staccato lacerations, binding his subject tightly to the page. A precarious act, this putting Gérôme to paper. After all, paper was the material of that artist's multiplicity, the support by which he impressed himself on an audience of unprecedented scale. The knotted problem posed by Gérôme's authorial practice will be pursued in this essay, and it is with paper that I will begin.

In 1892 a young American librarian, Fanny Field Hering, published her first book, *Gérôme: The Life and Works of Jean Léon Gérôme*.[6] It was one of merely a handful of full-length monographs on living artists commissioned during the nineteenth century and almost certainly the most elaborate. Although valued as a source of text penned by Gérôme and as a scrapbook of contemporary critical responses to the artist and his oeuvre, it has been overlooked as a material artifact. Upon its release, Hering's volume was hailed as both a milestone in American publishing and as a veritable objet d'art. Enfolded in this 288-page tome were nineteen full-page photogravures, twenty-five full-page halftone illustrations, and colored reproductions of fifty sketches. This agglomeration of images and text, bound within the architecture of a book, brought Gérôme within the shadow of a venerable Vasarian tradition. But, as will be seen, the monographic genre was placed under continual strain by its own subject and his ambivalent relationship with mechanical reproduction.

The circumstances by which Hering became acquainted with Gérôme are unclear. A note from the artist dated May 7, 1887, indicates, however, they were first in contact around that time.[7] Hering visited Gérôme on several occasions in the following months, and the possibilities of a short article in the *Century Magazine* and a book-length project were discussed.[8] In late January 1888 Oscar Dunham, managing editor of New York's Cassell and Company, confirmed his interest in the monograph.[9] The contract between the parties has not surfaced, but their correspondence suggests that Gérôme's supervision of the author's research was a specific requirement of the publisher.[10] Supervision, as we will see, rapidly became collaboration. As it progressed the monograph occupied an increasingly liminal space between biography and autobiography, between the manuscript destined for reproduction and the original art object.

The Life and Works of Jean Léon Gérôme was intended to fulfill a purpose distinct from that of cheap, serialized biographies.[11] "Our object," wrote Hering's editor, "is to make this book superior to anything else in this line that has ever been done."[12] And indeed, the monograph eschews the outward appearance of a transient, mass-produced commodity. At around forty-five centimeters high

(eighteen inches), each oversized, gilt-edged copy asserts a voluptuous material-ity. It took its destined place within that class of luxury items Walter Benjamin envisioned all glittering and enthroned in the cavernous department stores of the *expositions universelles*—the *spécialité*.[13] The strangely fetishistic engagement elicited from the monograph's readers was evoked by the *New York Herald* in amorous, pulpy prose:

> Some books seem to be showered upon us as thick as hailstones in a December storm, and other books come only once in a great while, for when they come they bring new sensations and fresh delights. We linger over them lov-ingly, turn the pages with reverent fingers and heave a sigh of regret when the end is reached. On our table at the moment lies a book of this description.[14]

In other words, the volume masked its serial condition. Bulky and housebound amid a rush of fin-de-siècle publications this expensive monograph must have assumed the stature and durability of a monument.[15]

Hering's written contribution frustrates any aspiration toward the singu-lar monument. The text is more assemblage than narrative, a mosaic of jagged edges constituted by long quotations from the writings of French and American critics. The insular armature of the book is continually breached by a clamor-ing menagerie of voices. Such a text, as Jacques Derrida noted, is "no longer a finished corpus of writing, some content enclosed in a book or its margin, but a differentiated network, a fabric of traces referring endlessly to something other than itself, to other differentiated traces."[16] Further puncturing the text, on yet another frequency, is the startling voice of the artist himself—startling because of its incursive, dissonant appearance in the form of lengthy excerpts from his cor-respondence with Hering as well as autobiographical notes. An epistolary theater is constructed wherein the reader is encouraged to play the part of addressee to the artist's whispered and fragmented confidences.[17]

Unpublished portions of Gérôme's letters to Hering disclose his fear of compromising the book's integrity by this technique of simulated presence. Her request that the artist provide a preface to the monograph was met with resistance: "I believe it is difficult and delicate from the vantage point of my situation."[18] Eventually he was persuaded to furnish the piece, but the passage avoided all discussion of his oeuvre and, rather disingenuously, denied all knowledge of the monograph's content. "This volume," he wrote, "is written in English and I am unacquainted with that language—consequently, I can express no opinion about it."[19] With this diabolically self-aware proposition Gérôme ungrounds the mono-graph, confounding the notion that authors precede their work.[20]

What is the monograph if not a monstrance for the nonreproducible artistic mark? The status of that mythic trace is the central problem of Hering's book and, I would suggest, Gérôme's entire oeuvre. At one point in the text, Hering anxiously promotes the artist's authenticity with an anecdote of an incomplete painting stolen from Gérôme's studio and which reappeared on the market several years later: "So inimitable is Gérôme's style and draughtsmanship, however, that there is little danger of any spurious work appearing under his ostensible signature, whereas even his unfinished work bears the unmistakable imprint of this master-hand."[21] Gérôme's authorship is literally stamped at the conclusion of his preface, a sign that openly conflicts with his text. There, seemingly scratched directly onto the page, is the artist's signature. This clever counterfeit, photomechanically extracted from one sheet of paper and deposited on hundreds of others initiates a spritely dance between the autograph and the automatic.[22]

For a critic at the *New York Times* Hering's authorial technique functioned in a similar fashion to the mechanical transfer of Gérôme's signature:

> From the artist's standpoint women make the best critics—*lucus à non lucendo*—because they do not really criticize; they enthuse and rhapsodize. Mrs. Fanny Field Hering is one of these charming interpreters. They are like modern process-work, which reproduces an artist's picture faithfully in some ways but does not tell all, since defects of color are charitably concealed; whereas the critic is more like an etching or engraving, which is affected by the nature of the engraver.[23]

This astounding statement maps mechanical reproduction and authorship onto the ever-present problem of Woman. Hering is portrayed by the critic as an android—a mechanized amanuensis. More medium than creator, she provides a conduit for the accurate transmission of Gérôme's authorial presence.[24] Although less admiring than the *New York Times*, Mrs. Schuyler Van Rensselaer, a prominent critic, seems to have employed a similar analytical process in her review of the monograph. "Mrs. Hering's attitude towards Gérôme," she wrote, "is one of unreasoning adoration, and she seems to think in about the same way of other persons who have spoken well of her hero." Immediately prior to this conclusion, Van Rensselaer complained that "those who admire Gérôme without stint will be better pleased with Mrs. Hering's text than those who love beautiful books as such, for, of course, no matter how good photographic reproductions of paintings may be, they have not the intrinsic charm and value of fine reproductive etchings or woodcuts."[25]

Authorial tension is most apparent in the relationship between Hering's text and illustrations. Many of the significant decisions concerning the book's

images were dictated by business and commercial interests. Initially Hering had hoped to include around 150 images, but this was reduced by Cassell and Company who feared a loss in profit; Gérôme, too, was skeptical of the addition of so many illustrations.[26] The choice of reproductions involved long and tense negotiations between Hering's publishers and the French firm Boussod, Valadon et cie (known as Goupil in its earlier incarnation). Gérôme's ties to Goupil/Boussod were close and complicated. As Hélène Lafont-Couturier has noted, "We do not know the specific terms of the 'contract' binding Gérôme to the firm.... Yet, apparently, the artist could not sell a painting directly without Goupil being able to reproduce it in some form; nor could he authorize anyone to use the reproductions of his works without asking permission."[27] Uncertainty surrounding Gérôme's contract also emerged during the production of the monograph, provoking confusion over who exactly owned the images. The problem centered on the legal status of Gérôme's relationship with Boussod and whether it had altered materially after 1884, when the firm changed hands. Edwin Bale, London-based art director at Cassell and Company, believed there was a different contract for works produced after that date:

> You [Hering] said that you would ask him especially as to the copyright. You told me at the same time that he had stated that the copyright of all his pictures belonged to Boussod & Valadon, but that does not accord with the statement made to me in Paris which was, if I remember rightly, to the effect that when Goupil left the business the old arrangement as to the copyright of Gérôme's pictures lapsed and that only a few of his later ones were the property of Boussod & Valadon.[28]

Writing to her family, Hering's mother made much the same claim: "Gérôme...will be able, it is hoped, through Boussod who is an honorable young fellow, to secure just such an arrangement as he wishes—otherwise, I believe, he has the reserved right to take all of his works out of their hands."[29] Gérôme was cast in the role of mediator and appears to have arranged meetings between the two publishing companies. For the "subject" of the monograph the irony of his situation must have been obvious.

Eventually it was agreed photogravures could not be made of paintings that had appeared in that format in previous American publications; such images could, however, be represented by lesser-quality halftone prints.[30] This demonstrates the protagonists' keen awareness of the difference in repetition, which complicates any generic Benjaminian explication of art reproductions, of their reception and perceived value.[31] Photogravure was the most sophisticated,

expensive, and time-consuming process of photomechanical reproduction. It effectively combined the tools of aquatint and engraving with the subtlety and tonal range of a photographic print. The resultant velvety images, printed on heavy board, have an unexpected three-dimensionality. As photogravures were prone to smudging, thin protective sheets were placed over each image, enhancing their materiality. It is possible to discern the ghostly shape of the image underneath the protective sheet, thereby intensifying the act of revelation and focus attendant upon turning the page. This act of revelation might very well have increased the libidinal and spectacular qualities inherent in many of Gérôme's own images, echoing their narratives of concealment and display. Halftone prints, on the other hand, were far less detailed than photogravures. These ancestors of modern newspaper images were produced by photographing a work through a screen punctured by tiny holes, and the final image, upon close examination, dissolves into a mass of identical, atomlike dots. The photogravure, then, presented a new, idiosyncratic object. The halftone, by comparison, was an obviously mechanical facsimile.

The most seductive illustrations are colored reproductions of fifty sketches by Gérôme interspersed within Hering's book (fig. 5). These were chosen by Hering and the artist from his collection. Substitutions were necessary when individual drawings did not photograph well; those on yellow paper, for example, seemed to have caused much strife. In contrast to the photogravures and halftones, Gérôme's printed drawings infiltrate the demarcated space of the written word, offering themselves to the reader as direct traces of the artist's hand. They abandon all conventional framing devices, forcing the text to weave around their bright, graphic forms. Image and text have little formal relationship within the structure of the book, and the apparent randomness of the drawings assists in the propagation of Gérôme's immediate presence. In this way the book is activated as a space of intimacy.[32] Many sketches are portraits supposedly created during his excursions in the East and assert the ethnographic accuracy of lived reportage. Others are seemingly preliminary drawings (fig. 6) for more famous paintings, such as the central figure in Gérôme's wildly successful *The Snake Charmer* (plate 3). That canvas was reproduced as a halftone print and so, perhaps to compensate for such an inadequate copy, the signed blue boy is appended. The sketch compels the reader to imagine the long process of manual, creative labor that marked the genesis of the painting—the arduous succession from drawing, to painted sketch, to finished work. Of course, in the end, the drawings are photomechanical and artificially colored reproductions—industrial copies. They return us to the problem raised by Henry Wolf's photographic wood engraving, an image of much the same order.

THE LIFE AND WORKS OF JEAN LÉON GÉRÔME. BY FANNY FIELD HERING.
FROM AUTOBIOGRAPHICAL NOTES AND LETTERS BY THE ARTIST HIMSELF,
WITH AN INTRODUCTION BY AUGUSTUS ST. GAUDENS. INCLUDING A
PORTRAIT OF GÉRÔME, NINETEEN FULL-PAGE PHOTOGRAVURES, AND
TWENTY-FIVE FULL-PAGE PHOTO-PROCESS REPRODUCTIONS OF HIS
PAINTINGS AND SCULPTURE, TOGETHER WITH FIFTY PENCIL-DRAWINGS,
MADE ESPECIALLY FOR THIS BOOK BY GÉRÔME, AND EXECUTED BY BOUS-
SOD, VALADON & CO., SUCCESSORS TO GOUPIL.

PUBLISHED BY CASSELL PUBLISHING COMPANY ◎ ◎ ◎ ◎
ONE HUNDRED AND FOUR AND ONE HUNDRED AND SIX
FOURTH AVENUE NEW YORK ◎ ◎ ◎ ◎ ◎ ◎ ◎ ◎

FIGURE 5

Title page from **Fanny Field Hering, *Gérôme: The Life and Works of Jean Léon Gérôme*** (1892).
Los Angeles, Research Library, Getty Research Institute (2716-658)

The sense of the ridiculous and love of abrupt contrast which are to be found in many of the master's paintings crop out in the last line of this impromptu "Envoi"—which reminds one of Heine, in its unexpected *dénoûment.*

In September, he writes :

"I am very much behindhand—forgive me. For some time I have been greatly oppressed with sorrow and melancholy—a sort of nostalgia. I have no courage to do anything, and do not like to burden others with my weaknesses. I have just returned from a short journey to the shores of the Mediterranean, where I made some studies of the sea which I need for a picture I am painting. And here I am again installed in Paris, preparing work for the winter—*for it is work alone which satisfies the mind and consoles the heart.* One cannot, in the course of a day, entirely re-create one's self. Still, one must not feebly succumb, but resist to the utmost ; not yield without a struggle, but always seek to regain full self-possession. *The spirit should always dominate the flesh.* I shall send you some photographic reproductions of some of my paintings and will keep you posted in regard to my future work."

In October, he writes :

"I have just sent you a collection of photographs of some of my pictures. I hope you will like them. In any event, I shall esteem myself happy if you will receive them favorably and occasionally glance at them. I have begun again to work with frenzy, to forget my grief and melancholy. Since I had the pleasure of seeing you I have finished several pictures which have gone to your country, and I have begun several others which will probably follow the same route. I also have a mind to model another figure in order not to lose time during the months of November and December, when the light is too poor to paint, but sufficient to model in clay."

In November, he writes :

"We are having days so gloomy that one might imagine one's self in England, and it is almost impossible to work. Nevertheless, I keep at it desperately, and expect to *fight on to my last breath !*"

In December, 1887 :

"Your letter just received. I hasten to reply. You are giving yourself too much trouble for me ; I am not worth it. I fear your conversation with

FIGURE 6
Page 257, with a drawing by Jean-Léon Gérôme for *The Snake Charmer* (ca. 1870; plate 3), from Fanny Field Hering, *Gérôme: The Life and Works of Jean Léon Gérôme* (1892). Los Angeles, Research Library, Getty Research Institute (2716-658)

The attempt to construct an unassailable monographic entity within *The Life and Works of Jean Léon Gérôme* only exposed the artist's inability to conform to that paradigm. In its fetishism of the artist's hand, the book produced a spectacle of the simulacra. It is significant, I believe, that Gérôme's painterly practice during that same period reflected the problems of the monograph. In tandem with Hering's activities of 1887 he began a series of paintings that staged and restaged self-portraits within the setting of his studio. In addition to their "documentary" tenor, the images present mythical scenes of creative origin. The earliest work in this group, *The End of the Session* (plate 2), wraps together creation, mimesis, and physical contact to produce an image of the artist as Pygmalion.[33] Here, the damp, mute sculpture bears the pressings and moldings of Gérôme's hands and tools, and the muddy residue of the event drips from his fingers. Hering's book continually evokes this sensuous theater of indexicality. In one memorable passage she enthusiastically describes the making of another sculpture, *Tanagra* of 1890:

> At [the sculpture's] feet was a mass of clay which the porter had just brought in for the next day's work. Suddenly seizing a double-handful, the master looked at it as one regards a beloved friend and cried, "Ah! The beautiful earth!" with such a fervor of tenderness that it seemed impossible the senseless clay should not have thrilled into instant and sentient being, under the vivifying touch of this Nineteenth-Century Pygmalion.[34]

Gérôme and his biographer cannot have been ignorant of the weakened rhetorical force of a primal myth of origin as the century lurched toward its close. Burgeoning technologies of mass production and reproduction had the effect of undermining traditional conceptions of the visual arts predicated on authorship and authenticity.[35] Moreover, by 1887 any artistic invocation of the Pygmalion myth flirted openly with cliché.[36]

The cliché is inseparable from nineteenth-century visual culture; it was inextricably bound to the ever-accelerating temporality and interlocked cycles of novelty and obsolescence characteristic of modernity. Literally emerging from technologies of industrial reproduction, the term was initially used to describe the "clicking" sound of the printing press as it produced multiple prints from a single plate. In addition to the notion of exhausted stereotype, cliché acquired complementary meanings, those of the photographic negative and the snapshot.[37] Repetition, then, forms the logic of the cliché. It annuls or displaces any stable connection between an image and the authority of its origin. Gilles Deleuze situated the cliché on the reverse of modern image production—as its negative. His extended discussion of Francis Bacon's paintings argued that clichés precede and

hinder the creation of artistic images. The blank white canvas, he wrote, has never existed. Instead, clichés in the form of preexisting images and ideas (*données* or "givens") are always already crowded within the frame "so that the painter does not have to cover a blank surface but would rather have to empty it out, clear it, clean it":

> Clichés! Clichés! The situation has hardly improved since Cézanne. Not only has there been a multiplication of images of every kind, around us and in our heads, but even the reactions against clichés are creating clichés.... Every imitator has always made the cliché rise up again, even from what had been freed from the cliché. The fight against the cliché is a terrible thing.[38]

Deleuze's understanding of the cliché seems overly romantic and unreasonably modernist-inflected. I wonder, however, if it might nonetheless offer a starting point for rethinking Gérôme's artistic practice, precisely by emphasizing the industrial and technological origins of the cliché.

Gérôme was a supremely photogenic painter. Notorious for their razor-sharp, glassy finish, his paintings gained an ally and coconspirator in the detail-hungry camera, making him the prized possession of the Goupil publishing empire. A petulant Émile Zola claimed on more than one occasion that Gérôme's paintings existed only to be photographically reproduced, that they were always already mass commodities: "une marchandise à la mode."[39] From the outset this artist's paintings lacked what Benjamin later described as "aura." Zola grasped the paradoxical reproducibility—the cliché—forever lurking at the pedestal of classicism, structuring its pedagogical program and bolstering its authority. Photography merely exposed this éminence grise. Gérôme's *End of the Session*, for example, literally began as cliché. As suggested by a series of photographs now conserved in the Bibliothèque nationale in Paris, the painting was a reenactment, or re-creation, of a prior photographic tableau.[40] The student of Paul Delaroche in more ways than one, Gérôme eulogized photography at the end of his life. Thanks to the photograph, he proclaimed in 1902, "Truth has finally emerged from her well."[41] This statement, seemingly straightforward, is shot through with ambiguity, not the least because he had recently completed multiple classicized, allegorical paintings on that very theme. The problem of the cliché permeated Gérôme's creative enterprise, yet this in no way diminishes his significance. On the contrary, repetition was harnessed by the artist as a *generative* force. The disintegration of authorship provoked by newly fluid borders between art and industry is apparent in many of his most interesting paintings and sculptures. Photographic Phrynes, Tanagra terracotta factories, assembly-lines of

models and their doubles—so many images multiplying, splitting, merging, and floating promiscuously between media.[42]

From his early and career-defining canvas, *Duel after the Masquerade* (1857), Gérôme played freely with difference and repetition. The *Duel* questions originality at every turn. Projected across its slick and glistening stage set is the double, *en abyme*.[43] A dying (miming?) figure, dressed up as Pierrot, is suspended in the shallow foreground of this dissimulating deposition, crumpled within a network of wordless, theatrical gestures. Among the mourners a scarlet-robed Venetian doge clutches the mime in disbelief—a brilliant move, the inclusion of a fraudulent magistrate who seems caught between stemming the blood flow from Pierrot's wound and groping for proof of its authenticity. Gérôme's tableau vivant of history painting destabilizes the traditional notion of a "pregnant moment," a maneuver he will revisit in later paintings. Soiled and disjointed impressions of temporality and narrative litter the ground at the gaping center of the canvas, marking only absence—chaotic footprints, a discarded cloak and mask, four stray feathers. All these traces soon to be buried by snowfall.[44]

The *Duel* offers a glimpse of what it might mean to construct Gérôme as a monographic subject. Long before Barthes, he perceived the unraveling of the author. To search for the monographic subject in Gérôme is to negotiate a series of feints and illusions, to witness repetition produce difference, and to question the authority—the very possibility—of creative origin. Engaging his practice on these terms opens up an entirely divergent nineteenth century, one of audacious visual contamination, complex cross-pollination, and permanent uncertainty. As Michel Foucault insisted, the second half of that century was marked not by the authorship of images but by a new freedom of their "transposition, displacement, and transformation, of resemblance and dissimulation, of reproduction, duplication, and trickery of effect."[45] Perhaps, then, it was Henry Wolf who came closest to understanding Gérôme. For it is in his test print, captured in an intermedial and intermediary form, that we observe the complexity and ambiguity that marked this artist in the modern age of mechanical reproducibility.

Notes

Earlier versions of this essay were presented at the College Art Association Annual Conference (February 2009) and the symposium "At the Boundaries of Images," University of Arts and Design, Karlsruhe (June 2009). For their advice and encouragement at various stages of my research, I am extremely grateful to Gerald Ackerman, Scott Allan, Jordan Bear, Jonathan Crary, Patrick Crowley, Anne Higonnet, Andrei Molotiu, Mary Morton, Linda Nochlin, David Pullins, Tina Rivers, Catherine Roach, Drew Sawyer, and Virginia Spate.

1. Henry Wolf, "A Symposium of Wood-Engravers," *Harpers New Monthly Magazine* 60, no. 357 (February 1880), p. 453.

2. On the "New School" controversy, see Gerry Beegan, *The Mass Image: A Cultural History*

of Photomechanical Reproduction in Victorian London (New York, 2008); Beegan, "Finding Florence in Birmingham: Hybridity and the Photomechanical Image in the 1890s," in *Visions of the Industrial Age, 1830–1914: Modernity and the Anxiety of Representation in Europe*, ed. Minsoo Kang and Amy Woodson-Boulton (Aldershot, UK, and Burlington, VT, 2008); Estelle Jussim, *Visual Communication and the Graphic Arts: Photographic Technologies in the Nineteenth Century* (New York, 1974).

3. The print is actually comprised of two sheets, now framed together. It is unclear whether the pieces were originally printed on the same sheet.

4. "The original must, as I have said, be faithfully reproduced" (Wolf [note 1], p. 453).

5. Jacques Derrida has carefully analyzed this effect in "The Double Session": "We are faced then with mimicry imitating nothing; faced, so to speak, with a double that doubles no simple, a double that nothing anticipates, nothing at least that is not itself already double.... This speculum reflects no reality; it produces mere 'reality-effects'" (Jacques Derrida, *Dissemination*, trans. Barbara Johnson [Chicago, 1981], p. 206). Rosalind Krauss has also probed the boundaries between model and copy in her brilliant discussion of Jean-Auguste-Dominique Ingres: "You Irreplaceable You," *Studies in the History of Art* 20 (1989): pp. 151–59.

6. Fanny Field Hering, *Gérôme: The Life and Works of Jean Léon Gérôme* (New York, 1892). It might seem odd that this work should be written by an American woman and distributed by the New York office of Cassel and Company, but at that time the United States represented a significant portion of Gérôme's consumer base, many of the nation's leading painters had studied with the artist in Paris, and he was active in the cultivation of American buyers, often writing letters to purchasers. See DeCourcey McIntosh, "Goupil and the American Triumph of Jean-Léon Gérôme," in *Gérôme and Goupil: Art and Enterprise*, exh. cat., trans. Isabel Ollivier (Paris and New York, 2000); and H. Barbara Weinberg, *The American Pupils of Jean-Léon Gérôme* (Fort Worth, 1984).

7. Jean-Léon Gérôme to Fanny Field Hering, Paris, May 7, 1887. Unless otherwise indicated, any correspondence cited here is drawn from the Oswald C. Hering Papers, box 7, "Fanny Field Hering—Letters Received, 1885–1898," New York Public Library, Archives and Manuscripts Division.

8. "Je veux vous remercier de votre attention aimable et de l'intérêt que vous portez à ma biographie, qui n'est malheureusement que d'un médiocre intérêt" (Gérôme to Hering, Paris, December 9, 1887). Hering's article on Gérôme describes a visit to the artist's studio in June 1887 and much of the piece is reprinted in the monograph (Fanny Field Hering, "Gérôme," *Century Magazine* 37, no. 4 [February 1889], pp. 483–99). Letters from Hering to R. W. Gilder, editor of the journal, as well as a note from Gérôme expressing his delight at the quality of the illustrations in Hering's piece, are housed in the magazine's archives (The Century Collection, New York Public Library, Manuscripts and Archives Division). Henry Wolf produced illustrations for Hering's article.

9. "We have heard from our London office regarding the Gérôme book and I am pleased to say that the scheme seems to be quite satisfactory to them and they are content to take it up providing of course the subject matter is also satisfactory. Of this itself I think there is very little doubt as you have every facility for and full access to procuring the material as you stated" (Oscar Dunham to Hering, January 28, 1888).

10. "Your favor of Jan 31 at hand and I am glad to know that you are still as enthusiastic regarding the new book as when I saw you and that M. Gérôme is willing to assist you in any and every way.... We shall also include in the contract that M. Gérôme is to write an introduction" (Dunham to Hering, New York, February 3, 1888).

11. As Julie Codell has demonstrated, serialized artists' biographies were ubiquitous in the late nineteenth century. Generally, each book was pocket-sized and relatively inexpensive.

According to Codell, repetition of form and content governed the relations between individual biographies in any given series and "leveled distinction, in that all biographical subjects shared the aura, and every artist in a series appeared equal to every other artist" (Julie Codell, "Serialized Artists' Biographies: A Culture Industry in Late Victorian Britain," *Book History* 3 [2000], p.104). See also Trevor Fawcett, "The Nineteenth-Century Art Book: Content, Style, and Context," *Art Libraries Journal* 17, no. 3 (1992), pp. 12–17.

12. Dunham to Hering, New York, January 28, 1888.

13. Walter Benjamin, "Paris, the Capital of the Nineteenth Century," in *The Work of Art in the Age of Its Technological Reproducibility, and Other Writings on Media,* trans. Edmund Jephcott et al. (Cambridge, MA, 2008), pp. 101–2.

14. *New York Herald,* 1892 (undated clipping, Oswald C. Hering Papers, box 7).

15. In his correspondence with Hering, Gérôme frequently refers to the monograph as a "monument." Ironically the book proved to have had far less circulation than intended. One year after the monograph's publication Hering received a letter from her editor expressing dissatisfaction with its sales: "I am sorry to inform you that the sale of Gérôme, de Luxe Edition [the only edition of the book, which sold for thirty dollars] is proceeding very slowly, and we wish you could arrange to devote a little more time to it. We feel confident that a little energy in this direction would result in orders. We would even be willing to sell it on the installment plan, $3 to $5 on delivery and balance in $10 monthly installments" (Dunham to Hering, New York, March 13, 1893). The hint of desperation in Dunham's missive would be explained three months later when Cassell suddenly entered receivership. A remarkable tale of fraud perpetrated by Hering's editor unfolded in June 1893. In what was described as "a shock that will be felt far beyond the book trade," Dunham was found to have converted 180 thousand dollars of the company's funds over a period of three years ("The Cassell Publishing Company Wrecked," *Publishers' Weekly,* June 24, 1893, p. 945). Adding to the spectacle was Dunham's mysterious disappearance. Nothing was known of his whereabouts until January 1897, when it emerged he had recently been found dead in Canada. There, under an assumed name, he had become vice president of a mining company ("The Late Oscar M. Dunham," *New York Times,* January 9, 1897). In the meantime, Cassell's American operation had been sold at auction and failed by late 1899. Perhaps the last significant commercial appearance of Hering's monograph is within an advertisement of 1898 by the colossal New York department store Sampson, Crawford, and Simpson, announcing their "Great Annual Sale of High Class Books" (*New York Times,* November 27, 1898). The company purchased the entire stock of art books produced by Cassell, with *The Life and Works of Jean Léon Gérôme* heading the list. Reduced from thirty dollars to $9.75 Hering's luxurious monograph lost much of its rarified dazzle.

16. Jacques Derrida, "Living On: Borderlines," in *Deconstruction and Criticism,* ed. Harold Bloom (New York, 1979), pp. 83–84.

17. The omission of Hering's contribution to their correspondence produces another fissure in the structure of the book. She also edited Gérôme's letters carefully, cutting most references to the production of the monograph and certain of his more extreme opinions.

18. Gérôme to Hering, Paris, May 20, 1890.

19. Hering (note 6), p. v.

20. The problematic nature of the preface is examined in Jacques Derrida's "Outwork," in *Dissemination* (note 5), pp. 1–60.

21. Hering (note 6), p. 227.

22. On the conceptual vagaries of the signature, see Jacques Derrida, "Signature, Event, Context," in *Margins of Philosophy,* trans. Alan Bass (Chicago, 1982). In a wonderful unpublished letter to Hering, Gérôme cheekily indicates his sensitivity to issues of imitation, counterfeiting, and the signature: "Vous me parlez de l'École de Barbizon: cette école, c'est Millet, Rousseau,

Diaz. Ils ont certainement du talent, mais à mon sens, ces artistes ont été bien surfaits—il y a là-dessous une question commerciale et mercantile; leurs ouvrages ont atteint des prix absurdes qui ne sont vraiment pas en rapport à leur valeur artistique. La preuve de leur infériorité, c'est la facilité avec lequel on les imite—il existait ici un atelier de contrefaçons où faisait des faux Diaz, des faux Corot, des faux Rousseau qui revendaient très bien et qui sont aujourd'hui dans les collections des amateurs Américains, ce sont ceux qu'on admira le plus—risum teneatis!" (Gérôme to Hering, Paris, December 19, 1887).

23. "A Splendid Art Life," *New York Times*, April 10, 1892, p. 19.

24. The fantasy of woman as android received its most memorable treatment in the notorious novel of Villiers de l'Isle Adam, *L'Ève future* (1886); reprinted as *The Future Eve* in *The Decadent Reader: Fiction, Fantasy, and Perversion from Fin-de-siècle France*, ed. Asti Hustvedt (New York, 1998). Villiers's novel imagines a scenario in which Thomas Edison creates an artificial woman using contemporary technological developments (inspired by Edison's own scientific advances). The production of this electric automaton is made analogous with printing technology: "the process is rather like that by which printing presses pass from one roller to another the sheets to be printed" (p. 652; trans. Hustvedt).

25. M. G. Schuyler Van Rensselaer in *The World*, April 10, 1892, p. 30. Hering's editor responded to this review in a letter to Hering: "I must agree with you that the Van Rensselaer article in the Sunday WORLD was a savage attack, and I hope the artistic people will take as 'little stock' in her article as they do, in what another art critic here called 'The key-hole sheet.' It is too personal to be considered for the moment, as a criticism of either your work, or that of Gérôme" (Dunham to Hering, April 12, 1892). On gender and art criticism more generally in the nineteenth century, see Anne Higonnet, "Imaging Gender," in *Art Cricism and Its Institutions in Nineteenth-Century France*, ed. Michael R. Orwicz (Manchester and New York, 1994).

26. "M. Gérôme was perhaps hard on you, but he showed his wisdom when he told you it was folly to take so many sketches. . . . You, perhaps, have hardly realized the enormous additional expense it would be upon the book to make the extra plates and blocks that you have proposed" (Edwin Bale to Hering, London, November 1888).

27. Hélène Lafont-Couturier, "Mr. Gérôme Works for Goupil," in *Gérôme and Goupil* (note 6), pp. 17–19.

28. Bale to Hering, London, November 1888.

29. Emily Gregory to her family, Paris, May 20, 1889. This letter also indicates that Boussod, Valadon et cie offered Hering a more lucrative contract to publish the work exclusively with them (a much cheaper enterprise as they held the reproduction rights to Gérôme's images). She, however, remained loyal to Cassell.

30. The previous American publication was *Gérôme: A Collection of the Works of J. L. Gérôme in One Hundred Photogravures*, ed. Edward Strahan [Earl Shinn], 4 vols. (New York, 1881).

31. Other scholars who have insisted on the differing properties of nineteenth-century reproduction technologies include Beegan (note 2: *Mass Image*); Stephen Bann, *Parallel Lines: Printmakers, Painters, and Photographers in Nineteenth-Century France* (New Haven, 2001).

32. Hering emphasizes this intimacy in a discussion of Gérôme's Orientalist paintings: "His numerous and well-filled portfolios of sketches—which till now have been for the most part 'sealed books,' save to a few intimate friends—reveal the source of these truthful and vivid reproductions of life in these picturesque and fascinating countries. We congratulate ourselves again that a morning spent by [Théophile] Gautier in Gérôme's studio, over these very portfolios, inspired this gifted writer to embody his impressions in a delightful article, entitled, 'Gérôme; Pictures, Studies, and Sketches of Travel'" (Hering [note 6], p. 22).

33. The association is strongest in Gérôme's later self-portrait, *Working in Marble* (fig. 2), which includes an embedded image of his painting *Pygmalion and Galatea* (ca. 1890). The female body

was continually at the center of discourse surrounding mimesis and realism in the nineteenth century. As Christopher Prendergast has written in this context, "the [female] body and sexuality…hold out the promise of contact with an origin, anchoring the representation of reality in the ultimate unveiling of a truth" (Christopher Prendergast, *The Triangle of Representation* [New York, 2000], p. 128–29).

34. Hering (note 6), p. 268.

35. As Jean Baudrillard explained, it was the series that distinguished production in the wake of the industrial revolution. For Baudrillard the relationship between serial objects "is no longer that of an original and its counterfeit, analogy, or reflection, but is instead one of equivalence and indifference. In the series, objects become indistinct simulacra of one another and, along with objects, of the men that produce them" (Jean Baudrillard, *Symbolic Exchange and Death*, trans. Iain Hamilton Grant [London, 1993], p. 55).

36. On the Pygmalion myth in the nineteenth century, see Alexandra K. Wettlaufer, *Pen Vs. Paintbrush: Girodet, Balzac, and the Myth of Pygmalion in Post-Revolutionary France* (New York, 2001); Victor I. Stoichita, *The Pygmalion Effect: From Ovid to Hitchcock*, trans. Alison Anderson (Chicago, 2008), pp. 161–80. For the seemingly endless exploitation of Pygmalionesque scenarios in popular entertainment of the late nineteenth-century, see Lynda Nead, *The Haunted Gallery: Painting, Photography, Film, c. 1900* (New Haven and London, 2007), pp. 58–104. Both Stoichita and Nead highlight the frequency with which new technologies of illusion and deception (especially the fledgling film industry) were drawn to Ovid's scenario of transformation.

37. See the entry on *cliché* in Pierre Larousse, *Grand dictionnaire universel du XIXe siècle, français, historique, géographique, mythologique, bibliographique, littéraire, artistique, scientifique, etc.* (Paris, 1866–[90]), 3: pp. 443–44. Elizabeth Barry provides a useful introduction to the critical history and possibilities of the concept in her *Beckett and Authority: The Uses of Cliché* (Basingstoke, UK, 2006).

38. Gilles Deleuze, *Francis Bacon: The Logic of Sensation*, trans. Daniel W. Smith (Minneapolis, 2003), pp. 71–76.

39. For Zola's two extended commentaries on Gérôme, see "Nos peintres au Champ-de-mars" (1867) and "Lettres de Paris: L'École française de peinture à l'exposition de 1878," in *Écrits sur l'art*, ed. Jean-Pierre Leduc-Adine (Paris, 1991).

40. The photographs were taken by Louis Bonnard. For more on these images, see Stoichita (note 36). This was not the first time photography and painting had come into charged contact in Gérôme's working practice. Consider that for his famous canvas of 1861, *Phryne before the Areopagus*, it has been shown that Gérôme copied his Phryne from a photograph purchased from his friend Félix Nadar (Sylvie Aubenas, "Modèles de peinture, modèles de photographe," in Sylvie Aubenas et al., *L'Art du nu au XIXe siècle: Le Photographe et son modèle*, exh. cat. [Paris, 1997], p. 46). This Phryne, then, inhabits a distinctly modern world of mechanical reproduction and networks of mass circulation, which are also networks of sexual desire and consumption. When the painting was reexhibited at the 1867 Exposition universelle, Goupil exploited the moment by selling a range of statuettes that reproduced the nude woman. Significantly, as Gérôme confided to Hering ([note 6], p. 210), the statuettes were designed by *other* sculptors contracted by Goupil. With the statuette Gérôme's nude was extracted from the canvas and came to rest in bourgeois interiors and cabinets of curiosity. Gérôme returned to Nadar's photographic figure throughout his career. She reappears, for example, in the *Slave Sale at Rome* (1884), but her body is seen from behind. Around this time the figure also reemerges in a photograph of a now-habitual scene: Gérôme in his studio with a model. Restored to flesh within the artist's work space the figure is reclaimed by Gérôme, who emphasizes his own hand at work. But, of course, the clashes between and doublings of representational mediums are immediately apparent; and Gérôme, turning to display his profile, is equally as posed as the model. On the sculptural reproduction

of Phryne, see Florence Rionnet, "Goupil and Gérôme: Two Views of the Sculpture Industry," in *Gérôme and Goupil* (note 6), pp. 49–50.

41. Jean-Léon Gérôme, preface to Emile Bayard, *Le Nu esthétique* (October 1906), quoted in Hélène Pinet, "De l'Étude d'après nature au nu esthétique," in Aubenas et al. [note 40], p. 33.

42. Gérôme created an extensive series of paintings and sculptures on the subject of ancient Tanagra. From the moment of their discovery in the early 1870s, archaeologists had speculated as to the mode of production and the purpose of authentic Tanagra figures. It was increasingly argued these objects were reproductions cast from molds. In the popular and scientific nineteenth-century imagination, Tanagra figures were the highly commercial bibelots of the deceased, bric-à-brac that once populated the ancient equivalent of the bourgeois household's nest of *things*. In relation to one of his paintings on this theme, Gérôme provocatively stated that "if I do not belong to the inventors, I am at least a renovator" (Gérôme to William J. Curtis, via Knoedler, Paris, January 14, 1903 [Curtis-Pierce Collection, New York Public Library, Manuscripts and Archives Division]).

43. Edmond About explicitly raised the issue of mimicry in relation to the *Duel*, humorously invoking intellectual property law: "M. Couture a peint, lui aussi, un duel de Pierrots, et il assure qu'il avait déposé son esquisse à la chambre de commerce avant M. Gérôme. Quelle que soit la date de son brevet, l'invention n'est pas nouvelle, ou plutôt ce n'est pas une invention. Le bois de Boulogne a vu deux ou trois de ces duels enfarinés, et l'idée est tombée dans le domaine public, surtout si les inventeurs sont mort" (Edmond About, *Nos Artistes au Salon de 1857* [Paris, 1858], p. 73).

44. There was some confusion concerning the identity of Pierrot's opponent, more often from French than British audiences. In later versions of the painting Gérôme adjusted the composition to express the narrative causality more clearly (Hering [note 6], p. 77).

45. Michel Foucault, "Photogenic Painting," in *Revisions 2, Photogenic Painting—Gérard Fromanger: Writings by Gilles Deleuze and Michel Foucault*, ed. Sarah Wilson (London, 1999), p. 83.

Blood Spectacle
Gérôme in the Arena

EMILY BEENY

Into the Arena

"Are you not entertained?" snarls the gladiator glaring up into the stands of a packed arena. Following his gaze, the camera pans swiftly upward to survey the crowd with righteous anger and disgust. Ridley Scott's 2000 epic *Gladiator* invites us into the arena to watch the ancient Roman spectacle unfold through the eyes of its performers. The director's chosen vantage point, down in the blood-soaked sand, encourages us to identify with Maximus, the hero of the picture, even while we enjoy his violent degradation. Scott's camera placement seems to absolve us of our complicity in the slaughter, of our equivalence to the bloodthirsty rabble on the screen. Yet Maximus's question "Are you not entertained?" cuts us to the quick, for, of course, like the Roman mob, we are indeed.

Like much of its mise-en-scène, the movie owes its perspective on the Roman arena to a series of vigorously researched and fiercely vivid pictures painted by Jean-Léon Gérôme between 1859 and 1883. With these paintings, which circulated widely in photographic reproduction, the artist etched the Circus Maximus and Colosseum into the modern imagination. In popular literature, illustration, theater, and film, images of gladiators and Christian martyrs borrowed from Gérôme's work have helped form the aesthetic vocabulary with which mass culture describes ancient Rome. The familiar cinematic Rome remains, to some substantial degree, Gérôme's invention.[1]

Reproduced on an industrial scale and hence playing a formative role in mass visual culture, these pictures might be regarded as early emanations of what Guy Debord famously termed "the society of the spectacle," a modern social configuration that dislocates lived experience into representation, reality into spectacle.[2] It is not my intention to apply Debord's ethical and political assessment of spectacular culture to Gérôme's arena pictures, but I will use the terms *spectacle* and *spectator* to examine the artist's mediation through these images of

his relationship to nascent mass culture. I employ the two words to distinguish tawdry mass entertainment, either ancient or modern, from fine art. As Gérôme's own crossover success demonstrates, these distinctions came to seem increasingly unstable, even arbitrary, over the course of the century, but they were personally important to Gérôme in his often conflicted position as both a fine artist and a producer of images for mass consumption. I consequently distinguish between *spectator* and *viewer, spectacle* and *artwork* to tease out a conflict within Gérôme's arena art and to understand the painter's ambivalent relationship to his new mass audience. For, like Maximus's question in *Gladiator*, Gérôme's arena pictures constitute a double entendre, forcing us as viewers—or spectators—to ask ourselves, "Are we not entertained?"

Those People

Passing through the Place Saint-Sulpice one morning around 1890, Gérôme's friend the sculptor Augustin Moreau-Vauthier pointed out to him a reproduction of his *The Christian Martyrs' Last Prayer* (plate 4) that was displayed in the window of one of the square's inexpensive religious print shops. The picture portrays a group of Roman Christians cowering in the Circus Maximus as wild cats emerge from their underground kennels. Tracks left in the sand confirm the building's more accustomed use—chariot racing—but here martyrdom adds flavor to the afternoon's entertainment. The image is strangely powerful, if an odd candidate for sale in a devotional print shop.

Standing before the storefront, Gérôme turned to his friend and replied with a smile, "Yes, I work for those people."[3] His reaction has been interpreted as one of coy self-effacement, indicating both a polite disdain for the print trade and a hint of embarrassment at the crass commercialization of his work. But the words may have contained a grain of defiance as well. Painting at the moment when advanced art criticism and popular opinion parted company, Gérôme must have recognized in "*those* people" (*ces gens-là*), the people who bought and sold penny prints after his pictures, an audience ultimately more important than the American millionaires who could afford originals or the handful of critics who continued to review his work favorably.

Gérôme's dry, "Yes, I work for those people" corresponds closely, moreover, to a famous sentence written some twenty years earlier by Émile Zola in his review of the 1867 Exposition universelle: "Monsieur Gérôme evidently works for Goupil's. He paints a picture, so that it may be photographed and printed and sold by the thousand.... M. Gérôme works for all tastes."[4] Both Gérôme's style of historical genre painting and his close affiliation with the international art dealer and publisher Adolphe Goupil sparked the avant-garde critic's contempt.

Nonetheless, although Zola's snide comment is generally read—and was doubtless intended—as a rebuke of the artist's commercialism, the remark also points to Gérôme's extraordinary mass-cultural success. As the artist himself surely knew, it was this success that secured for him both his personal fortune and a legacy that would outlast his decline from critical favor.

Zola was not the first critic to notice Gérôme's shameless appeal to a popular audience. From the earliest years of his commercial success, he was accused of painting "boudoir pictures" and chided for catering to "the mob."[5] His populism was, however, part of a larger strategy, neatly complementing his special relationship with the Goupil company. Recent scholarship has clearly outlined the role played by photographic reproductions in the artist's career.[6] Suffice it here to say that his relationship with Goupil granted Gérôme celebrity and financial security. With galleries across Europe and America and warehouses all over the globe, Goupil's firm offered artists international distribution and made Gérôme, the company star, arguably the world's most famous living artist by 1880. Whether or not his half-ironic self-identification as the employee of *ces gens-là* reflects a familiarity with Zola's review, it points to Gérôme's keen awareness of his unique position as a painter for reproduction and, by extension, for the masses.

O Honest and Intelligent Crowd!

Among his most popular works in photographic reproduction, the arena pictures were destined for a mass audience almost from their conception. The first in the series, *Ave Caesar! Morituri Te Salutant* (fig. 7), was included in the initial batch of Gérôme's works acquired, published, and sold by Goupil in 1859.[7] The picture presents an extraordinary reconstruction of the Colosseum, teeming with Roman spectators and littered with corpses. At center stands a group of gladiators who hoist their shields, broadswords, and tridents in salute to the emperor Vitellius, a corpulent lush perched above in the imperial box. To his right sits a row of Vestal Virgins clad in white. The sand below is darkened with blood and sprinkled with discarded weapons. A giant awning shades the crowd, distributing light and shadow in such a way as to signal the saluting gladiators' imminent passage from light into darkness, from life to death. "Ave Caesar, morituri te salutant!" the gladiators cry, "Hail Caesar, those who are about to die salute you!"

In a glowing Salon review, Théophile Gautier called readers' attention to the painting's archaeological finesse and celebrated its popular reception:

> This is the picture before which the crowd stops most willingly. To see it, it is almost necessary to fall in line.... O honest and intelligent crowd! Whom we have so often abused when we have surprised thee in the act of using as

EMILY BEENY

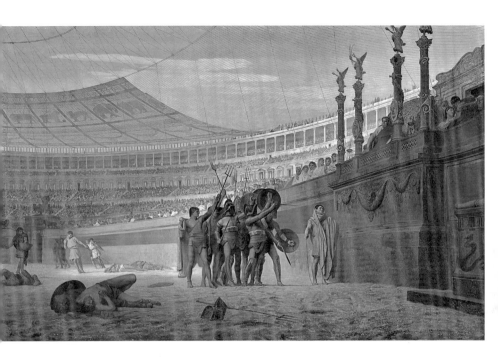

FIGURE 7
Jean-Léon Gérôme, *Ave Caesar! Morituri Te Salutant*, 1859. Oil on canvas, 93.1 × 145.4 cm
(36 ⅝ × 57 ¼ in). New Haven, Yale University Art Gallery. Gift of Ruxton Love, Jr., B.A. 1925 (1969.85)

a mirror the varnish of some abominable painting! We gladly award thee the praise thou meritest.[8]

The trope of an eager crowd clustered before Gérôme's work is one that appears again and again in Gautier's Salon reviews.[9] Nevertheless, the fact that Gautier aligned the aesthetic success of Gérôme's work with its popular success is telling; however repellent avant-garde critics like Zola might find such pictures, the "honest crowd" recognized their merit. Thus Gautier's insistence on the popularity of *Ave Caesar!* carries an ideological weight, but it also seems to document a social fact of the exhibition. Gautier was not the only critic to remark on the singular appeal of such pictures to the Salon audience, and Goupil would certainly not have purchased the painting—intending, as he did, to reproduce it on a large scale—had he not believed in its broad appeal. So what in the picture attracted such a crowd? In part, certainly, its thrilling violence and apparent archaeological precision but also, perhaps, Gérôme's representation of the arena crowd.

Like so many of the artist's works, and like all the arena paintings, *Ave Caesar!* is a picture about *looking*. It is an image of an audience observing the same scene beheld by the painting's actual viewers. The device of representing both a spectacle and its spectators surfaces repeatedly in Gérôme's oeuvre—in his *Phryne before the Areopagus* (1861), his *Dance of the Almeh* (fig. 25), his Roman slave-market pictures (1884 and 1886), and his famous *The Snake Charmer* (plate 3), among others. These paintings have been astutely described as displacing the viewer's gaze—with all its potentially associated lust and prurience—onto painted spectators.[10] But Gérôme, I would argue, was playing a far more subtle game. In these paintings the audience looks out at itself from within the frame, establishing a correspondence orchestrated by Gérôme with masterful irony. Contemporary viewers, in other words, experienced both a moral repulsion from and a narcissistic attraction to their painted counterparts. The Salon public was not, in Gautier's formulation, caught using the painting's varnish as a mirror but, rather, caught using as a mirror the image itself.

For many Second-Empire Salon-goers, being part of a mass audience, a crowd of spectators, was a relatively novel experience, a hallmark of modernity. The proliferation of boulevard theaters, *cafés-concerts*, and other venues for popular entertainment—literally built into the fabric of Baron Haussmann's modern Paris—has been amply explored elsewhere.[11] The world's fairs of 1855 and 1867 (which, not incidentally, included a massive reconstruction of the Roman Colosseum) completed the transformation of Paris into a city of modern spectacle.[12] The degeneration of the Salon from a lofty haven for humanist values to merely another venue for popular entertainment (through the influx

of working-class visitors and the introduction of admission fees) became a commonplace of caricature and critical discontent. Thus, though veiled in antique reference, Gérôme's evocation in his arena pictures of a very modern experience of spectatorship was unmistakable.

Upon purchasing *Ave Caesar!* in 1859 as part of an initial investment in six of Gérôme's pictures, Goupil had the work photographed for a new Galerie photographique series of prints sized and priced for home decoration at twenty-four by forty centimeters and twenty francs.[13] The success of this edition prompted the firm to issue others, beginning with a carte-de-visite, first sold around 1868 for one franc (later fifty centimes). As important a role as higher-quality prints played in bringing *Ave Caesar!* into middle-class homes, this inexpensive calling-card edition established the image's mass-cultural celebrity. In 1872 Goupil followed the carte-de-visite with another small edition for album collections sold for one and a half francs; larger photogravure plates ranging in price from six to twenty francs appeared in 1877 and from 1899 on. By producing versions of the picture suited to every budget, Goupil insured its broadest possible circulation. This strategy was a success; the firm continued to publish *Ave Caesar!* in some form until 1909, five years after Gérôme's death.[14]

Thumbs Down

With his second gladiatorial picture and arguably his masterpiece, *Pollice Verso* (plate 5), Gérôme followed up the popular triumph of *Ave Caesar!*, intensifying his focus on the arena crowd. The scene of this painting, first exhibited at the private Salon des Mirlitons in 1873, is set once more in the Colosseum, where a hulking gladiator, his face hidden beneath the visor of a fearsome helmet, plants a foot on his defeated opponent's chest and looks up into the stands for the spectators' terrible verdict. The fallen gladiator raises his arm to the audience, pleading for mercy, but is greeted instead with the dreaded thumbs down or *pollice verso*.[15] The dramatic gestural clarity of the central group, heightened archaeological rigor, atmospheric handling of sun-streaked shade, and convincing, violent instantaneity place *Pollice Verso* in a different class from *Ave Caesar!*, but it is the carefully described reaction of the arena audience that gives the second picture its name. In the upper stands, spectators rise to their feet, eager to see the deathblow struck. Below, the emperor, negligently eating figs, appears perversely unmoved by the scene unfolding around him. At right, in the most frequently remarked-on detail of the painting, six Vestal Virgins snarl in their lust for blood.

Both Gérôme's supporters and his detractors fixated on this last passage as emblematic of the scene overall. A critic for the *New York Times*, having proclaimed in his review of the painting's 1876 exhibition at the New York Academy

of Design, "We do not know of a more revolting work of art, a more morally hideous spectacle than this picture of Gérôme," moved on to attack the Vestals:

> Nor does the expression in the faces of those women, fierce, bloodthirsty, sensual, almost brutal, at all accord with the supposition that they are exercising woman's supposed prerogative of mercy. Their eyes are plainly eager for the spout of blood which shall follow the sword thrust.... And when we reflect that those fierce, imbruted, white-stoled women, whom he shows us demanding blood, are the Vestal Virgins, we see that his sin against his art is all the greater.[16]

The image derives much of its force from its unsettling depiction of corrupted purity. Gérôme had obviously sought to overturn viewers' expectations, to shock and titillate; the negative review bears witness to his success. It is remarkable, surely, that, even in condemning the painting's unseemly depiction of the Vestals, the *Times* critic could not help indulging in an anxiety-ridden sexual fantasy of his own, describing the priestesses' gaze in palpably sexual language as "plainly eager for the spout of blood which shall follow the sword thrust." The flushed eagerness he identified in the Vestals seems an unwitting, transparent reflection of his own.

The spectacle of female spectators proved equally fascinating to Gérôme's supporters. Earl Shinn described the Vestals at length in an essay accompanying the deluxe folio edition of Gérôme's oeuvre published in the United States:

> The artist's unequaled piquancy of spirit leads him to seize upon the paradox of the Vestal Virgins—emblems of all immaculacy—savagely demanding in a body the death of the vanquished gladiator.... It was easy for the artist to imagine a moment when they could be carried away by the rush of the spectacle, and feel their grim Roman veins throbbing to the point of a wild clamor for blood. Accordingly we see the chaste creatures in a row in the foreground, excited to the ferocity of fishwives, their hot mouths open for cries of death.... What artist... has found such a mighty type? On the one side, the great achievement of antiquity in the way of subjection of the passions of the body, in religious purity; on the other, the pressure of the only civilization that ever made human death its artistic delight.[17]

Shinn's remark that imperial Rome was "the only civilization that ever made human death its artistic delight" strikes the modern reader as almost laughably

unself-conscious. After all, in its own way, *Pollice Verso* turns human death into artistic delight. For Shinn, as for so many of Gérôme's viewers, the Vestals stood by metonymy for the crowd as a whole and thus invited a reading of the mob itself as both bloodthirsty and feminine. Like the *Times* critic, Shinn described the Vestals in emphatically sexual language: their veins throb; their mouths are "hot" and "open"; he compares them to fishwives, working-class women of the nineteenth century.

The identification of the ferocious crowd as a whole with its prominent female constituents falls into a pattern in late-nineteenth-century discourse of associating the masses' supposed irrationality and violence with femininity.[18] In his 1895 study, *La Psychologie des foules*, Gustave Le Bon wrote:

> Crowds are everywhere distinguished by feminine characteristics...the simplicity and exaggeration of the sentiments of crowds have for a result that a throng knows neither doubt nor uncertainty. Like woman, it goes at once to extremes....A commencement of antipathy or disapprobation, which in the case of an isolated individual would not gain strength, becomes at once furious hatred in the case of an individual in a crowd.[19]

Gérôme's pointedly gendered representation of the ruthless Roman mob seems to prefigure Le Bon's fin-de-siècle conception of the masses and certainly reflects a kindred anxiety.

One result of couching an evocation of the modern mob in terms of antique femininity, however, was that Gérôme's viewers generally failed to recognize the picture's concealed jab at their own eager spectatorship. The Vestals' gender made the crowd for which they stood both equivalent to a modern mob and pointedly different from the presumptive male viewer, who might be captivated and horrified by the Vestals but could not consciously identify with them. Thus the artist's mirror trick, his location of the act of spectatorship both within and without the picture frame, has gone largely undetected, preventing even modern viewers from recognizing the profound ambiguity of Gérôme's positioning. The pleasure the picture affords might accurately be described as sadomasochistic. Positive and negative reactions, pleasure and displeasure, come to very nearly the same thing. The painting satisfies our desire to watch a gruesome spectacle even as it subtly chastises us for this very desire. Gérôme positions himself as both a purveyor of spectacles (the employee of *ces gens-là*) and a critic of the Roman rabble. He makes us hover between the sand and the stands, at once critical and complicit. Are we not, the painting asks, entertained?

Through the Looking Glass

Goupil purchased *Pollice Verso* in 1873 and published a print as part of the Galerie photographique series the following year. An album-card size was released in 1875, followed by three photogravure editions, all of which remained in print through the first decade of the twentieth century.[20] The reproductive history of this picture, however, is more complex than the Goupil company ledgers alone suggest. Of all his paintings, *Pollice Verso* was Gérôme's favorite,[21] and he took its central group as the subject for his first full-scale sculpture. Now in the Musée d'Orsay, *The Gladiators* (fig. 8) first appeared to considerable acclaim at the 1878 Exposition universelle. In his review of the exhibition, the critic Joseph Dubosc de Pesquidoux wrote, "This creation has a spirit and a power that throw the exquisite and incomparable pictures of the artist into the background and place the sculptor before the painter."[22] Written as straightforward praise for the painter's crossover success in sculpture, this sentence provides a keen, if inadvertent, insight into how the sculpture functions. *Pollice Verso* is here literally thrown into the background, since the sculpture relies for its intelligibility on viewers' familiarity with the earlier image. The review continues

> The *retiarius* [the defeated gladiator] retains scarce force enough to raise his arm toward the assembly and holds up two fingers in a desperate appeal to the clemency of the spectators. The *mirmillo* [the victorious gladiator], triumphant and superb . . . turns toward the seats and awaits the popular verdict that shall deliver or slay his adversary.[23]

Of course, there are no spectators here, no seats or popular verdict. These features of the original composition have been pared away. To understand the narrative, one must imagine, as did de Pesquidoux, the now-invisible stands, the whole context of the arena, which Gérôme could by 1878 assume had entered his public's consciousness through Goupil's prints. As anyone familiar with *Pollice Verso* must immediately recognize, the sculpture's wit resides in its replacement of the ancient Roman audience with a modern Parisian one. The sculpture's viewers now occupy roughly the position vacated by the absent arena crowd. Transformed from viewers into spectators, we have passed through Gautier's looking glass, into the stands of the Colosseum.

Never recast, *The Gladiators* is itself, in effect, a kind of reproduction, a three-dimensional copy of *Pollice Verso*. The sculpture almost literally fleshes out a painting that Gérôme seems to have felt demanded a more palpably physical embodiment. He would not have been surprised to see directors of stage and screen follow suit. His pictures' familiarity and their reputation for archaeological

EMILY BEENY

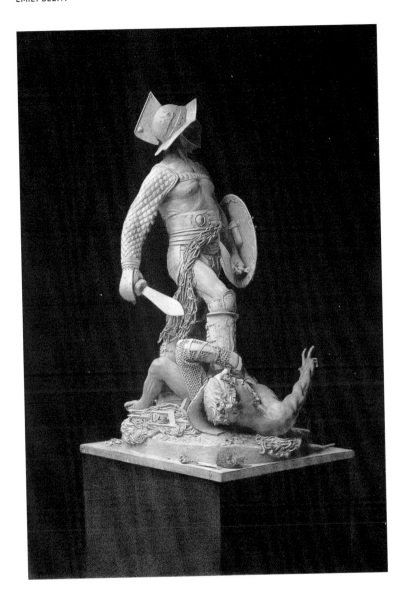

FIGURE 8
Jean-Léon Gérôme, *The Gladiators.* Photogravure by Boussod, Valadon et cie from Fanny Field Hering,
Gérôme: The Life and Works of Jean Léon Gérôme (1892), facing page 48. Los Angeles, Research
Library, Getty Research Institute (2716-658)

accuracy made them a popular basis for theatrical mise-en-scènes at the turn of the century. The debut of Henryk Sienkiewicz's pious historical novel *Quo Vadis*, serially published from 1894 to 1896 and rapidly translated into a dozen languages, lent the Roman arena a new degree of pop-cultural notoriety through its grisly accounts of gladiatorial combat and Christian martyrdom. The Polish novelist owed a debt to Gérôme for his imagining of these scenes, and the artist's images were used to illustrate later editions of the book.[24] Widespread, international enthusiasm for *Quo Vadis* made it an ideal subject for early cinema, and filmmakers often adapted Gérôme's illustrations along with Sienkiewicz's story.

French and Italian silent films presented scenes from the novel as tableaux vivants, using Gérôme's pictures as models. For his 1913 *Quo Vadis?* (figs. 11 and 12), Enrico Guazzoni chose *Ave Caesar!*, *Pollice Verso*, and *The Christian Martyrs' Last Prayers*—pictures with ready-made mass-cultural currency—as the anchors for a film that helped establish the Roman epic as a cinematic genre. Audiences are said to have erupted in applause each time they recognized these popular images on the screen.[25] Hollywood directors from Cecil B. DeMille to Mervyn Le Roy to Stanley Kubrick rehearsed the same formulae of Roman decadence, including sets and camera angles courtesy of Gérôme. Ridley Scott has credited *Pollice Verso* as the inspiration for his 2000 film.[26]

But the cinema was not the only pop-cultural venue to adopt Gérôme's arena. In a wrinkle that would have pleased the artist no end, the Barnum and Bailey Circus borrowed *Pollice Verso's* central motif for the program cover of its 1890 show *Nero or the Destruction of Rome* (fig. 9).[27] At center, a *mirmillo* stands over a dying *retiarius*, while a crowd of Vestals gives the thumbs down. The image is a rather crude, apparently unlicensed copy, but it testifies to the picture's commercial appeal. As astute a businessman as P. T. Barnum would never have permitted his advertising materials to bear an image unlikely to fill seats. The show itself, which included restagings of gladiatorial combats, chariot races, and the slaughter of Christians—all subjects represented by Gérôme—was set in a reconstructed Circus Maximus. Thus Gérôme's painted circus became an actual one, realizing the artist's stated desire to resurrect Rome's *"panem et circenses"* (bread and circuses) through the mass diffusion of his pictures.[28]

I wish to return in closing to Gérôme and his friend before the print-shop window in the Place Saint-Sulpice. After remarking, "I work for those people," Gérôme continued wryly, "It's not the first time. You see I made some Stations of the Cross in my youth.... We set up the canvases in a row and painted all the reds, passing from one canvas to the next, then all the blues."[29] Gérôme was describing the primitive assembly-line production of inexpensive devotional pictures in the lean year of 1848. Some artists starved that year for lack of work, and the practice

EMILY BEENY

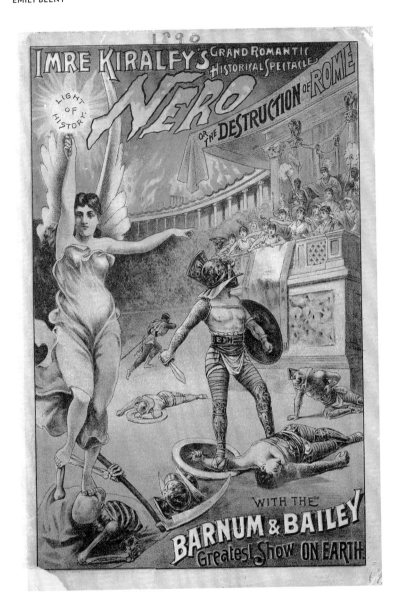

FIGURE 9
Imre Kiralfy's Grand Romantic Historical Spectacle, Nero or the Destruction of Rome, with the Barnum & Bailey Greatest Show on Earth (program cover), 1890. Collection of the John and Mable Ringling Museum of Art, the State Art Museum of Florida, a division of Florida State University (SN 1554.270.122)

of assembly-line painting seems to have become a survival strategy among young artists.[30] Gérôme's connection of the two events—his youthful assembly-line production and his encounter in old age with the penny print—indicates an awareness of how intimately his own survival—both literal and professional—had been tied to the popular audience he could reach through multiple production. Critics might sneer at the vulgarity of his pictures, but his fate, like a gladiator's, rested in the hands of the mob.

Notes

I wish to thank Cordula Grewe, Gerald Ackerman, Marc Gotlieb, Scott Allan, and Mary Morton for their guidance in preparing this essay.

1. For more on Gérôme's arena pictures and film, see Marc Gotlieb, "Gérôme's Cinematic Imagination," in the present volume; Monica Silveira Cyrino, *Big Screen Rome* (Malden, MA, 2005), pp. 221, 225; Martin M. Winkler, "Gladiator and the Colosseum: Ambiguities of Spectacle," in *Gladiator: Film and History*, ed. Martin M. Winkler (Malden, MA, 2004), pp. 87–111; Ivo Blom, "Gérôme en Quo Vadis? Picturale invloeden in de Film" in *Jong Holland* 4 (Summer 2001), pp. 19–28; and Maria Wyke, *Projecting the Past: Ancient Rome, Cinema, and History* (New York, 1997).

2. Guy Debord, *La Société du spectacle* (Paris, 1967), pp. 9–10. Unless otherwise noted, all translations are my own.

3. Charles Moreau-Vauthier, *Gérôme, peintre et sculpteur, l'homme et l'artiste, d'après sa correspondance, ses notes, les souvenirs de ses élèves et de ses amis* (Paris, 1906), p. 51.

4. Émile Zola, "Nos peintres au Champ-de-mars" (1867) in *Le Bon combat: De Courbet aux impressionnistes, anthologie d'écrits sur l'art*, ed. Jean-Paul Bouillon (Paris, 1974), p. 97.

5. See, for example, Maxime Du Camp, *Le Salon de 1861* (Paris, 1861), p. 95.

6. See *Gérôme and Goupil: Art and Enterprise*, exh. cat., trans. Isabel Ollivier (Paris and New York, 2000), particularly the essays "Mr. Gérôme Works for Goupil" by Hélène Lafont-Couturier (pp. 13–30) and "Gérôme and Goupil: A Family Affair" by Régine Bigorne (pp. 71–76) and the appendix catalogue "Works by Jean-Léon Gérôme Reproduced and Published by Goupil" by Pierre-Lin Renié (pp. 150–63).

7. Ibid., p. 19.

8. Théophile Gautier, "Exposition de 1859," translated in Fanny Field Hering, *Gérôme: The Life and Works of Jean Léon Gérôme* (New York, 1892), p. 84.

9. Of Gérôme's *Duel after the Masquerade* (1857), for example, the critic wrote "One is always sure of finding a large crowd stationed before the Duel.... It is the popular success of the Salon" (Théophile Gautier, "Exposition de 1857," translated in Hering [note 8], p. 71).

10. See most famously Linda Nochlin, "The Imaginary Orient" (1983), in *The Politics of Vision: Essays on Nineteenth-Century Art and Society* (New York, 1989), pp. 33–59.

11. See, for example, Robert L. Herbert, *Impressionism: Art, Leisure, and Parisian Society* (New Haven, 1988); T. J. Clark, *The Painting of Modern Life: Paris in the Art of Manet and His Followers* (New York, 1984); Matthew Truesdell, *Spectacular Politics: Louis-Napoleon and the Fête Impériale, 1849–1870* (Oxford, 1997); and Vanessa R. Schwartz, *Spectacular Realities: Early Mass Culture in Fin-de-siècle Paris* (Berkeley, 1998).

12. On these fairs, see Patricia Mainardi, *Art and Politics of the Second Empire: The Universal Expositions of 1855 and 1867* (New Haven, 1987).

13. *Gérôme and Goupil* (note 6), p. 23.

14. Ibid., p. 151.

15. The appropriate translation for the phrase *pollice verso* and the kind of gesture it describes have long been contested. Most classical historians today believe that the gesture was actually closer to a "thumbs up." See, for example, Donald G. Kyle, *Spectacles of Death in Ancient Rome* (New York, 1998), p. 94. For the contemporary debate, see John T. Montgomery, "Pollice Verso," in *The Librarian*, November 2, 1878, pp. 110–11; and the artist's rebuttal in a letter to Alexander T. Stewart in *Pollice Verso*, ed. I. Pemberton (Paris, 1879), pp. 4–5.

16. "Revolting Art," *New York Times*, July 5, 1876, p. 6.

17. *Gérôme: A Collection of the Works of J. L. Gérôme in One Hundred Photogravures*, ed. Edward Strahan [Earl Shinn], 4 vols. (New York, 1881), 3: n.p.

18. Andreas Huyssen identifies this tendency in "Mass Culture as Woman: Modernism's Other," in *After the Great Divide: Modernism, Mass Culture, Postmodernism* (Bloomington, 1986), pp. 44–62.

19. Gustave Le Bon, *La Psychologie des foules* (1895), translated in Huyssen (note 18), p. 52.

20. *Gérôme and Goupil* (note 6), p. 38.

21. Jean-Léon Gérôme, *Notes autobiographiques*, ed. Gerald M. Ackerman (Vesoul, 1981), p. 11.

22. Joseph Dubosc de Pesquidoux, "L'Art du dix-neuvième siècle," review of the 1878 Exposition universelle, translated in Hering (note 8), p. 222.

23. Ibid.

24. Wyke (note 1), pp. 112–18.

25. Ibid.

26. DeMille, *The Sign of the Cross* (1932); LeRoy, *Quo Vadis* (1951); Kubrick, *Spartacus* (1960).

27. Wyke (note 1), p. 123.

28. Jean-Léon Gérôme, quoted in Moreau-Vauthier (note 3), p. 65. The phrase *panem et circenses* comes, of course, from Juvenal's *Satires* (10.81), which Gérôme had likely read in the original Latin. The artist was not the first to draw an analogy between his paintings and the Roman *panem et circenses*. In 1857, before Gérôme had exhibited a single arena picture, a critic used the same phrase to ridicule Salon-goers' attraction to his *Duel after the Masquerade*. See La Gavinie, "Salon de 1857" in *La Lumière* 7, no. 35 (August 29, 1857), p. 139: "Le public, qui veut toujours du spectacle, panem et circenses, regarde à peine ce qu'il ne comprend pas facilement." My thanks to Scott Allan for calling this review to my attention.

29. Moreau-Vauthier (note 3), p. 51. See also Hering (note 8), p. 58.

30. A similar story appears in the Goncourt brothers' art-world novel, *Manette Salomon* (1867; Paris, 1894), p. 106.

Gérôme's Cinematic Imagination

MARC GOTLIEB

Jean-Léon Gérôme described *The Christian Martyrs' Last Prayer* (plate 4) as among his most important paintings; the artist worked on the picture on and off for twenty years, repainting it three times before at last ceding it in 1883 to William Walters. The setting is Nero's Rome, in an arena resembling the Circus Maximus. Dusk falls before 150 thousand spectators as a small group of men, women, and children huddle in prayer. A line of lions and tigers emerges from beneath a trapdoor on the arena floor, the lead lion momentarily stunned by the sudden exposure to light and the roar of the crowd. Not only is the hour late, the day has been long. A dense network of chariot tracks covers the arena's sandy floor. Judging from the orientation of the hoof marks, the chariots had rounded the arena in a counterclockwise rotation, thundering across the spot where we, the painting's viewers, now seem to stand. Track by track we may count the passage of time, a full day of sporting events at last culminating in the grisly scene about to unfold.

The painting's title is straightforward but does not quite describe what the painting delivers. Against the classic tradition of French history painting, Gérôme does not organize the action around a central defining event. A group of martyrs would normally inspire a profound sense of pathos, the Christians' stoic resolve offering a classic subject of moral reflection. And yet the martyrs scarcely hold our attention, dwarfed as they are by the animals emerging from under the trapdoor. Of course, it is impossible for the viewer not to be moved, but the victims are simply too small, and peripherally located, to command much attention. The huddling martyrs constitute just one part of the picture's narrative machinery, whose structure and operation we have only begun to explore.

Far from offering a clear sense of the picture's action, Gérôme compels us to engage in a process of discovery and analysis, facilitated through an elaborate mise-en-scène punctuated with details central to the picture's unfolding.

Consider, for example, the procession of wild beasts ascending from underneath the arena. The animals have been kept hungry and in darkness for days, assuring the likelihood of aggressive behavior. We do not know how many will emerge, but we do know that more are to come, their slow pace intensifying the effect of looming violence. We might think of this procession as contributing to the painting's complex melodic line, the animals' unhurried pace offering an acute contrast to the thundering chariots indexed by the tracks on the floor. Of course, the animals will shortly explode into furious action—yet another temporal and auditory contrast the picture embeds. It is also worth pointing out that we see the lions and tigers before their victims do. Gérôme borrows a mode of dramatic irony from his teacher Paul Delaroche: for example, the famous slit of light visible beneath the door in his 1831 *Princes in the Tower* (*The Children of Edward*). In Delaroche's painting this thin band of light signals the approach of the executioners from outside, an approach that we observe but that the doomed children do not. And yet for all the pertinence of this comparison, it only takes us so far. Instead, we might think of Gérôme as embracing cinematic conventions of narrative suspense as, for example, when the audience witnesses a threat posed to the film's protagonist before the protagonist does himself. This is the first of several manifestly anachronistic references I will be making to Gérôme and cinema, whose relevance to the artist operates at both a historical and formal level.

If the martyrs do not command our attention, where does the picture's action lie? In a letter to Walters, Gérôme described the wild beasts as astonished by the "bright daylight" and the "great mass" of people before them.[1] But the lead lion evinces more than astonishment. He pauses, his head cocked and tail tensed. The light blinds him, but he also catches a scent—the scent of burning flesh. Around the circumference of the arena's floor a long circle of crucified corpses has been put aflame. Each has been slathered in pitch, a resinous substance designed to facilitate burning. Not all the corpses burn at once. Some smolder, while others have only recently been set ablaze. Once again Gérôme layers into his painting a careful temporal sequence, except that this ring of crucified figures orbits the arena far more slowly than the chariots indexed on the arena floor. Indeed, the "pace" set by the crucified ring is excruciatingly protracted; it is measured by a single figure making his way through the dense crowd. As we trace the progress of the grotesque series, we pause before a long pole, illuminated at one end with a torch and supported at the other by a man. This man is the lighter. His job is to set the pitch-slathered victims aflame, filling the arena with the scent of burning flesh and stimulating the lions' rage. With this detail in place we can at last plot the scene before us. The violence about to unfold vastly exceeds and yet is still traceable to the lighter's routine movements as he traverses the arena,

offering us one more melodic line discretely embedded in the picture's appalling counterpoint.

The methodical work of the torchbearer, the slow procession of animals, the chariot tracks that measure the progress of the day—these and similar flourishes typify the work of an artist who, then as now, has left art critics worried. We often speak of Gérôme as an "academic" or "salon" artist, terms signaling his loyalty to a network of pedagogical, commercial, and exhibiting institutions that, well before the artist's death, had already lost much of their historic force and authority. Even in Gérôme's lifetime the attack was well underway, critics charging him with violating the limits of his medium and of confusing literature with painting. Modernist critics would launch a more developed version of this charge, once again keyed to Gérôme's seeming breach of the inherent limits, demands, and future burdens of his painting medium. Despite the weakening of the modernist edifice, the high price now paid for Gérôme's pictures, and the interest evinced by curators and academics, the critique has currency into the present day.

Let it be said, Gérôme himself was not helpful in this matter. Take the case of his 1859 *Ave Caesar! Morituri Te Salutant* (fig. 7), his first arena painting and a work that to this day remains in the shadow of *Pollice Verso* (plate 5), painted thirteen years later in 1872. As Gérôme explained, he was delighted to begin the subject anew, for in the earlier picture he had erred in the detailing of the gladiators' weapons and armor. Elsewhere Gérôme spoke of *Pollice Verso* as probably his best picture because "[at last] I had all the documentation needed, as a result of my researches."[2] Coming as they do from the artist himself, these remarks can seem utterly deflating. Do they not confirm the charge that he maintained a narrowly positivist and artistically trivial conception of his enterprise? As the critique goes, Gérôme's obsession with historical accuracy found its counterpart in the impersonality of his touch, as if his paintings aspired to be transparent windows that erased all trace of the artist's hand. Master of the licked surface, his anecdotalizing subjects avoid reference to modern life in favor of archaeological reconstructions laced with ethnographic and racial stereotypes catering to the biases of his age. The culture of bread and circuses that his arena pictures purportedly denounce is exactly what they deliver. Their spectacle of violence and verisimilitude was destined to stupefy viewers, as Nero did his subjects, into a state of pleasurable complicity.

In recent years these complaints have begun to lose their purchase. We have become newly aware of Gérôme's affiliation to cutting-edge practices of photographic reproduction and publicity, prints after his work circulating into households across the developed world. We are no less alert to the pedagogical and institutional network spawned from his instruction, his followers circulating

in Europe, the United States, the Ottoman Empire, Japan, and elsewhere. We have become sensitive to the disturbing cultural resonances of his Orientalism, his *The Snake Charmer* (plate 3) emerging as among the most infamous pictures of our day. Finally, we have come to see Gérôme as implicated in the rise of mass-market entertainments, thanks to his affiliation with new-media technologies that seemed effortlessly to mix exotic imagery and cultural stereotypes. These and related frameworks have inserted Gérôme into a new genealogy of mass culture and its unique instruments.[3] Doubtless such frameworks cannot overturn, and may even reinforce, classic suspicions regarding the artist, his painting and sculpture seeming antithetical to a legitimately critical and reflexive modernism. Nevertheless, we now see his work as an important effect of modernity and demanding interrogation on precisely those terms.

The argument of this essay is that Gérôme has a cousin in the cinema, a suggestion already floated by some of the artist's most astute recent interpreters, including Wolfgang Kemp and Stephen Bann.[4] The relationship to film is in part historical, embracing Gérôme as well as other artists with whom he is often grouped. *Intolerance*, D. W. Griffith's epic of 1916, stands as the most famous example, the director mining works by Lawrence Alma-Tadema, Edward Poynter, and Georges Rochegrosse, among others. As for Gérôme, both *The Christian Martyrs' Last Prayer* and *Pollice Verso* figured in Enrico Guazzoni's *Quo Vadis?* of 1912, a landmark epic from a director trained as an artist and set designer.[5] Indeed as Ivo Blom has shown, *Quo Vadis?* offers us a veritable smoking gun, so direct are the borrowings (more on these shortly). We may also credit Gérôme with helping revive the sword-and-sandal epic after the genre had become moribund. It was upon being presented with a reproduction of Gérôme's *Pollice Verso* by Walter Parkes, a DreamWorks executive, that Ridley Scott first envisaged his blockbuster film *Gladiator*. In fact, as Scott tells it, while looking at Gérôme's picture he was seized by the film's prospect, before even reading the script: "I looked at it and said, 'I'll do it.' [Parkes] looked at me, shocked, and said, 'But you don't know what it's about!' I said, 'I'll do it!'"[6]

Such links are revealing, but there is more to Gérôme's cinematic imagination than a walk-on part in the genealogy of the Hollywood epic. Indeed, considered from this genealogical perspective, his paintings may look not cinematic enough, as if handicapped by their medium. Some of Gérôme's paintings beg for such a conclusion, including his 1876 *Chariot Race* (fig. 10). The painting's panoramic effect is partly attributable to a subtle change in format designed to capture the elliptical sweep of the Circus Maximus at midday. To borrow a cinematic term, the painting relies on an aspect ratio, Gérôme elongating his canvas slightly compared to other arena pictures. This aspect ratio recalls the wide-screen

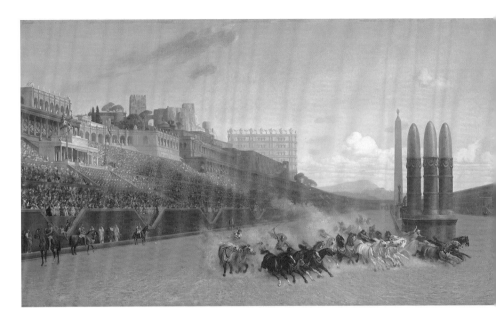

FIGURE 10
Jean-Léon Gérôme, *Chariot Race,* 1876. Oil on cradled panel, 86.3 × 156 cm (34 × 61 $^{7}\!/_{16}$ in.).
The Art Institute of Chicago. George F. Harding Collection (1983.380)

formats introduced after 1951, and yet arguably the painting fails. As Gérôme pulls back to capture the ellipsis, he so diminishes the central figure group that the action feels lost, as if operating in mechanical miniature. The vast background architecture, for its part, feels motionless, flat, and apart from the main action. All this is to say that his *Chariot Race* seems to beg for tools that Gérôme did not possess, from mobile camera work and montage to the immersive effects of wide-screen formats.

Film scholarship has in part signed on to this conclusion. Guazzoni's *Quo Vadis?* offers a case in point, the film's time-based medium introducing elements that Gérôme could not. For example, Guazzoni begins his sequence from *The Christian Martyrs* earlier than does the painting, his long shot allowing us to see the trapdoor opening from the arena floor (fig. 11). Guazzoni also concludes the sequence later, adding a shot of the beasts fighting over the victims' clothes and remains. Between these new narrative markers Guazzoni cuts to close shots that Gérôme cannot, including a shot of the emperor's box and another of the martyrs huddling in terror. Finally, elsewhere in the same film Guazzoni closes a gladiatorial combat by resolving into Gérôme's *Pollice Verso*, a shot restaged as a publicity still. In light of these reframings, a recent study treats *Quo Vadis?* as going beyond Gérôme's painting, cinema borrowing its "iconography" but transcending the painting's "simple" or "static" presentation. As Maria Wyke suggests, the film's combination of close and long shots as well as "multiplying" points of view appears to challenge "the stasis" of the "nineteenth-century picture frame."[7]

For all the accomplishments of *Quo Vadis?*, a genealogy that envisions film as overcoming the limits of Gérôme's painting also misses the point, relying as it does on a positivist conception that only cinema conveys time. The lions in *Quo Vadis?* do not pause in the blinding sun nor do they catch the scent of burning flesh, features central to Gérôme's narrative counterpoint and underwriting its enthralling suspense. Similarly, Guazzoni adds a close shot of the victims gesticulating wildly (fig. 12). This scene adds a note of melodrama borrowed from the stage. Here as elsewhere, the film perhaps more than the painting partly operates like a sequence of tableaux, exactly what Gérôme's pictorial counterpoint proposed to complicate or undermine. The cinema discovered in Gérôme accounts for much more than a reservoir of sets, costumes, and social types. Rather, the artist offered the cinema a vision of its narrative and immersive future. His paintings present the beholder with a "world," to borrow the term Scott himself used to describe *Pollice Verso*'s impression on him. It was not a gradual handoff from one medium to another, Gérôme forging narrative practices that would take the cinema decades to invent.

GÉRÔME'S CINEMATIC IMAGINATION

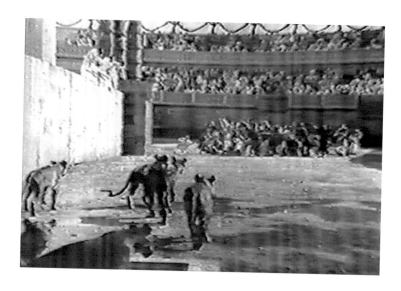

FIGURE 11

Lions entering the arena, film still from *Quo Vadis?* (1912) directed by Enrico Guazzoni

FIGURE 12

Christian martyrs in the arena, film still from *Quo Vadis?* (1912) directed by Enrico Guazzoni

For a demonstration of this claim, let us return to the arena and to the action of what was, at one time, Gérôme's most famous painting, *Pollice Verso*. Before a vast crowd, a victorious gladiator clamps his foot on the shoulders of his victim. The vanquished gladiator pleads to the Vestal Virgins for mercy, but a crush of arms gestures thumbs down—*pollice verso*—in unanimous condemnation. In contrast to the subtle layering of *The Christian Martyrs' Last Prayer*, Gérôme's *Pollice Verso* seems organized around a single, powerful moment. At first sight, this narrative conception seems consistent with the French tradition of ambitious historical painting. It was an abiding precept of French art criticism that a compelling tableau should evince a conspicuous sense of unity, allowing the painting to be absorbed in a glance, or *coup d'oeil*. Painters might adduce a range of strategies in an effort to convey such instantaneity, including the representation of intense action. To be sure, this is not the place to explore a complex and unstable dynamic whose work across French painting has been adumbrated by Michael Fried in a suite of influential studies. Suffice it to say that, at first sight, *Pollice Verso* wholly commits itself to such heightened effects of pictorial unity, the crowd's thundering gesture underwriting a single instant on a massive scale.[8]

And yet for all the painting's affiliation to such precepts, *Pollice Verso* also undermines them, Gérôme complicating and dissolving the instantaneity he so powerfully put in place. To begin, the painting's implicit visual field exceeds its borders, an effect promoted by our partial view onto some of its key figures. I am thinking in particular of the Vestal Virgins, whose virtue Gérôme satirizes in the ferociousness of their denunciation, and two of whose faces are nearly obscured from us by the thick arms and fists of their priestly sisters. (Note in passing the virgin to the far right, her drunken garrulousness signaled by her left arm, on which she is obliged to lean for support.) To the right, a crush of radically foreshortened arms highlights this broader visual field, propelling us into the center of the arena, where we stand miraculously placed on a raised platform on the arena floor. From this vantage point we can just make out the red splotches barely visible on the lower wall—traces of caked blood signaling the elapse of time as well as the routine nature of the arena's violence.

In *Chariot Race* Gérôme pulled back to pan the scene before him, but in *Pollice Verso* he shoots from the center, embracing the viewer on all sides. Beyond the painting's radical cropping, a sense of immersion is also promoted by the thin bands of light distributed across the painting's bottom half. The bands emanate from slits cut into the rotating canvas roof, designed to protect the emperor from the sun. Doubtless this detail constitutes one more expression of Gérôme's seemingly obsessive archaeological fidelity. But the bands also create an unexpected sense of expansion and breadth, as if at any moment we could turn our heads and

see the vast arena before us, its enormous circumference only minimally hinted at, yet through this conceit of light and shade almost miraculously there. And speaking of immersive experiences, note that the sound produced by this picture is no less than surround, critics speaking of the arena's deafening roar even as it makes not a sound.

Gérôme's arena pictures construct the viewer as witness to the scene, located not only before but in the arena. Unlike in many paintings by Edgar Degas or Édouard Manet, however, we do not implicitly participate. We exist as dematerialized observers located on the arena floor, projecting ourselves into the panorama but never mistaking ourselves for the crowd. Gérôme's affiliation to the nineteenth-century panorama and related technologies of visual spectacle is sometimes casually rehearsed, those technologies constituting a so-called regime of visibility whose commitment to verisimilitude puts the observer in a relation of bad faith toward the subject. But the affiliation only goes so far. If the panorama unfurls for the viewer as a sequential, un-unified, and additive aggregate of dis-crete events, Gérôme's viewer moves back and forth. In *Pollice Verso*, the viewer occupies a position impossible from a narrative point of view, that is, on the arena floor. There is much more to say about this sense of viewer mobility. But right away we should note that it recalls cinema's so-called omniscient spectator, a core trope of narrative film that envisions the viewer as able to occupy locations in and out, above and underneath, in front and behind the film's action.[9]

Gérôme's omniscient spectator, I want to argue, subtly undermines *Pollice Verso*'s massive effect of instantaneity. Scanning the crowd, we discover that the painting's action is not unified behind a single gesture. The gladiators face the virgins, who along with the rows of men behind them gesture "thumbs down." But the spectators behind do not gesture, which is to say that the combat-ants address not the entire crowd but a select group. To the left of the emperor's box we encounter other details that diverge from the main action. In the front row, men lean into the arena, looking at the gladiators. Some spectators behind them look over to the side, as if trying to catch sight of the virgins. None of these details undo the painting's powerful sense of narrative instantaneity, but the emperor and his entourage present a more complex picture. To the right of his box his consort holds her hand to her breast, as if overtaken with feeling. Other members of the emperor's entourage gaze down at the gladiators without gesturing. By virtue of their affiliation to the power at the center, they wait. It is the emperor, after taking the temperature of the crowd, who will tip the balance from life to death.

Consider him at last, the hidden engine of the picture's action. Although he is diminutively scaled, the emperor functions in a manner similar to that assigned to the lighter in *The Christian Martyrs' Last Prayer*. True, the emperor

dictates future action while the lighter, torching the crucified victims one by one, has already filled the arena with the smell of burning flesh. Needless to add, the lighter occupies a place near the bottom of the social hierarchy while the emperor sits on top. But in Gérôme's narrative machinery the two figures occupy similar roles, their shared responsibility for motivating the picture's action obliterating social difference. Emotionless in the face of the spectacle, the emperor takes the measure of the audience before he, too, will extend his arms and make the final decision. Heir to *Sardanapalus* (1827), like Delacroix's antihero, the emperor remains aloof before the violence orchestrated for his pleasure. But unlike in Delacroix's picture, the emperor does not rest his head on his hand in a melancholy pose nor is he motionless, any less than the lighter, slowly making his way through the arena. The emperor remains seated, but he is eating what appears to be fruit, his hand going back and forth from his mouth to the bowl in a habitual gesture undisturbed by the violence before him.

As we focus on this figure—his remote affect, the slowly methodical nature of his action—the scene suddenly pivots along a new temporal axis. We are launched as if into the instant itself, experiencing the noise and violence with unexpected serenity. The action hovers before us in a newly distended temporal field, defined by the time consumed to eat a bowl of figs. Once again we might call on the cinema to give a name to this sense of elasticity operating within the instant itself. The sense of duration promoted by this detail recalls the experience of so-called bullet time, a digitally enhanced slow-motion visual effect made famous by *The Matrix*, but with roots in Japanese anime and Hong Kong martial-arts films. In bullet time, a character and sometimes simply the viewer witness something we normally cannot, such as a speeding bullet. Time is so slowed that we may also move around the speeding bullet at normal speed, observing its motion from a range of perspectives.[10]

The association may seem farfetched, but its relevance I hope is clear. The picture's temporality now maps the unhurried motion of the emperor's hand or for that matter the mechanical chewing of his jaw. Back and forth within this dilated instant the viewer weaves his or her way around victor and victim, among the virgins, and through the crowd, tracing a path oblivious to the deafening roar. No wonder *Pollice Verso* catalyzed Ridley Scott's sense of future possibility. Here as elsewhere Gérôme develops a host of narrative strategies that launch the viewer vertiginously across the scene and seemingly across time. All of this is to say that we have yet to come to grips with an artist who left critics worried but audiences enthralled. True, we now grant him a minor role in the modern history of mass entertainment, but we can also think of him as mobilizing modes of viewer experience that would flourish into the present day. My frankly anachronistic readings

have sought to explore the spell his paintings once cast in familiar and contemporary terms, allowing us briefly to bracket the climate of suspicion that continues to dog the artist. Perhaps we needed the cinema to see Gérôme anew, our affinity for its immersive dream opening his pictures to new and fertile interrogation.

Notes

Many thanks to Michael Fried, Holly Clayson, Charles Palermo, Gülru Çakmak, and Emily Beeny for valuable comments and suggestions following oral versions of this essay.

1. Walters Art Gallery, *Catalogue of Paintings* (n.d.), p. 39, cited in Gerald M. Ackerman, *Jean-Léon Gérôme (1824–1904)*, exh. cat. (Dayton, 1972), p. 87.

2. Fanny Field Hering, *Gérôme: The Life and Work of Jean Léon Gérôme* (New York, 1892), p. 88; and Jean-Léon Gérôme, "Notes et fragments de J. L. Gérôme du souvenirs inédits du maître," ed. Frédéric Masson, *Les Arts* 26 (February 1904), p. 26, cited in Ackerman (note 2), p. 69.

3. See, in particular, *Gérôme and Goupil: Art and Enterprise*, exh. cat., trans. Isabel Ollivier (Paris and New York, 2000); Stephen Bann, "Reassessing Repetition in Nineteenth-Century Academic Painting: Delaroche, Gérôme, Ingres," in *The Repeating Image: Multiples in French Painting from David to Matisse*, exh. cat., ed. Eik Kahng (Baltimore, 2007), pp. 27–52; Margaret Malamud, "The Greatest Show on Earth: Roman Entertainments in Turn-of-the-Century New York City," *Journal of Popular Culture* 35, no. 3 (Winter 2001), pp. 43–58; and Holly Edwards, *Noble Dreams, Wicked Pleasures: Orientalism in America, 1870–1930*, exh. cat. (Princeton, 2000).

4. See Wolgang Kemp, "Death at Work: A Case Study on Constitutive Blanks in Nineteenth-Century Painting," *Representations* 10 (Spring 1985), esp. pp. 119–20; and Stephen Bann, *Ways around Modernism* (New York, 2007), pp. 190–91.

5. Ivo Blom, "Gérôme en Quo Vadis? Picturale invloeden in de film," *Jong Holland* 17, no. 4 (2001), pp. 19–28.

6. "Ridley Scott Uncut: Exclusive Online Interview," *Times Online*, October 5, 2006. In this "interview" Scott garbles *Ave Caesar!* and *Pollice Verso*, for both of which he may have had pictures at hand. Remarks by Walter Parkes included in the official history of the film confirm the priority of *Pollice Verso*. Parkes explains that as he made his pitch, Scott's eyes "kept wandering back to the image." See *Gladiator: The Making of the Ridley Scott Epic*, ed. Diana Landau (New York, 2000), p. 11.

7. Maria Wyke, *Projecting the Past: Ancient Rome, Cinema, and History* (New York, 1997), pp. 120–23.

8. See, in particular, three books by Michael Fried: *Absorption and Theatricality: Painting and Beholder in the Age of Diderot* (Berkeley, 1980); *Courbet's Realism* (Chicago, 1990); and *Manet's Modernism, or, The Face of Painting in the 1860s* (Chicago, 1996). For all its affinity to the cinema, Gérôme's painting is no less dominated by concerns that structured French art making in the 1860s and 1870s, notably the absorptive dynamic as traced by Fried.

9. For omniscience in Hollywood narration, see David Bordwell, Janet Staiger, and Kristin Thompson, *The Classical Hollywood Cinema: Film Style and Mode of Production to 1960* (New York, 1985); also see Bordwell's *Narration in the Fiction Film* (Madison, 1985).

10. For bullet time see Darren Tofts, "Truth at Twelve Thousand Frames per Second: *The Matrix* and Time-Image Cinema," in *24/7: Time and Temporality in the Network Society*, ed. Robert Hassan and Ronald E. Purser (Stanford, 2007), pp. 109–21; and Bob Rehak, "The Migration of Forms: Bullet Time as Microgenre," *Film Criticism* 32 (Fall 2007), pp. 26–48.

The Salon of 1859 and *Caesar*
The Limits of Painting

GÜLRU ÇAKMAK

For many of his critics Gérôme's painted canvases constituted a litmus test where marks made on a surface were not considered painting anymore.[1] "His brush turns into a pen," contended Paul de Saint-Victor, "he lists in detail and in an exact manner interesting subjects and ingenious ideas."[2] Although recent scholarship has rehearsed the notion that Gérôme's narrative strategies exemplified mid-nineteenth-century efforts to counter the rapid extinction of traditional history painting, it has seldom fared better than reproducing the stock stereotype, already established in the artist's lifetime, of his primarily commercial interest in producing painstakingly detailed anecdotal paintings.[3] I argue, in contrast, that there is nothing inherently regressive in close attention to detail. Although Gérôme has been repeatedly accused of painting simple anecdotes aimed to be grasped right away by the masses, rather than thinking about the medium-specificity of his work, I would like to make a case for the aesthetic stakes of the artist's work as I advocate a closer look, one that corresponds to his notoriously close attention to detail. In what follows I shall focus on one of his paintings shown at the Salon of 1859, *Caesar*, in an attempt to demonstrate that the artist thought deeply about the question of what constituted the limits of the medium of painting and what it was legitimately allowed to do.[4] A work long lost, *Caesar* constitutes a foundational moment in the artist's practice as he reflected on how the art of painting could legitimately induce a powerful beholding experience.

Claiming to be a conventional history painting in its large dimensions[5]—as well as in its unmistakably historic subject matter, with affiliations to tragedy—*Caesar* received one of the most laudatory reviews from an unexpected quarter when it was exhibited at the Salon of 1859. "The effect is truly great," exclaimed Charles Baudelaire, impressed by Gérôme's unorthodox rendering of

the assassination of Julius Caesar at the Curia Pompey on March 15, 44 B.C. "This terrible summary suffices."[6] The only extant black-and-white photograph of the painting shows a single figure, somewhat off center in the left foreground, lying on the floor against a classical architectural backdrop (fig. 13). Severely foreshortened, the abandoned Caesar stretches diagonally, his head in the immediate foreground and his feet leading the eye into a hallway flanked by a row of columns in the upper-right corner. The elaborately ornamented mosaic floor centers on a Medusa head. Smoke billowing from a tripod provides the only motion in this otherwise very still scene.

All critics were not equally enchanted with Gérôme's rendering of this scene from Roman history. Many complained that this spectacle of death, where clues about the unfolding of events are strewn throughout—the toppled throne, the scroll on the floor, the bloodstained pedestal of Pompey's statue—failed to add up to a self-contained narrative that could be grasped without resorting to the Salon catalogue, thus jeopardizing the autonomy of the painting. In one of the harshest reviews, Jules-Antoine Castagnary referred to the artist as a clumsy inventor and a petty composer and described *Caesar* as a feeble lesson in moralizing aesthetics. A real painter would have used this opportunity to engage the emotions of the viewer by interpreting history as a tragedy. "Crossing in one leap the twenty centuries which separate us from this bright expiation," prescribed the critic, "[Gérôme] should have brought the assassins and victim back from death, with their fierce procession of passions and hatreds."[7] Gérôme instead had replaced the appropriate representation of lofty emotions with small details of archaeological curiosity that left the viewer unaffected.

What did *Caesar* offer if not the "passion, movement, and grandeur"[8] of a tragic image, or the neutral, safe distance of a meditative image?[9] According to Théophile Gautier, when seen at a distance, even before one had a chance to comprehend its subject matter, the epically scaled *Caesar* captured the Salon visitor by its "sinister, mysterious, and solitary appearance."[10] Alexandre Dumas declared the composition "grand, captivating, solemn."[11] Maxime Du Camp commented on the "sensation of silence" emanating from the scene.[12]

For many, however, there was something deeply disturbing about standing in front of the painting. The shadow cast on the upper half of the body, in particular, was strongly criticized by reviewers of various convictions, from an already belligerent Castagnary to an otherwise unflinchingly supportive Gautier. By enveloping Caesar's face in shadow, many protested, Gérôme undercut any possibility for the viewer to be moved by the scene. Racial categories mobilized to describe the dark effect of modeling—mulatto (*mulâtre*),[13] Kabyle,[14] Maghrebi (*maugrabin*),[15] Numidian king (*roi numide*)[16]—disclose the extent to which the

GÜLRU ÇAKMAK

FIGURE 13
Jean-Léon Gérôme, *Caesar*, 1859. Oil on canvas, 218 x 317.5 cm (85 ¹³⁄₁₆ x 125 in.). Location unknown

critics were disturbed by such a rendering that did not befit established notions of a tragic hero. It seemed unmotivated, in the same way that the extremely powerful perspective device that drew the attention away from Caesar seemed out of place. "It is voluntarily and with the intention to express an *idea* the end of which, it has to be confessed, escapes us that the artist has presented a painting in quite large dimensions in which the eye is initially pulled in to the depth by an immense marble tiling, while a very small space is occupied by a drapery under which one can suppose that a corpse is hidden," wrote the critic Étienne-Jean Delécluze.[17]

One can only hypothesize the effect the long-lost painting might have produced on the viewer. What can be discerned from the photograph is a disjunction between the monumentality of the space and a very limited view of that same space because of the way in which it is cropped. Everything is cut in half: the columns, the statues, the walls. This is an utterly anomalous space with a general sensation of an oppressive horizontality.

> By not showing more than a part of things, by clumsily cropping the columns to show but the bases, [M. Gérôme] dismembered his composition. He did not make a tableau, but only a half or even a quarter of a tableau. It is undoubtedly for this reason that in front of his *Caesar* the spectator experiences a feeling of unease he does not know how to explain.[18]

What is noted by Paul Mantz in this passage is a proliferation of the effect of dismemberment, or even decapitation, in the overall composition, one finding its expression in the partial views of the columns in the background, the omitted torsos of the statues of Pompey and of Roma, and the hardly visible body of Caesar buried under layers of drapery and partially covered by dark shadow. The critic's account is made all the more suggestive by his resort to a highly charged set of terms in an attempt to explain his sense of unease: crop (*couper*), dismember (*disloquer*), half (*la moitié*), quarter (*le quart*).

Despite such powerful quasi-corporeal responses the painting seems to have generated in its viewers, it is perhaps curious that many critics did not perceive in its inexplicable aspects anything other than a miscalculation on the part of the painter. It had been known, at least since Gautier visited Gérôme's studio in May 1858, that initially the artist had worked on a related composition, which is today identified as *The Death of Caesar*, now at the Walters Art Museum in Baltimore (plate 6).[19] When Gautier saw the Salon painting, he reported that it had derived from this earlier work.[20] For many who were made uncomfortable by *Caesar*, here was an explanation: surely the general sense of truncation was due to the fact that the Salon painting was, in fact, nothing but a fragment of a much

more comprehensive scene. In a curious account that mixed facts with hearsay, Mathilde Stevens offered a similar explanation for the heavy shadows in *Caesar*.[21] According to Stevens, Gérôme had *The Death of Caesar* photographed after completing it. The resulting lighting effect took him by surprise: "It left the assassins in shadow, it lit up the body of Caesar admirably."[22] Stevens argues that it was this unexpected result that motivated the artist to produce the Salon painting, and that its dark shadows were a consequence of the artist's emulation of photography. This curious account is self-contradictory: Stevens does not explain why or how the brightly illuminated body in the alleged photographic image would come to be cast in heavy shadows in the resulting Salon painting. Nonetheless, this is an invaluable account, for it demonstrates that in artistic circles there had been word of a photograph of the Baltimore painting that inspired the Salon *Caesar*.

There is, in fact, a little-known studio photograph in one of the albums donated by the artist's widow to the Cabinet des estampes in the Bibliothèque nationale de France (fig. 14).[23] The partially erased list on the red cover of the tome contains a barely legible "César mort." The corresponding photograph in the album does not, however, match the one described by Stevens. Instead of a black-and-white reproduction of the scene of assassination featuring all the actors of the Baltimore *Death of Caesar*, here the majority of the frame is occupied by Caesar's body. If this photograph bears a family relationship to either of the two paintings, it is to the Salon *Caesar*: a heavily draped and severely foreshortened Caesar, the blood-stained pedestal of Pompey's statue, an overturned throne, a tripod, the patterned floor are all present. An attentive look, however, reveals that it is not a reproduction of the lost Salon painting, for there is no receding perspective that draws attention away from the body.

What the photograph captures is, in fact, a detail of the Baltimore *Death of Caesar*. The upper-right corner shows the feet and legs of two of the assassins instead of the Salon painting's colonnaded hallway. The lack of bloodstained footprints on the mosaic floor attests to the fact that the photograph was taken before *The Death of Caesar* was completed. What it captures is the painter pondering as he looks very intently at a detail of a work in progress.

Far from taken by surprise as suggested by Stevens, Gérôme intentionally chose to frame the unfinished painting from a specific viewpoint when he had it photographed. The differences between the photograph and the Salon painting attest to the fact that the artist made very deliberate choices when he created the painting's peculiar composition and lighting. He removed the assassins and inserted the receding perspective. Despite the extended space, the painting preserves the truncated ambiance captured by the photograph. He moved Caesar from the center toward the left, thus retaining the body's prominent position in

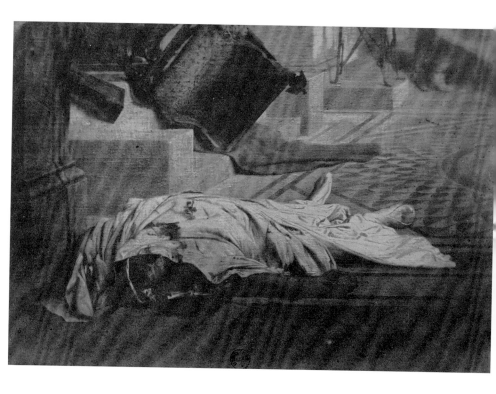

FIGURE 14
"César mort," photograph in "28 volumes contenant les reproductions photographiques de l'œuvre de
L. Gérôme," vol. 23. Paris, Cabinet des estampes, Bibliothèque nationale de France (DC-293 [A+, 23])

the foreground. He changed neither the drawing of the body nor the distribution of light and shadow over it. The folds of the drapery in the Cabinet des estampes photograph are identical to the ones in the Salon *Caesar*. Most significantly, he retained the inexplicable dark shadows enveloping Caesar's face that proved so puzzling to critics. If the photograph proves that there was nothing accidental in *Caesar*, it hardly explains the *idea*, to repeat Delécluze, that motivated the painter to offer this amorphous figure whose face was in shadow and feet in light, located in an anomalous space that pulled the viewer in. To explore this question, we will need to shift our attention momentarily to the painting that was clearly started earlier and that contains the kernels of the Salon work.

The much more complex and multilayered *Death of Caesar* presents the corpse spread diagonally in the lower-left corner, senators fleeing the scene of murder in the center, and, in the right middle ground, a lone senator seated in the empty hall. This last figure has been considered the quintessential anecdotal figure by generations who have looked at Gérôme's work through the eyes of habit. He has always been assumed to be deep asleep, and as such, thought to introduce a note of comic relief into an otherwise dramatic scene.[24]

Yet he is not sleeping. A careful examination discloses that he is very much awake: his left fist is clenched, and his wide-open eyes look straight ahead. Angry, alone in his reaction, the senator looks at the podium, toward where the crime happened. It is correct that his body is in a state of stasis, but this is more an intense concentration akin to a hypnotic state rather than the abandon of sleep. His heaviness is not merely anecdotal: it is there to accentuate his state of motionlessness, his solidity. In brief, he is petrified. If we trace his gaze across the canvas following the direction of his eyes and the tilt of his head, we arrive at the heart of his petrification: the Medusa head.

In the axis of looking that takes place between Medusa and the lone senator, Gérôme reflects on the conventional viewing experience. What that senator witnessed—what led to his current state of petrification as a consequence of an excess of emotions—would have been a scene very close to what many would rather have had Gérôme depict: a scene displaying a variety of responses to an emotionally charged moment, such as the pathos of Caesar's *tu quoque*, the brutality of the assassins, and various reactions of bystanders. The public failure of his monumental *The Age of Augustus* (fig. 19) at the Exposition universelle had made Gérôme acutely aware that the contemporary viewer demanded a radically different relation to the painted image.[25] Intent on devising a new type of history painting, Gérôme found the conventional representation of personages frozen in the midst of their actions and responding attitudes unpersuasive in engaging the contemporary viewer. In both *Caesar* and *The Death of Caesar*, the

"extraordinarily animated expression" that critics sought to see on Caesar's face is displaced to the Medusa emblem adorning the mosaic floor.[26] Her mouth open and her brow furrowed, hers is an expression forever locked in "an embryonic time, an infinitesimal moment during which she has just looked at herself and is no longer doing so."[27] The "embryonic time" captured in her face here stands in for the type of historical representation meticulously described and demanded by most of Gérôme's critics, one that complied with the definition of painting as a medium that should represent a single moment of the sort that Charles Blanc had praised Paul Delaroche for achieving in *The Assassination of the Duc de Guise* (1834): "What a wonderful intuition of history! What a talent, in an art which can represent only a single moment, to be able to choose precisely that instant which brings out all the characters in relief!"[28] Gérôme's work shows a heightened consciousness that the famous single moment proper to the realm of painting was a fabrication, a synthetic summary aspiring to reconstruct the past. Rather than conjuring a face for Caesar in what would be a vain attempt to generate an emotional response in the viewer, Gérôme preferred to thematize this bankrupted paradigm of historical representation in the prominently positioned figure of Medusa.

For the painter, a powerful beholding experience had to be a temporal and spatial engagement with the work rather than a passive taking-in of the represented scene.[29] In *Caesar,* the scroll lying on the ground right above Medusa encapsulates the paradigmatic shift Gérôme wanted to bring about, the recognition that viewing is an active, ongoing event that takes place at the present time. The scroll is the letter given by Artemidorus to Caesar revealing the conspiracy, the one Caesar kept with him but never had the time to read.[30] By depicting Medusa as an archaeological layer embedded in the stone pavement and buried under physical traces of the event as it unfolded, Gérôme signals that the famous single moment, forever capturing that infinitesimal moment, does not take place at the present. The past can only be experienced through its physical residues in the viewer's imagination.

If we return to the Baltimore painting once more, we can begin to appreciate the extent to which Gérôme sought to plunge the viewer into action. The very same Medusa figure, the one that allegorizes the petrifying fascination of looking in relation to the figure of the lone senator, also demonstrates the artist's intention to stimulate in the viewer an almost corporeal fantasy of entering the depicted scene. The direction of her head, facing right toward rows of empty seats, actively lures the viewer into looking at the painting in a very specific way. The semicircular rotation of the seats of the Curia provides a space for the viewer who wants to look at the Medusa head-on. In the lower right, the first row of seats under heavy shadow

GÜLRU ÇAKMAK

occupies the foreground, extending all the way to the edge of the canvas cut by the frame. This area is made immediately accessible by virtue of a certain sharp tilt Gérôme gave the motifs and objects, as if the peacefully curving seats unexpectedly arrived at the edge of an abyss and then fell off—out of the picture plane and into the space of the beholder. This sense of continuity has a purpose: to stimulate the viewer to imagine occupying one of the curule seats, somewhere near the lone senator, and to look at the podium.[31]

We can approximate the senator's position if we take in the painting from the very right of the canvas, imagining looking at Medusa frontally, just as she invites us to. Once we do that, the Medusa head emerges as a full moon, while Caesar is marginalized to the left, the only discernible part of his body remaining his feet (fig. 15). The rest of his shriveled corpse lingers on the periphery of our vision, an effect of anamorphic foreshortening.[32] If we are to follow an imaginary semicircle, as I believe the row of chairs suddenly cut by the frame urges us to do, and walk from the right of the painting to its left as if walking in that invisible section of the auditorium, the full circle of the Medusa head gradually narrows into an oval and the body of Caesar conversely gains more substance. Eventually, by the time we reach Caesar's body and view the composition from the lower-left corner, as the foreshortened figure invites us to do, we come to see the corpse in its fullness. Looked at from this viewpoint, the diagonal directionality of the foreshortened body, joining forces with the corresponding lines of the mosaic pavement, points like the needle of a compass toward the arcaded doorway through which the crowd is fleeing (fig. 16).

While working on this painting, Gérôme seems to have reflected deeply on what a history painting was and what it was capable of showing. Neither the painter nor the viewer can have access to the actual scene that petrified the senator; the past is fundamentally remote from the present. What a history painting can offer to its viewer instead is an opportunity to navigate the scene and collect the physical traces of the past, which to Gérôme is the only possible way to bring that lost historical moment into the real time of the act of beholding.[33] If the means proper to the medium of painting allowed it to show only one moment in history, Gérôme preferred to stretch that moment by allowing the viewer to adjust to different calibrations of time and perspective. The viewer is therefore given the possibility to imagine entering the picture and moving inside, inhabiting that space, choosing a seat near the petrified senator who witnessed the crime (even if it is impossible for her to see what he would have seen), looking at the podium and at Medusa, and looking from dead Caesar's viewpoint toward the perspective structure's projection into the future, from the disorder that has already happened to the tumult that is yet to take place.[34]

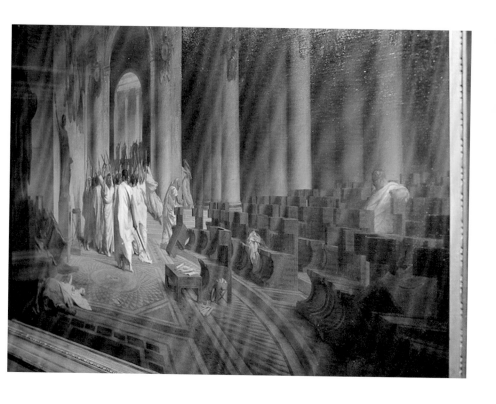

FIGURE 15
Jean-Léon Gérôme's *The Death of Caesar* (1859; plate 6) photographed obliquely from the right

GÜLRU ÇAKMAK

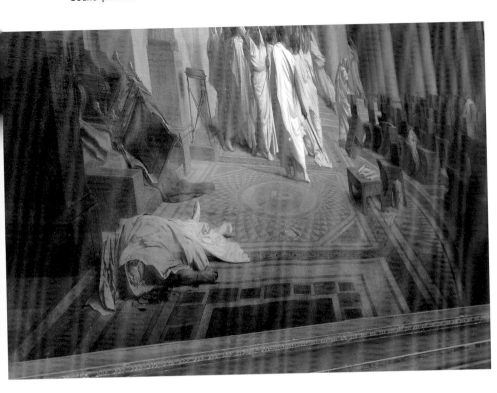

FIGURE 16
Jean-Léon Gérôme's *The Death of Caesar* (1859; plate 6) photographed obliquely from the left

What occupied Gérôme for such a long time in the two canvases was his realization that a new model of history painting that claimed to compete with the tragic effect of the conventional mode would have to find the means to move the viewer on a more fundamental level. As he pondered on how to transfer the Baltimore composition's complex structure of beholding to a larger canvas destined for the Salon—"painting, erasing, repainting, discouraged at the sight of the work made so gropingly," to quote Stevens[35]—the Cabinet des estampes photograph assisted Gérôme in isolating the structure of the diagonal swing from the corpse of Caesar toward the arcaded exit of the Curia Pompey (see fig. 14). By selecting this specific and highly charged axis of looking as the focus of his Salon painting, Gérôme sought to generate a powerful emotional response in the viewer. According to Gautier, the resulting painting was imbued with a tragic effect: "M. Gérôme turned over this composition in various manners, and he has settled on the most sober, the most severe, the most tragic one."[36] As the critical response demonstrates, Gérôme succeeded in painting a scene whose partial monumentality strongly implicated the physicality of the viewer, with its chopped statues, truncated columns, amorphous dictator, and the powerful vacuum of the empty corridor in the upper-right corner.

A short paragraph in Gérôme's *Notes autobiographiques* gives us an understanding of the extent of the artist's unfulfilled ambitions in the Caesar project:

> During the same period "The Death of Caesar" came out of my atelier, which some amiable critics have called "Day of the Laundress." I, who am no enemy to such joviality, recognize and appreciate the humor of such a pleasantry. However, leaving all modesty aside, this composition merits a much more serious consideration. The presentation of the subject is dramatic and original. It is a small canvas that could have been executed on a much larger scale without losing any of its character, a claim which I cannot make for many of my works.[37]

By "The Death of Caesar" Gérôme initially seems to refer to the Salon painting, since "Day of the Laundress" possibly alludes to the caricature by Cham (Charles Amédée de Noé) of the Salon *Caesar* in *Le Charivari*.[38] Yet the large Salon painting cannot be what he refers to as a "small canvas." It is striking that the artist conflated the two paintings, less than two decades after the Salon exhibition of the large *Caesar* and less than one decade after the appearance of the smaller *Death of Caesar* at the 1867 Exposition universelle. This short paragraph provides us with an understanding that the two Caesar paintings constituted part of one

GÜLRU ÇAKMAK

and the same project to the extent that they were indistinguishable in Gérôme's mind. Nonetheless, the possibility of reproducing the complex viewing structure of the Baltimore painting in a larger format, one that would have engulfed the viewer, always lingered in the artist's mind, without ever being realized.

In the two Caesar paintings Gérôme thought deeply about a new kind of history painting, one that invited nothing short of a physical entry into the picture, at least a fantasy of such an experience. As the general inclination of his Salon reception indicated in 1859, however, the path he traced for the new history painting to follow did not become transparent to most of his viewers. While the innovative aspect of the tragic effect *Caesar* sought to instill in its viewer was intuited and appreciated by a handful of critics, it remained opaque to many. By not arriving "straight at the fact," contended Delécluze, the painter transgressed "the limits naturally imposed on his art."[39] The fits and starts that marked the production of the two paintings indicate the possibility that even Gérôme himself could not fully articulate his intuition about a new history painting and had difficulties reconciling his ambition to move the viewer with his acute awareness of the distance between the past and the present. The fact that the artist had the photograph taken at a point when he interrupted his work on the Baltimore painting attests to his indecision and hesitation, an aspect that has been left unaddressed in the scholarly literature on this painter of polished surfaces and thoroughly calculated narrative strategies.[40]

Notes

1. Ever since the exhibition of *Anacreon, Bacchus, and Cupid* at the Salon of 1848, Gérôme's color had been commonly found dry (*sèche*) and his wielding of the brush tight (*serré*). Initially attributed to the young artist's miscalculated Ingrisme and *archaisme étrusque*, often excused as an honest mistake, in time criticism acquired a serious tone of accusation.

2. Paul de Saint-Victor, "Salon de 1859. II. MM. Gérôme, Hebert, Baudry, Bouguereau, Mazerolle," *La Presse*, April 30, 1859, n.p. Unless otherwise noted, all translations are my own.

3. See James Kearns, "Quelle histoire? Gautier devant l'oeuvre de Gérôme au Salon de 1859," in *Le Champ littéraire, 1860–1900: Études offertes à Michael Pakenham*, ed. Keith Cameron and James Kearns (Amsterdam and Atlanta, 1996); Stéphane Guégan, "Le Regard de Gygès," in *Théophile Gautier, la critique en liberté: Catalogue*, exh. cat., ed. Stéphane Guégan (Paris, 1997); and John House, "History without Values? Gérôme's History Paintings," *Journal of the Warburg and Courtauld Institutes* 71 (December 2008), pp. 261–76. Exceptions to these reiterative accounts have been offered by Wolfgang Kemp's "Death at Work: A Case Study on Constitutive Blanks in Nineteenth-Century Painting," *Representations* 10 (Spring 1985), pp. 102–23; and Judith Ryan's "More Seductive than Phryne: Baudelaire, Gérôme, Rilke, and the Problem of Autonomous Art," in *PMLA (Publications of the Modern Language Association of America)* 108, no. 5 (October 1993), pp. 1128–41.

4. Deaccessioned by the Corcoran Gallery of Art in 1951, the painting has since been lost. According to an entry in Corcoran's file of the painting, forwarded to me by the assistant registrar Ila Furman, *Caesar* was sent to Knoedler's in New York in March 1951 and was "disposed of

through auction at Tobias, Fischer and Co., New York City." William Johnston, senior curator of European painting and sculpture at the Walters Art Museum, communicated to me in a written correspondence that the painting was sold for thirty-five dollars to an individual in Scotland, who seems to have been much more interested in the frame than in the canvas itself. In the course of my research I have come across a number of instances in which Gérôme designed his own frames. The closest example that can give us an idea about the frame of the lost *Caesar* is that of *The Death of Caesar* at the Walters Art Museum, whose short sides are designed as two fluted columns, complementing the antique setting of the painting.

5. The Corcoran's file of the deaccessioned painting contains a registration card that gives the dimensions of the painting as "86 × 125." The 1890 edition of the Corcoran Gallery catalogue gives the dimensions in inches and confirms the information on the registration card (*The Corcoran Gallery of Art. Catalogue* [Washington, D.C., 1890], no. 35, p. 21). Gerald M. Ackerman also confirms its large dimensions, 218 × 317.5 cm (*Jean-Léon Gérôme: Monographie révisée, catalogue raisonné mis à jour* (Courbevoie, 2000), no. 109, p. 240). As the Salon criticism demonstrates, the critics described and evaluated this painting as a proper *peinture d'histoire*, rather than a modest-sized easel painting, and noted that it was much larger than the other two paintings Gérôme exhibited at the same Salon.

6. Charles Baudelaire, *Salon de 1859: Texte de la revue française* (Paris, 2006), p. 35.

7. Jules-Antoine Castagnary, "Salon de 1859," in *Salons (1857–1870): Avec une préface de Eugène Spuller et un portrait à l'eau-forte de Bracquemond*, 2 vols. (Paris, 1892), 1: p. 94.

8. H. Dumesnil, *Le Salon de 1859* (Paris, 1859), p. 89.

9. Two painterly meditations on death repeatedly brought up by critics to dispute Gérôme's rendering of the death of Caesar were Philippe de Champaigne's *Dead Christ Lying in His Shroud* (1654) and *A Dead Soldier* (seventeenth century), a painting that many would have seen in the Pourtalès Collection, attributed in the nineteenth century to Vélazquez.

10. Théophile Gautier, "Exposition de 1859. M. Gérôme," in *Le Moniteur universel: Journal officiel de l'empire français* 113 (April 23, 1859), p. 465.

11. Alexandre Dumas, *L'Art et les artistes contemporains au Salon de 1859* (Paris, 1859), p. 38.

12. Maxime Du Camp, *Le Salon de 1859* (Paris, 1859), p. 70.

13. Castagnary (note 7), p. 96.

14. Gautier (note 10).

15. Baudelaire (note 6), p. 35.

16. Saint-Victor (note 2).

17. Étienne-Jean Delécluze, "Exposition de 1859 (Premier article)," *Journal des débats, politiques, et littéraires*, April 27, 1859, n.p.

18. Paul Mantz, "Salon de 1859: Deuxième article," *Gazette des beaux-arts* 2, no. 4 (May 15, 1859), p. 199.

19. Théophile Gautier, "À travers les ateliers: Gérôme, Gleyre, Delacroix, Appert, Paul Huet," in *L'Artiste* 4 (May 16, 1858), p. 18.

20. Gautier (note 10), p. 465.

21. Mathilde Stevens, *Impressions d'une femme au Salon de 1859* (Paris, 1859), p. 14.

22. Ibid.

23. This collection can be found in the catalogue of the Cabinet des Estampes, Bibliothèque nationale, under "28 volumes contenant les reproductions photographiques de l'œuvre de L. Gérôme" (call number DC-293A). Titles of photographs were inscribed by hand, in all probability Gérôme's own, on sheets of paper, which were then glued to the cover of each tome. The photograph listed as "César mort" is in volume 23 (call number DC-293 [A+, 23]). According to the inventory information found in Rés-Ye-85-Pet Fol., this collection was donated by "Mme. Gérôme" and accessioned on December 8, 1905.

24. The source of this misperception was Théophile Gautier, who had seen the unfinished canvas in Gérôme's studio in 1858: "Épouvantés du meurtre, et craignant d'être compromis, les sénateurs ont pris la fuite, à l'exception d'un seul, vieillard obèse, resté endormi dans sa chaise curule; appesanti par quelque excès de luxure ou de bonne chère, il n'a rien entendu à travers son sommeil opaque, et ne se doute pas de la chose" (Gautier [note 19], p. 18). In his review of the Salon of 1859, Gautier remembered this figure: "Un vieillard obèse, apoplectique, endormi pendant la discussion, seul ne l'avait pas bougé de sa place; le meurtre ne l'avait pas réveillé et il continuait son sommeil, ne se doutant pas de la chose; c'était certes très-fin, très-ingénieux, trop ingénieux sans doute" (Gautier [note 10], p. 465). Gautier's account was unquestioningly taken over by other critics who had never seen the painting. When Anatole France's poem "Un sénateur romain" was published side by side with Gérôme's etching of the dead Caesar in Philippe Burty's *Sonnets et eaux-fortes* in late 1868, the humorous interpretation of the figure was sealed: "César, sur le pavé d'une salle déserte, / Gît, drapé dans sa toge et dans sa majesté. / Le bronze de Pompée avec sa lèvre verte, / A ce cadavre blanc sourit ensanglanté. / L'âme qui vient de fuir par une route ouverte / Sous le fer de Brutus et de la Liberté, / Triste, voltige autour de sa dépouille inerte / Où l'indulgente mort mit sa pâle beauté. / Et sur le marbre nu des bancs, tout seul au centre, / Des mouvements égaux de son énorme ventre / Rhythmant [sic] ses ronflements, dort un vieux sénateur. / Le silence l'éveille, et, l'œil trouble, il s'écrie / D'un ton rauque, à travers l'horreur de la curie: / 'Je vote la couronne à César dictateur.'" Even Gérôme's biographer Charles Moreau-Vauthier described the figure of the lone senator as asleep and comical (*Gérôme, peintre et sculpteur, l'homme et l'artiste, d'après sa correspondance, ses notes, les souvenirs de ses élèves et de ses amis* [Paris, 1906], p. 153).

25. Augustin-Joseph Du Pays had lamented the rapid extinction of history painting and tragedy in "Salon de 1857 (huitième article)," in *L'Illustration, journal universel* 29 (August 15, 1857), p. 107: "La peinture historique semble de jour en jour devenir plus rare à nos expositions; de même que les tragédies se retirent de nos théâtres. Ce sont des formes de l'art qui captivent moins le public."

26. Castagnary (note 7), p. 96.

27. Louis Marin, *To Destroy Painting*, trans. Mette Hjort (Chicago and London, 1995), p. 149.

28. Charles Blanc, "Paul Delaroche," in *Histoire des peintres de toutes les écoles: École française* (Paris, 1865), 7: p. 6.

29. The difference between what may be an initial conception—which was recently on the art market—for the Baltimore *Death of Caesar* (see W. M. Brady & Co., *Drawings and Oil Sketches, 1700–1900,* exh. cat. [New York, 2009], no. 21) and the finished painting itself gives us an idea about the painter's process as he thought through the kind of effect a new history painting would produce. The sketch shows a fairly early stage of the composition: the foreshortened body is there and so is the fallen throne; the elaborate mosaic floor with the trompe l'oeil pattern and the Medusa emblem are missing and so are the bloody footprints and the lone senator. There is a general sense of emptiness as the crowd rapidly evacuates the premises. Left at this stage, the painting would have represented one single moment: the deed is done, the throne has already fallen, the corpse is on the floor, and the culpables as well as the witnesses are in flight. I am grateful to Eik Kahng for drawing my attention to this sketch.

30. Plutarch, *Fall of the Roman Republic*, rev. ed. (London, 2005), p. 317.

31. In "Death at Work: A Case Study on Constitutive Blanks in Nineteenth-Century Painting," one of the most compelling accounts of Gérôme's work to this day, Wolfgang Kemp gives an account of the artist's *December 7, 1815, 9 O'clock in the Morning* (plate 7) as a new type of painting, the need for which had gained in urgency since the beginning of the nineteenth century. Whereas conventional history painting prescribed for the beholder a preconceived set of emotional responses with which to experience the scene, he argues that Gérôme's innovative deployment

of indeterminate spaces in his history paintings implicated the neutrality and belatedness of the beholder without prescribing a strict set of emotional responses (Kemp [note 3]).

32. The composition's anamorphic character was recognized by Joseph Adhémar, who, in his *Études supplémentaires*, published in 1859 to complement the second edition of *Traité de perspective à l'usage des artistes*, attributed it to a miscalculation by the painter. See B. Maurice, "Nouvelles études de perspective par M. J. Adhémar," *Gazette des beaux-arts* 4, no. 3 (November 1, 1859), p. 174.

33. Baudelaire remarked that everybody knew enough of Roman history to deduce the story, "this terrible summary," from the clues strewn across the scene (Baudelaire [note 6], p. 35).

34. As remarked by Baudelaire (note 6, p. 35), if the clues signaled the past, the powerful perspective that pulled the viewer in encouraged her to imagine the outside, the afterward.

35. Stevens (note 21), p. 14

36. Gautier (note 10), p. 465.

37. Jean-Léon Gérôme, *Notes autobiographiques* [1874], ed. Gerald M. Ackerman (Vesoul, 1981), p. 12.

38. The caption under the caricature read: "La mort de Pierrot: Ayant succombé dans son duel Pierrot est rapporté a son domicile. Sa femme de ménage n'a pas jugé à propos de faire sa chambre. A-t-elle eu tort ou raison? Tout est là!" (*Le Charivari*, May 15, 1859, n.p.).

39. Delécluze (note 17).

40. Mirroring the relationship between *Caesar* and *The Death of Caesar*, the present essay is based on a much larger and thorough analysis I offer in a chapter of my dissertation, "Jean-Léon Gérôme: The Formative Years (1855–1864)." I am deeply grateful to my supervisors, Michael Fried and Kathryn Tuma, at Johns Hopkins University, and to my colleagues and dear friends Katherine Markoski, Joyce Tsai, and Octavi Comeron for the insightful comments and recommendations they have offered on the chapter and the essay. I would like to thank Ila Furman of the Corcoran Gallery of Art for her assistance during my research. Susan Tobin of the Walters Art Museum and Jamie Magruder have very kindly helped me acquire the detail photographs of the Baltimore painting. I am deeply thankful to Eik Kahng and Neil Hertz for the long and fruitful discussions we had in front of *The Death of Caesar*.

Crime, Time, and *The Death of Caesar*

NINA LÜBBREN

Jean-Léon Gérôme's 1859 painting *The Death of Caesar* (plate 6) in the Walters Art Museum in Baltimore shows us a crime scene in the ancient Roman Senate.[1] Caesar's corpse lies stretched out in a corner of the picture, surrounded by a mosaic floor, as if waiting for the homicide detectives to arrive and to outline it in chalk. In the middle ground, a throng of men brandish daggers, and toward the back, witnesses flee the incident. We note traces of violence—the throne toppled from its dais, a torn-off imperial mantle, streaks of blood—and the signs of sudden disruption—a discarded toga, two fallen chairs, a scroll on the floor. The inanimate objects strewn across the scene are clues to a murder that occurred here before we entered on the scene. We are not eyewitnesses to the criminal act itself, but the ample evidence enables us to reconstruct the course of events in detail, as if we were police officers undertaking a criminal investigation.

Of course, the death of Caesar does not, strictly speaking, constitute a "crime scene." The killing of Caesar is not a "crime" in the modern sense of the word. The historical sources on which Gérôme's painting was based represented the attack on the Roman emperor as the righteous assassination of a tyrant, anticipated by omens and other portents. Plutarch, Suetonius, and Shakespeare treated the assassination as a grand tragic death, willed by fate and attended by prophetic signs: augurs' divinations, portentous inscriptions, weeping horses, dreams, and other paranormal occurrences.[2] Later sources, in particular Voltaire's tragedy *The Death of Caesar* (1735) and Vittorio Alfieri's play *The Second Brutus* (1788), add the psychological complication of making Caesar's slayer, Brutus, his own son.[3] Supernatural omens and complex character bonds turn the story of Caesar's death into something other than a mere "murder scene." What is, therefore, striking about Gérôme's treatment of the subject is the extent to which these factors are absent. The Baltimore painting ignores the fraught relationship between Caesar

and Brutus, and, more importantly, it entirely evacuates any trace of transcendent symbolism from the events.

The story is told retrospectively, literally "after the event." Viewers are invited to imagine what has happened here—not what is happening here right now. Almost all the inanimate clues in the picture point to the past. A throne leans sideways because someone overturned it. A toga lies on a chair because someone crumpled it up and left it there, and this someone hurried away from the scene. The swords with which the emperor was pierced to death are brandished. Gérôme's Caesar is no tragic hero but a lifeless and faceless murder victim, abandoned in a corner of the canvas. The handling of the topic constitutes a radical break with the conventions of history painting. History painting, up to the mid-nineteenth century, had shown the public figures of classical antiquity as heroes—at the very least, as tragic heroes.

In this essay, I want first to convey a sharper sense of what was innovative in Gérôme's approach by comparing his *Death of Caesar* with an earlier, neoclassical painting of the same subject by the Italian Vincenzo Camuccini. The essay also explores the relationship between the kind of pictorial narrative practiced by Gérôme and his contemporaries and crime fiction. In particular, I focus on how the deployment of inanimate objects as clues intimates a modern world emptied of transcendental significance.

Gérôme and Camuccini

Let us look closely at Vincenzo Camuccini's *The Death of Caesar* (fig. 17), painted in Naples from 1793 to 1818 and now in the Capodimonte Gallery in Naples. Both the Camuccini and the Gérôme show the assassination of Julius Caesar at the hands of a group of Republican conspirators within the Roman Senate. Both paintings represent the same ensemble of elements: the throng of assassins, the architecture of the Senate, the dais for Caesar's throne, and the statues, most importantly the statue of Pompey, Caesar's former coregent, who was vanquished by Caesar and at the foot of whose statue Caesar met his own end. But these common elements are deployed to very different effect.

Camuccini's composition places Caesar at its center. Caesar-as-hero forms the focus of the classical pyramidal grouping. He is distinguished by the color of his clothing and by his expansive gesture. He is an active protagonist. Every single figure in Camuccini's painting (with only two exceptions) is focused on Caesar and on the central group.

By contrast, the Caesar in Gérôme's painting is no longer an active protagonist, or even an animate one, nor is he the center of the composition. In fact, Gérôme's composition has no immediately obvious focal center. Attention

83

NINA LÜBBREN

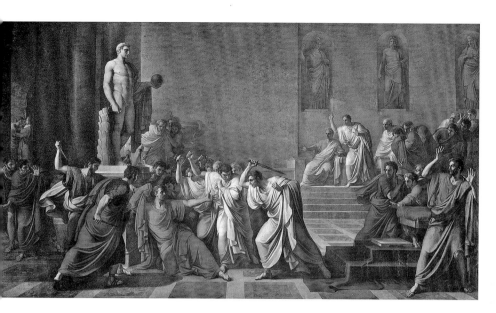

FIGURE 17
Vincenzo Camuccini (Italian, 1771–1844), *The Death of Caesar*, 1793–1818. Oil on canvas, 4 x 7 m
(13 ft. 1 in. x 22 ft. 11½ in.). Naples, Museo e Gallerie Nazonali di Capodimonte

is dispersed across the canvas: corpse, chair, assassins in the background, seated senator at right. Everywhere, people are rushing in different directions and pursuing agendas of their own (not least the senator who remains seated at right). Compare this with Camuccini's observation of the traditional academic unity of action. It is tempting to draw parallels between Gérôme's dispersed foci and what Mikhail Bakhtin has called the heteroglot polyvocality of the modern novel.[4] What is essential to the novel is the way narration weaves in and out of a number of subjectivities and discursive registers. A novel always furnishes us with multiple points of view, and this is exactly what Gérôme's picture achieves.

Of particular note in this context is the figure of the portly senator at right. The senator sits slumped in his chair, one fist on the armrest, his lower lip jutting out, and his gaze directed at the distant archway. This senator is unthinkable within the neoclassical framework of compositional unity operative in Camuccini's *Death of Caesar*. Furthermore, the idiosyncratic figure of the corpulent senator appears in none of the textual sources; he is an original invention, conjured into life for the narrative purposes of this particular painting. The senator forms a kind of mininarrative in its own right, as evidenced by Théophile Gautier's delighted speculations about this character and his personal history:

> Appalled by the murder, and fearing to be compromised, the senators have taken flight, with the exception of one obese old man who has gone to sleep in his curule chair; grown heavy and dull through excessive indulgence in good cheer, he has heard nothing through his profound slumber and has no idea of what has taken place. Imagine the scene![5]

What is interesting about Gautier's response is not so much the fact that he misremembered the wide-awake status of the senator but the way in which he fitted the senator into a clear narrative framework. Gautier imagined himself into a scene that posited the senator as a diegetic stand-in for us, the viewers. The allegedly sleeping senator would, on waking, see the very scene we are now witnessing ourselves.

Gérôme's grim senator is a pictorial instance of novelistic polyvocality; he provides a point of view on the proceedings that is at odds with that of the agitated crowd in the Senate and certainly with the omniscient moral narrator of Camuccini's picture. The plump senator is, to use a narratological term made familiar by Gérard Genette and Mieke Bal, a "focalisor"; he invites us to "see" the scene through his eyes.[6] He is immobile and, just like us, does not participate in the action; at the same time, he provides an emotional temperature that is a counterweight to the excitement and agitation of the men in the middle ground.

The thrust of Gérôme's narrative is analeptic, that is, retrospective. We are asked to construct what *has* happened rather than anticipate what *will* happen. There is, however, one striking example of anticipatory or proleptic narration in the painting, namely the fleeing senators. Whereas Camuccini's *Death of Caesar* is essentially a foreground frieze of actors set against a background of lesser figures and props, Gérôme's painting activates depth in a quasi-baroque fashion. Foreground, middle ground, and background interact dynamically, and the background is not of lesser informational value; on the contrary, it contains crucial clues and protagonists and, above all, it stretches out time into the future. The assassins in the second plane represent the immediate aftermath of what has just "happened" in the foreground, the direct "after." The figures rushing into the distant street, visible through the archway piercing the architectural coulisse, not only represent the slightly more distant future but also the more historically significant and long-term effects of the assassination: the moment when the Roman people will be apprised of the death of their emperor, and when the Republic will (or will not) be restored.

The interaction of retrospective and anticipatory narration in Gérôme's *Death of Caesar* makes for the peculiarly equivocal or, to speak with Bakhtin, "open-ended" treatment of the story. Camuccini's *Death of Caesar* leaves no doubt as to the outcome of events and their moral impact: Caesar will be killed and the onlookers will be horrified, as should we, as viewers before the canvas. Gérôme's painting offers no such certitudes: neither the temporal nor the moral message is at all clear. Some protagonists in his scene will be horrified, others rejoice, yet others brood, while the future will bring political turmoil and uncertainty. Not only is this a modern "novelization" of the story of Caesar, in the sense that there are multiple viewpoints and voices, but it is also a modern liberation of the image from its text-based sources. Though nominally tethered to the literary canon, Gérôme's picture contains enough independent and invented elements to render it a self-contained, autonomous pictorial narrative. Educated viewers will doubtless derive extra pleasure from being able to connect, say, the scroll to Shakespeare and Plutarch, but even those of us who cannot remember our Suetonius will be able to piece together the story of a killing and its implications. In short, we no longer need the canonical text to understand Gérôme in the way that we do in order to derive maximum satisfaction from Camuccini.

The demise of the centrality of the hero carries in its wake the demise of the centrality of the human figure in history painting. For centuries, the human figure had ranked above all else in the academic hierarchy of subjects.[7] Gérôme's *Death of Caesar* transfers the narrative power and eloquence from the human protagonists and disperses it among a diversity of nonhuman, inanimate things.

In doing so, the Baltimore picture transforms these things from secondary accessories into principal narrative agents. Let us take the example of the empty throne to demonstrate this process.

The throne in Camuccini's *Death of Caesar* stands in the right foreground, connected to Caesar-as-hero by the color of its upholstery (echoed in Caesar's toga) and the sightlines pointing toward it from Caesar's hand, foot, and profile. In terms of action, however, it is unclear how Caesar actually got from the chair to his present position or, indeed, if he had ever even reached the throne. What is more important than temporal and causal logic is the symbolic link of the fallen emperor to the empty throne. Gérôme's empty and toppled throne is of a quite different order. This throne has shed any symbolic overtones. It speaks not of the ephemeral nature of power or of the doom of despots but of the material effects of physical violence. It is a prop that points not to Caesar himself but to the past, to the "before" of the scene we witness. Whereas Camuccini's throne asks us to ponder timeless moral verities, Gérôme's throne activates our narrative imaginations in reconstructing the plot of the picture. In short, the Baltimore throne is a throne rich in temporal narrative potential. It is a thoroughly narrativized object, as are, indeed, most of the other inanimate props in Gérôme's painting.

The fundamentally different character of inanimate objects in Camuccini's and Gérôme's pictorial worlds arises directly from the initial choice of the "fruitful moment."[8] Camuccini chose the moment "before," the instant immediately preceding the killing wherein daggers are poised before the fatal blows. Gérôme's version is located in the aftermath of the story's climax, and it is this choice of the "after" that has wide-reaching consequences for the effect of every single element in the composition. Once a story is not presumed to be known and hence predictable, the moment "after" becomes privileged, because it is only the aftermath that allows viewers to reconstruct what has happened. And it is in the service of permitting viewers' reconstructions that inanimate objects take on their prominent narrative roles. Objects become clues, and viewers become detectives.

Detectives, too, must make do without familiar, ready-made stories. To discover "what happened," they must be prepared to read even the most seemingly insignificant clues at the scene of a crime. Gérôme's painting transformed the death of Caesar from a heroic *exemplum virtutis* into an eyewitness report of a crime scene. And it did so at a time when the forensic investigation and reporting of crime was still something of a novelty.

Clues, Detectives, and Storytelling

The mid-nineteenth century saw a general shift in the fact and fiction of forensic investigation, away from a search for truth predicated on the extortion of confessions to one that turned on the correct interpretation of clues.[9] The 1829 memoirs of a former criminal turned police investigator, François Eugène Vidocq, included a small amount of clue detection but revolved mainly around Vidocq's success as a master of disguise in trapping unwitting crooks into betraying their guilt.[10] By the end of the century Hans Gross's immensely influential handbook of the new science of "criminalistics" furnished long and detailed instructions on how to collect and analyze material evidence, ranging from the taking of fingerprints to the correct reading of blood splatters.[11]

Forensic analysis was (and remains) in essence a narrative science whose evolving methodology was mediated to a broad reading public by a new fictional genre. Detective fiction dates from the 1840s, when Edgar Allan Poe published his seminal tales of the amateur sleuth Auguste Dupin.[12] In "The Murders in the Rue Morgue" (1841), Dupin encounters a room strewn with even more clues than contained in Gérôme's *Death of Caesar*:

> The apartment was in the wildest disorder—the furniture broken and thrown about in all directions. There was only one bedstead; and from this the bed had been removed, and thrown into the middle of the floor. On a chair lay a razor, besmeared with blood. On the hearth were two or three long and thick tresses of grey human hair, also dabbled in blood, and seeming to have been pulled out by the roots. On the floor were found four Napoleons, an ear-ring of topaz, three large silver spoons, three smaller of *métal d'Alger*, and two bags, containing nearly four thousand francs in gold [and so forth].[13]

Clue by clue, Dupin proceeds to deduce causal connections from one object to the next, until he has traced the chain of signifying clues to its ultimate cause: "There was no flaw in any link of the chain. I had traced the secret to its ultimate result—and that result was *the nail*."[14] No confession is needed; indeed, none is possible, since this story does not contain a criminal perpetrator. Scenes of this type recur in later nineteenth-century police fiction, for example, in Émile Gaboriau's *L'Affaire Lerouge* (1865), published in Paris six years after Gérôme's *Death of Caesar*:

> They all took in at a glance the scene of the crime.... In the middle of the room was a table covered with a fine linen cloth, white as snow. Upon this was placed a magnificent wineglass of the rarest manufacture, a very

handsome knife, and a plate of the finest porcelain. There was an opened bottle of wine, hardly touched, and another of brandy, from which about five or six small glassfuls had been taken....At the end of the room, near the fireplace, a large cupboard, used for keeping the crockery, was wide open. On the other side of the fireplace, an old secretary with a marble top had been forced, broken, smashed into bits, and rummaged, no doubt, to its inmost recesses. The desk, wrenched away, hung by a single hinge. The drawers had been pulled out and thrown upon the floor.[15]

Not every inanimate object is a clue. Poe's Dupin praises attentive observation but cautions: "The necessary knowledge is that of *what* to observe."[16] The real clues must be distinguished from the red herrings. In Gérôme's picture, too, viewers are asked to pick out the relevant objects; for example, the insignia on the columns do not furnish direct clues to the events. What is remarkable, though, is the extent to which nonnarrating objects have been subordinated to those that tell a story. The Baltimore painting is positively saturated with narrative import.

In detective fiction, false clues are hidden within the text. In a painting, no such concealment is possible. All objects are in plain view, much as Poe's purloined letter is in plain view.[17] In this sense, there is also no retardation, no suspense, no Aristotelian peripeteia and anagnorises, no final "reveal"—none of that accelerated pace of the last chapters of a detective novel wherein the missing pieces of the puzzle are finally supplied. Gérôme's picture is no "puzzle." Instead, we have in the Baltimore painting a translation of temporal effects into spatial organization. Let me elaborate.

A clue is a narrative object that is out of place and discrete yet embedded in a network of causal connections. If we take Gérôme's scroll, discarded on the mosaic floor, we can see that it is an object out of place; it "should" be in the *capsa* (book box) or with the other documents on the footstool at right. It is a discrete object that is not part of any still-lifelike agglomeration of things. The scroll is marked out as discrete by being placed in a spatial void, in what Karen Bork calls a *Leere* or emptiness.[18] Bork describes the void in Gérôme's *Death of Caesar* as a "dynamised emptiness."[19] The area of mosaic floor around the scroll is no mean-ingless blank square footage but an energized space that both separates the scroll from its surroundings and connects it to the other clues in the picture. The void is this immaterial space surrounding solids that sets up a narrative tension among the things in the composition. This allows each individual object to resonate for itself at the same time as it draws invisible narrative threads to the other objects. The lone scroll is narratively important by itself: for example, learned viewers may construe it as the document that contained a warning of the planned assassination

but was never read by Caesar.[20] At the same time, the discarded scroll, toppled throne, and shrouded corpse are triangulated in a nexus of causes and effects.

Nineteenth-century narrative paintings tell prose stories that proceed with the metonymic logic of realism.[21] The objects in Gérôme's *Death of Caesar*— and, for that matter, in his *Duel after the Masquerade* (1857) and *The Christian Martyrs' Last Prayer* (plate 4) or in pictures by contemporaries, such as Karl von Piloty (*Seni before the Corpse of Wallenstein*, 1855)—are indexical clues to causal agency, to metaphors or symbols of extra-diegetic truths. This kind of logical, causal relationship is a profoundly positivist, empirical one. The narratives of *Caesar*, *Seni*, and others are realistic, rational narratives that have no recourse to transcendental or allegorical verities. They are centuries removed from the objects in, for example, Jan van Eyck's *Arnolfini Wedding* (1434), which belong to both this world and to a metaphysical realm.[22] The objects in nineteenth-century pictures are resolutely prosaic and of the here and now.

Siegfried Kracauer described the detective as the paradigmatic modern figure who makes reality rational and eschews metaphysics.[23] The modern world is rational: it is *entzaubert* or disenchanted. The objects in it are no longer symbols or emanations of the divine; they have been emptied of such meanings and, as such, posit an indefinable threat of emptiness and loss. Filling them with narrative meaning, which turns them into clues, takes the sting out of this meaninglessness. Narrative may now paper over the feared and repressed absence of meaning. This requires, of course, that we suppress doubts about our capacity to identify clues and read them correctly. On this score, Gérôme's *Death of Caesar* betrays no trace of uncertainty; the picture evinces a confident faith in the ability of objects to yield narrative meaning.

Notes

1. The painting is traditionally dated to 1867 on account of its exhibition at the Exposition universelle in Paris of that year. The work, however, was actually painted in 1859. A photograph of the painting was published in 1859 by Goupil, and the picture was shown at the Goupil gallery in Paris in 1860 and described in *L'Illustration, journal universel* in the same year. See Gerald M. Ackerman, *Jean-Léon Gérôme: Monographie révisée, catalogue raisonné mis à jour* (Courbevoie, 2000), no. 168, p. 262. I am grateful to Scott Allan for pointing this out.

2. See Gaius Suetonius Tranquillus, *The Twelve Caesars* (1957), trans. Robert Graves (London, 1964); and *Shakespeare's Plutarch: The Lives of Julius Caesar, Brutus, Marcus Antonius, and Coriolanus in the Translation of Sir Thomas North* (1579), ed. T. J. B. Spencer (Harmondsworth, 1964).

3. See Voltaire, *Seven Plays* (1901), trans. William F. Fleming (New York, 1988); and Vittorio Alfieri, *The Tragedies of Vittorio Alfieri: Complete, Including His Posthumous Works*, ed. and trans. Edgar Alfred Bowring, 2 vols. (London, 1876).

4. M. M. Bakhtin, *The Dialogic Imagination: Four Essays*, ed. Michael Holquist, trans. Caryl Emerson and Michael Holquist (Austin, 1981).

5. Théophile Gautier, "À travers les ateliers: Gérôme, Gleyre, Delacroix, Appert, Paul Huet," in *L'Artiste* 4 (May 16, 1858), p. 18. For another interpretation of the portly senator, see Gülru Çakmak, "The Salon of 1859 and *Caesar:* The Limits of Painting," in the present volume. I am grateful to Scott Allan for reminding me of the wide-awake status of this senator!

6. Gérard Genette, *Narrative Discourse: An Essay in Method* (1972), trans. Jane E. Lewin (Ithaca, 1980); and Mieke Bal, *Narratology: Introduction to the Theory of Narrative*, trans. Christine van Boheemen, 2d rev. ed. (Toronto, 1997). The *focalisor* is the narrative agent who *sees*, contrasted with the narrator who *tells*.

7. See André Félibien, "Conférences de l'Académie royale de peinture et de sculpture" (1668), excerpted in *Historienmalerei*, ed. Thomas W. Gaehtgens and Uwe Fleckner (Berlin, 1996), pp. 156–65; and Anthony Ashley Cooper, "A Notion of the Historical Draught of the Tablature of the Judgement of Hercules" (1712), excerpted in *Art in Theory, 1648–1815: An Anthology of Changing Ideas*, ed. Charles Harrison, Paul Wood, and Jason Gaiger (Oxford, 2000), pp. 373–81.

8. Gotthold Ephraim Lessing, "Laokoon; Oder über die Grenzen der Malerei und Poesie. Erster Teil" (1766), in *Werke 1766–1769*, ed. Wilfried Barner, vol. 5, pt. 2 (Frankfurt am Main, 1990). English translation by Edward Allen McCormick extracted in *Art in Theory* (note 7), pp. 477–86. Lessing's "*fruchtbarer*" or "*prägnanter Augenblick*" is sometimes also translated as "pregnant moment."

9. See Daniel Vyleta, "The Cultural History of Crime," in *A Companion to Nineteenth-Century Europe, 1789–1914*, ed. Stefan Berger (Malden, MA, 2006), pp. 355–68; and Carlo Ginzburg, "Morelli, Freud, and Sherlock Holmes: Clues and Scientific Method," in *Popular Fiction: Technology, Ideology, Production, Reading* (1979), ed. Tony Bennett (London, 1990).

10. François Eugène Vidocq, *Memoirs of Vidocq: Master of Crime* (1829), trans. Edwin Gile Rich (Edinburgh, 2003).

11. Hans Gross, *Criminal Investigation: A Practical Handbook for Magistrates, Police Officers, and Lawyers* (1893), trans. John Adam and J. Collyer Adam (London, 1907). The German title was *System der Kriminalistik* (System of criminalistics). Michael Bringmann links forensic reports and diagrams published in the press to contemporary history painting in his "Tod und Verklärung: Zum Dilemma realistischer Historienmalerei am Beispiel von Pilotys 'Seni vor der Leiche Wallensteins,'" in *Historienmalerei in Europa: Paradigmen in Form, Funktion, und Ideologie*, ed. Ekkehard Mai (Mainz, 1990), pp. 229–51.

12. The term *detective fiction* is somewhat anachronistic when applied to the nineteenth century; contemporaries called these kinds of stories "mystery stories," "court stories," or "sensation stories," among others. The genre of detective fiction had not as yet coalesced into the distinct entity it was to become in the 1920s with the "classic" detective novels of Agatha Christie and Dorothy L. Sayers, but the mode certainly existed as a literary type.

13. Edgar Allan Poe, "The Murders in the Rue Morgue" (1841), in *Selected Tales*, ed. David Van Leer (Oxford, 1998), p. 99.

14. Ibid., p. 111.

15. Émile Gaboriau, *The Lerouge Case* (Teddington, UK, 2006), p. 7. (The translator is not given, but the text is based on the first English-language translation of 1873). The original was serialized as a "*roman judiciaire*" in *Le Soleil* in 1865 and published as *L'Affaire Lerouge* in 1866.

16. Poe (note 13), p. 93.

17. Edgar Allan Poe, "The Purloined Letter" (1844), in Poe (note 13), pp. 262–23.

18. Karen Bork, *Gemalte Leere: Furcht und Faszination im französischen Historienbild des 19. Jahrhunderts* (Frankfurt am Main, 2000).

19. Ibid., chapter 8, "Dynamisierte Leere. Jean-Léon Gérôme: 'La mort de César.' Die Fassungen von 1859 und 1867," pp. 105–26.

NINA LÜBBREN

20. As mentioned by Suetonius, Plutarch, and Shakespeare. See also the contribution by Gülru Çakmak in this volume.

21. On metonymy and realism, see Roman Jakobson, "Two Aspects of Language and Two Types of Aphasic Disturbances" (1956), in *Language in Literature*, ed. Krystyna Pomorska and Stephen Rudy (Cambridge, MA, 1987), pp. 95–114, 511–12 (esp. p. 111).

22. See Erwin Panofsky's famous interpretation in his "Jan van Eyck's *Arnolfini* Portrait," *Burlington Magazine* 64 (1934), pp. 117–27.

23. Siegfried Kracauer, "Der Detektiv-Roman: Ein philosophischer Traktat" (1923–25), in *Schriften* (Frankfurt am Main, 1971), vol. 1: pp. 103–204.

The Damaged Mirror
Gérôme's Narrative Technique and the Fractures of French History

CLAUDINE MITCHELL

In the early 1860s Jean-Léon Gérôme had the reputation of being a literary artist who showed talent in transposing preexisting narratives into the visual medium and inventing his own pictorial narratives. In 1868 it was also said that Gérôme was taking new directions, as he, who had earlier applied his considerable knowledge to re-create events of the distant classical past, now turned his attention to the subject of French contemporary history. His advocates promised that Gérôme would come to conceptualize a thoroughly modern painting.

The notion of modern history painting involved the awareness that artistic audiences were expanding and that the painter must render the subject matter intelligible and interesting. Above all, the concept of "modern" rested with a belief in objectivity. The painter would return to primary sources and seek absolute veracity of all details. He would abstain from melodrama or pomposity. For Théophile Gautier, the painter would withdraw from the painting to leave the sheer spectacle to reveal itself. This project consisted in placing the beholder as eyewitness.

The temporal precision of the original title *December 7, 1815, 9 o'clock in the Morning* (plate 7)—for the painting also known as *The Execution of Marshal Ney*—indicates Gérôme's commitment to adopt the modality of reportage. To refer to a historical event by its date also invited reflections on issues

concerning knowledge and memory. What could it imply for an individual or for society generally should that date no longer signify? Alternatively, was the event considered so significant as to be preserved in collective memory by the mere use of a date?

This essay is concerned with the relation between aesthetic conceptions and history.[1] It explores the modalities that made nineteenth-century commentators ascertain that the depicted scene was an accurate representation of the historical event or contest its credibility. The essay further investigates how the debate concerning aesthetics and politics, provoked by Gérôme's painting of the execution of Marshal Ney, affected the artist's reputation within French culture.

Historical Narrative, Verism, and Veracity

December 7, 1815 was first exhibited at the Paris Salon of 1868. Salon reviews generally contained a narrative description of the work by which critics purported to explain its significance to the general public. Their texts, published in the daily press and in specialist reviews, constitute a rich corpus by which to analyze narrativity in painting.[2] To explore the intellectual operations used to validate the credibility of the painting, I shall consider the review of Théophile Gautier, the eminent writer and art critic who was close to Gérôme. Gautier defined the depicted moment as follows:

> As he fell, the Marshal seemed to have gathered solitude, rejection, and terror around him. In the shock and catharsis of *murder*, everybody has fled the corpse that was alive only a few moments before and that the bullets of so many battlefields had spared. It is believed that the corpse of the Marshal lay in solitude *ten to fifteen minutes*. As if no one dared to come near. *This is the moment* that M. Gérôme has so marvelously expressed.…*The artist has withdrawn to allow the scene alone to appear* [italics added].[3]

The temporal precision of the depicted moment seems essential for the critic to believe in the authenticity of the scene. The use of the present tense in the core of Gautier's description makes this notion apparent, as if the critic were witnessing an event in its moment of occurrence. To make sense of the depicted moment, the critic must refer to the event preceding it. Several factual traces in the painting signify the anterior event. The circular white marks on the wall are understood to result from the volley of the firing squad, and in the foreground cartridges are observed to be still smoking. The attentive beholder may further notice the two footprints near the wall indicating where Ney had stood when facing the firing squad. The temporal scale of the painting accordingly expands before and after

the depicted moment to account for the execution of Marshal Ney. The word *murder*, which Gautier uses to refer to the execution of Marshal Ney, appropriately characterizes the mise-en-scène of Gérôme's painting. This term could be understood in two ways. It could refer to the event of a corpse lying in a street (Gérôme's narrative technique). It could also encapsulate an ethical judgment concerning the historical event. The application of the terminology of criminality to the death of Marshal Ney had a well-known history, which allowed the overlap between narrative, ethics, and politics.

Michel Ney, having rejoined Napoléon during the emperor's Hundred Days and acted as his second-in-command at the Battle of Waterloo, was arrested on the charge of treason when the Bourbon branch of the French monarchy was restored in July 1815. After a brief trial, conducted by the overwhelmingly ultraroyalist Upper Chamber, Ney was sentenced to death. The Bonapartists called the verdict a "crime" and circulated a print bearing the caption "L'assassinat juridique [legalized murder] du Maréchal Ney."[4] More generally, the terminology of murder crystallized the disturbing idea that a conspiracy had taken place between the French monarchy and a coalition of European monarchies. As did other nineteenth-century historians and commentators critical of the Restoration, Alphonse de Lamartine, the romantic poet and politician, appropriated this language; in his *Histoire de la restauration* he argued that the condemnation of Marshal Ney to death rather than to deportation was "the vengeance" of the ultraroyalists and called the execution a "crime."[5]

When designing the painting, Gérôme considered a number of pieces of evidence that contradicted the notion of a state military execution. It was known that Ney wore civilian clothes and that, following military regulations, the corpse had remained exposed for a quarter of an hour.[6] To prevent public protests the execution site was secretly changed from Grenelle, where military executions traditionally took place, to the boulevard leading to the Paris Observatory.[7] Gérôme worked on all these elements to design his painting in the manner of a street crime. The image of a corpse lying on the ground formed part of the iconography of murder, and the precedents that readily came to mind in 1868 were the version of Gérôme's *Death of Caesar* (plate 6) exhibited in 1867 and Paul Delaroche's *Assassination of the Duc de Guise* (1834).[8]

In Gérôme's painting the credibility of the street-crime scenario rests in large measure with the fundamental antinomy that exists between the character and the depicted space, between the expensive stylishness with which the character is dressed and the attributes of the street landscape. The stretch of wall that expands diagonally across the composition marks a border zone. Beyond it, the dome signifies the sphere of the French capital as the domain of culture

and perhaps that of human aspirations too. The space in which the corpse lies is marked by the pervasive imagery of sterility and decay, both in nature and in culture. The border zone itself, with the imagery of scrawled-out inscriptions and peeling plaster, its former whiteness turned gray, connotes the decaying state of the sphere of culture. Yet the motif of the streetlamp on the left connects that space to that of the city beyond. To the audience of 1868, who lived in the newly asphalted streets of Baron Haussmann's Paris, the depicted space did not solely register as of the past. It called to mind the Paris *barrière* (the outskirts), where urbanization had not yet taken place and which conveyed its own mythologies—via a fast growing literature and iconography—of lowlife, alcoholism, and criminality.[9]

To accept Gérôme's painting as a true representation of the death of Marshal Ney demanded a willingness to resolve this antinomy. And there was a further complex issue to negotiate. Marshal Ney, the hero of the battlefields, had been commemorated by François Rude in a statue unveiled with great ceremony in 1853 at the beginning of the Second Empire. Yet art had not sufficed to dispel the doubts conveyed by the remembrance of Ney. His shifts of political allegiances posed problems. Elevated to the rank of marshal by Napoléon in 1804, Ney had sworn allegiance to the king when the Bourbons were first restored to power in June 1814. Dispatched to Lyon to forestall the former emperor's attempt to regain power in March 1815, Ney nevertheless sided again with Napoléon. A motif of Gérôme's painting recalls this issue. Observe the political inscriptions featured on the wall. Both begin with the expression *Vive* (Long live). The first, containing the term *Empereur* (Emperor), is crossed out; the volleys of the firing squad have erased the main word of the slogan intended to replace it, most probably *Roi* (King).[10]

The core of Gautier's review of this painting consists in a long description as he scans the pictorial space starting with the wall, moves to the upper left, and finally lingers on the costume of Ney:

> A dirty stretch of wall of mean plaster occupies diagonally almost the entire length of the painting. It is scarred with political inscriptions that contradict and erase one another and a constellation of white stars picked out by a hail of bullets. It is still dark and the gray morning of a December day struggles to unwrap itself from *the fog of the night*. At the angle of the wall a swaying streetlamp sheds its dying yellow light and a line of soldiers, hasting away as in flight, can be glimpsed *in shadow*.
>
> In the foreground, a black cutout shape lying on the ground attracts the beholder's eye, troubled by this sinister solitude. It is Marshal Ney who

has fallen forward, as do all those shot through the heart. The face is slightly turned on the side; a long frock coat covers the body, revealing a silk stocking and patent leather shoes, for to meet death the *bravest of the brave* had dressed elegantly: that admirable stylishness of heroes!

His hat in the Bolivar style has rolled a few steps away from him. This hat, in the fashion of that age, conveys as tragic an effect as the shoe in the foreground of Meissonier's *Barricade*. . . . It dates the scene and even the bourgeois way of life of the era when this somber drama occurred. On the ground, amongst the mud and a few blades of grass that grow near the old wall, cartridges still smoke. . . .

We feel chilled in front of the painting as if we were facing reality . . . *the distressing black shape forever commands our attention* [italics added].[11]

Gautier does not question whether Gérôme's representation fulfills the code of the heroic; he ascertains the identity of the hero by quoting the popular phrase "the bravest of the brave."[12] In Gautier's text each pictorial fact is attributed meaning according to two primary modalities. The first consists in validating the veracity of Gérôme's depiction by referring to diverse bodies of knowledge. This mode of interpreting painting corresponds to what Roland Barthes in his analysis of the processes of reading called "cultural codes."[13] The situation in which Gérôme has depicted his character is authenticated in this manner. Gautier draws on medical knowledge to explain the posture and on historical sources to account for the isolation of the corpse. To authenticate the costume of Gérôme's character, Gautier draws on a narrative type, the aristocrat-warrior who confronts death with panache; such a literary figure is encountered in the novels of Alexandre Dumas and in the novel *Capitaine Fracasse* by Gautier.

The second modality involves what Barthes called the texture of "semes," flickers of meaning that each individual act of reading picks up and interconnects in a system of correspondences and echoes. In painting, this involves concomitantly the code Barthes called "symbolic," which defines the main articulations of meaning.[14] Pictorial facts are attributed secondary layers of meanings in connection with other pictorial facts. In Gautier's reading, the attributes of sordidness and emptiness are connected to the qualities of darkness to articulate the theme of death. The gray paint registered as "fog" connotes fear and danger: fog conceals threats; fog with "dirt" carries disease. On the upper left, the light registered as "dying" leads to the figures plunging into deep shade. The theme culminates in the subsequent perception of the corpse of Marshal Ney as "a black cutout shape." The composition of the painting, with its central void and diagonal axis leading from right to upper left and back to lower right, endows that shape with a further

dimension. In holding the viewer's gaze, the black shape becomes the symbol of a haunting memory.[15]

In Gautier's text the depicted event remains suspended in time. Gautier achieves this effect by avoiding any reference that would link the event of the execution to the historical circumstances that have brought it about. This process will become clearer by contrasting Gautier's comments to those of other critics. A review published in *L'Illustration* encapsulates the depicted moment in the expression "the crime has just been committed" and specifies its origin in "the somber works of the Upper Chamber." It further defines the historical temporal scale: "these reactionary political times that we wished could be erased from our History."[16] In the review the word *crime* unfolds a tripartite narrative schema: The Bourbon regime is evil — they killed/murdered a hero — the moral agent experiences moral doubts.[17] This schema reaffirmed the Bonapartist viewpoint on French history and demonstrated how Gérôme's painting could be seen to respect it. In Gautier's reading, the narrative schema remains in two parts: Evil has been committed [a hero has been killed] — the moral agent experiences mental distress. Significantly Gautier ends the description by asking whether the emotions aroused in the beholder are generated by the subject matter of the death of Marshal Ney or rather by "the art with which the artist has expressed it."[18] Perhaps it is a purely artistic effect, concludes Gautier, thinking this made painting even closer to the arts of language.

In Gautier's interpretation, the significance of the painting is not rooted in the tragic fate of the historical figure but in the ways in which the depicted space becomes the picture of a mental climate. Gautier advocates here an aesthetic that illustrates important parallels with that at work in the poetry of Charles Baudelaire, where the unaccountable and pervasive presence of evil generates a mental landscape.[19] For Gautier, this formed the core of modernity in Gérôme's painting.

Shall We Forget the Barricades?

In his brief memoir Gérôme recalled that the Salon of 1868 marked a difficult stage in his career. He explained how Alfred Emilien Nieuwerkerke, superintendant of fine arts, following a request from Marshal Ney's descendants, had asked the artist to withdraw the painting. Gérôme did not consent; as the Emperor Napoléon III had said nothing unfavorable when visiting the Salon before its opening, the administration allowed the painting to remain on view.[20] The critical reception was nonetheless violently split.

Supportive critics formed the minority; Gautier's arguments were reversed, and the term *literary* was made to convey negative values. One set of

criticisms concerned the specificity of the painting. Gérôme was blamed for dis-solving the artistic tradition because he brought to his practice modalities con-sidered to operate specifically in language. For example, it was argued that his narrative technique, which obliged the beholder to search for clues scattered in the pictorial space to make sense of the depicted moment, belonged to the genre of detective stories. Another set of criticisms concerned the commercialization of art, which Gérôme was considered to promote because he provided the general public with a deceptively easy access to painting via subject matter. This only served to mask the prevailing ignorance of pictorial traditions and encouraged their dissolution.[21]

The Salon of 1868 marked a long-lasting fracture between Gérôme and most French art critics.[22] Such cultural tensions, I believe, represent a deeply complex issue concerning conflicting conceptions of history—the fractures of French history. Gérôme was blamed for bringing politics into the sphere of art. Some considered the artist to have projected a political viewpoint, as when the critic of the Bonapartist paper *La Patrie*, Achille de Thermines, remarked angrily, "This is an exaggerated focus on the subject matter, this is politics."[23] More gener-ally, Gérôme was thought to provoke a political debate through his very narrative method.[24] Even Gautier felt it necessary to voice an opinion. While confirming the absolute freedom of the artist, he added the proviso: "We must, however, say that in a general way it would be better to abstain from these distressing scenes, these bleeding wounds of history that unnecessarily recall painful memories."[25]

The critics of the Salon of 1868 had to decide whether or not Gérôme's portrayal of Marshal Ney, dressed in bourgeois costume, the body prone, the head in the mud, amounted to demythologizing the Napoleonic hero. The key seemed to rest with the political inscriptions on the wall. Did they refer accusa-torily to Ney's shifts of political allegiances, as Gérôme later admitted?[26] That debate was to take the reflection further as it revealed that French history could not be reduced to the swing of power in party politics or the conflict between Bonapartist, royalist, and Republican forces that had seemed to mark the chrono-logical sequencing of history.

Three different arguments are deployed in the adverse reviews of 1868. One proposes an alternative version of the execution of Marshal Ney in the form of a short narrative that claims to be truer. The reviewer Ferdinand de Lasteyrie, who will be discussed later, adopts this strategy. Another approach negates the veracity of Gérôme's painting by exploiting the antinomy between the well-dressed character represented in the painting and the street landscape. In the form of a parody, the depicted scene is contextualized in a specific geographic space (the Paris *barrière*), and the situation that has befallen Gérôme's character

is accounted for as a narrative from the margins of the city that tells of theft and murder or a scene of debauchery. For example, writing in the Republican newspaper, *La Presse*, Marius Chaumelin contends that Gérôme has designed a popular form of recreational activity, a visual riddle (*rébus illustré; charade mimée*). Its first component would be a man lying in the street, and the whole amounts to a scene from the *barrière*. Gérôme's Ney would be accordingly identified as "a hat-maker in his Sunday-best who had gone to spend the night in a gambling-den of the *barrière*."[27] This mode sets the measure of the outrage Gérôme's painting constituted in a twofold process of degradation, one concerning the historical figure Gérôme claims to represent, the other concerning the status of the painting.

The third critical mode disrupts the contemplation of Gérôme's painting by recalling the street combats that occurred during the civil wars and revolutionary situations in France in the period 1830–52. This strategy aims to expose the difficulty in identifying a specific depicted moment, as when the critic A. de Belloy remarked: "We have seen so many people killed in the streets since December 7, 1815."[28]

Significantly, references to the violence of history also occurred in the reviews of critics who praised Gérôme's painting. These were written by two Republican intellectuals, Henry Fouquier and Théophile Thoré, who wished to question the ethics of war and the advent of military dictatorships, the latter commenting: "So many people have been shot in other circumstances, and yet the ethics of politics was not in the least concerned."[29]

The perplexing degree of hostility in art-critical discourse resonates in the caricature by Henri Oulevay (fig. 18). Gérôme is positioned where Ney had stood; the firing squad carries the quills of the art critics while the officer—the guardian of the traditions of art—holds a brush. In the foreground a broken pipe replaces the spent cartridges, a pun on the colloquial expression *casser sa pipe* (to die). On the wall, appears the name *Manet*, tightening the paradox of Gérôme's predicament as an eminent professor at the Beaux-Arts, who is as viciously attacked as the outsider artist accused of not knowing how to draw.

Oulevay's caricature, with its interpretation of the graffiti in Gérôme's painting, indicates some pertinent paths of inquiry. On the left, under the name of Manet, is observed a figure that connects Gérôme's work with a painting that likewise displays an infamous hat: Édouard Manet's *Absinth Drinker* (1858–59), the disturbing portrait of a ragman.[30] The caricature refers to our second critical method; it tells of the *barrière*. On the right, the political inscription is replaced by the first three letters of the word *anarchie* (anarchy). The word disappears under a shadow suggestive of a helmet, evoking the threat of war. The targets of the caricature are those who fear the disintegration of a social order that confers on them

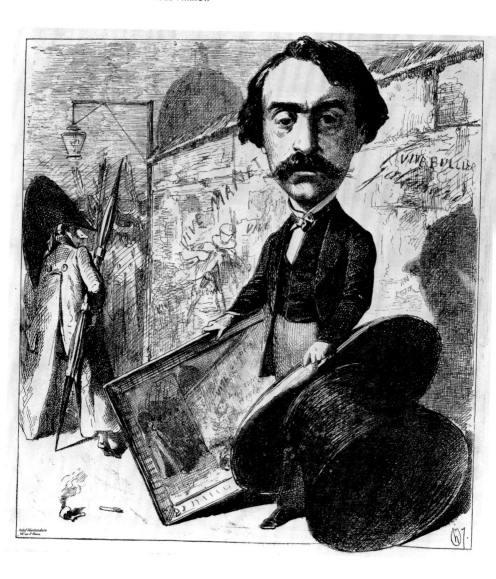

FIGURE 18
Henri Oulevay (French, act. nineteenth century), ***Caricature of Jean-Léon Gérôme.*** From "Le Salon repeint et mis à neuf," *Le Monde pour rire,* no. 3 (May 30, 1868), p. 4. Paris, Bibliothèque nationale de France

the privileges of ownership and status, the social class to which the well-dressed man in Gérôme's painting appears to belong. What the caricaturist has extracted among the discourse of art critics is the idea of a social space where class conflict becomes violently reactivated. The issue of the disintegration of history painting and the idea of the disintegration of the social order are seen as related.

With these sets of reflections in mind, let us consider how the alternative narratives offered by critics aimed to redefine the codes expected to operate in history painting. These critics approached painting with the notion that there was a long-established tradition that made the human body the main signifier. Facial expressions and bodily gestures indicated states of mind from which the identity of characters as well as the ways in which characters acted could be inferred or predicted. In his criticism of Gérôme, de Lasteyrie, writing in *L'Opinion nationale*, proposed the following account of the execution of Ney: "We readily visualize the heroic soldier, standing with his forehead raised. He gazes straight ahead to confront death, death that a dozen unhappy folk condemned to the role of executioners are to bring about, their hands shaking with emotion."[31]

There are two components in this narrative: Ney and the soldiers. The means of representation, the ways in which bodily gestures and facial expressions are thought to signify, are rooted in layers of received ideas concerning human behavior. The erect position, considered to distinguish humankind from animals, signifies human dignity when it is combined with a "raised" forehead. And with a steady gaze, this attitude suggests that the person about to be executed is in control of his own death. Reflecting the belief that the essential character of the person is revealed in the last moments of his life, the moments evoked by de Lasteyrie are considered to represent the real Ney.[32]

In the alternative narratives presented by the art critics, the portrayal of the common soldiers is given as much importance as that of Ney. The novelist Eugénie Chervet argues that the core of the drama lies in the relation between the soldiers and Ney.[33] Jules Castagnary, writing in the Republican newspaper *Le Siècle*, equally requires that the soldiers should look "desperate" as "they shouldered their rifles to shoot to death the person who had so often led them to victory."[34] The complex representation of the soldiers interacts with a twofold hierarchical system. There are the relations of power and bondage within the military hierarchy. Then there are the relations between social classes, an issue further complicated in this case by the fact that Marshal Ney was of modest origins, and the expensive costume of Gérôme's Ney comments on the new structures of wealth and power.[35]

The model against which Gérôme's painting was devalued in 1868 had been conceptualized in the aftermath of the Revolution of 1848. The government

of the Second Republic had undertaken to rehabilitate the memory of Marshal Ney with a memorial, under the aegis of Lamartine, featuring the execution.[36] In describing, on the one hand, Ney taking total command over his own death and, on the other, the admiration and love the soldiers felt for the former leader of the French army, Lamartine's verbal narrative of the execution of Marshal Ney gave form to the art of reconciliation respectful of social hierarchy.[37] Ney's shifting political allegiances, as much as his execution, crystallized the dilemmas and tragedy of civil war. Whether Ney's conduct had been motivated by a concern to prevent civil war in France remained a controversial enigma.[38] The codes of representation expressed in the depiction of the heroic death of Marshal Ney performed two clearly understood functions concerning atonement (the rehabilitation of Marshal Ney) and reconciliation (the relations of power and deference within the social hierarchy).

In his book *The Absolute Bourgeois*, T. J. Clark argued that the attempt to give an artistic form to the revolutionary situation of 1848 displaced the bourgeois.[39] Gérôme's painting plunged deeper into that fear of dissolution. In the eyes of his contemporaries, the mise-en-scène distressingly revealed the "execution of a bourgeois."[40] Furthermore, beyond the myths of the city margins, the inscriptions on the wall called attention to the reality of working-class politics.[41]

There were, of course, areas of thought left hovering in Gautier's eulogy of Gérôme's painting, ideas not entirely suppressed nor fully stated. The writer let transpire his doubts by bringing Gérôme's execution of Marshal Ney in parallel with *The Barricade* (1849) by Meissonier, a motif in one painting calling to mind a motif in the other.[42] In a poem written just after the Revolution of 1830, Gautier had reduced the barricades to a motif. History had proved so utterly destructive of ideals, the poem stated, that only the belief in art remained an absolute.[43] In the historical conjuncture of 1868, the confident determination to reject history no longer seemed tenable. The mental landscape of gloom conveyed by Gérôme's painting was a fitting symbol for the weight of memory and the anxiety of tomorrow.

Notes

1. Research for this essay is largely drawn from Claudine Mitchell, "The Problem of the Representation of Time in French Painting, 1860–75, with Particular Reference to History Painting" (PhD diss., University of Leeds, 1985).

2. For a list of critics at work in Paris, see Christopher Parsons and Martha Ward, *A Bibliography of Salon Criticism in Second Empire Paris* (Cambridge, 1986), pp. 198–217. For reviews of Gérôme in 1868, see Mitchell (note 1), pp. 80–81.

3. Théophile Gautier, "Le Salon de 1868," *Le Moniteur universel: Journal officiel de l'empire français*, no. 123 (May 2, 1868), p. 585. Unless otherwise noted, all translations are my own.

4. This print, designed in the manner of a pietà, was first published in England, then

reappeared in France in 1830. See Anne-Marie Rosset, *Collection de Vinck*, vol. 4, *La Restauration et les cent-jours* (Paris, 1938), in particular pp. 240–43 and the prints catalogued as nos. 9697 and 9698. Critic Ferdinand de Lasteyrie discussed this print in his review of Gérôme in "Salon de 1868," *L'Opinion nationale*, June 8, 1868, n.p.

5. Alphonse de Lamartine, *Histoire de la restauration*, 8 vols. (Paris, 1851–52). Republished in 1862, Lamartine's book then constituted the main historical source on the subject (see vol. 4, bk. 34: pp. 380–430). For the first English translation, see Alphonse de Lamartine, *History of the Restoration*, 4 vols. (London, 1851–53), 3, bk. 34: pp. 287–332.

6. It was well understood that Marshal Ney did not wear his military uniform so as not to undergo the rituals of military degradation.

7. This information is recorded by Lamartine (note 5); Gautier (note 3), p. 585, and other critics explained the details of Ney's clothing and posture; Charles Blanc (*Le Temps*, May 19, 1868, n.p.) discussed the site.

8. For an enlightening discussion of the relation between Gérôme, Paul Delaroche, and Honoré Daumier, see Stephen Bann, *Paul Delaroche: History Painted* (London, 1997), pp. 190–200.

9. Etymologically, the old-town gateway where tax on consumer goods had to be paid, the *barrière* came to signify by extension the city margins.

10. In an interview published after the artist's death, Gérôme questioned Ney's conduct "in his later days" and added that "it is unjust martyrdom, for it was secured by the capitulations, which has rehabilitated him" (Jean-Léon Gérôme, "Notes et fragments de J. L. Gérôme," ed. Frédéric Masson, *Les Arts* 26 [February 1904], pp. 25–26).

11. Gautier (note 3), p. 585.

12. The expression "the bravest of the brave" was believed to have been coined by Napoléon to qualify the extraordinary valor of Ney. For the heroic literature on Ney, see, for instance, Philippe-Paul, comte de Ségur, *La Campagne de Russie* (1812), popularized in the Nelson series edition, first published in 1824.

13. Roland Barthes, *S/Z* (Paris, 1970), pp. 26–27.

14. Ibid., pp. 25–29.

15. Wolfgang Kemp discusses the compositional structure and the "projective activity of the beholder" in his essay "Death at Work: A Case Study on Constitutive Blanks in Nineteenth-Century Painting," *Representations* 10 (Spring 1985), p. 114. Like Gautier, Kemp attributes a symbolic function to Gérôme's composition, "as the solitude of death, as dishonouring indifference" (p. 115).

16. S. T. "7 Décembre 1815. Tableau de M. Gérôme (Salon de 1868)," *L'Illustration, journal universel* 51, no. 1314 (May 2, 1868), p. 283.

17. For a discussion of the notion of pictorial narrative and historical temporal scale, see Claudine Mitchell, "Narrative and the Purity of History," in *Kunsthistorisches Jahrbuch Graz*, vols. 29–30, *Erzählte Zeit und Gedächtnis: Narrative Strukturen und das Problem der Sinnstiftung im Denkmal*, ed. Götz Pochat and Brigitte Wagner (Graz, 2005), pp. 101–10.

18. Gautier (note 3), p. 585.

19. Baudelaire dedicated *Flowers of Evil* (1857) to Gautier (Charles Baudelaire, *Les Fleurs du mal*, ed. Jacques Dupont [Paris, 1991], pp. 54, 259).

20. Gérôme (note 10), pp. 25–26. See also Charles Moreau-Vauthier, *Gérôme, peintre et sculpteur, l'homme et l'artiste, d'après sa correspondance, ses notes, les souvenirs de ses élèves et de ses amis* (Paris, 1906), pp. 253–54. For Gérôme admirers, his refusal to consent exemplified the artist's integrity and commitment to truth.

21. In 1868 critics discussed these issues, across the divides of political positions. Henry Fouquier in *L'Avenir national* (May 3, 1868, n.p.) argued that the word *literary* must be preserved as a positive value judgment.

22. The situation was to remain in France until Gerald M. Ackerman's research encouraged the reappraisal of Gérôme's reputation. See Claudine Mitchell, "Belly Dancing into History," *Art History* 10, no. 4 (December 1987), pp. 517–26.

23. Achille de Thermines, "Salon de 1868," *La Patrie*, June 3, 1868, n.p. De Thermines's review exemplifies the opposition of the Bonapartist circle recalled by Gérôme (Moreau-Vauthier [note 20], p. 253).

24. Charles Blanc, "Salon de 1868," *Le Temps*, May 19, 1868, n.p.

25. Gautier (note 3), p. 585.

26. See Gérôme (note 10).

27. Marius Chaumelin, *La Presse*, June 2, 1868, reprinted in Marius Chaumelin, *L'Art contemporain* (Paris, 1873), pp. 114–17. Chaumelin's account of Gérôme's charade runs more than one thousand words. This strategy is also pursued in the reviews of Louis Auvray, A. de Belloy, Firmin Boissin, Jules Castagnary, Charles Clement, Claudius Lavergne, and Eugénie Chervet (alias Raoul de la Navery/Eugène Palma) (see Parsons and Ward [note 2]).

28. A. de Belloy, *Le Correspondant* 38 (June 10, 1868), p. 897. *Le Correspondant* was a Catholic review.

29. Théophile Thoré, *Salons de W. Bürger* (Paris, 1869), p. 468. In exile for his political convictions, Thoré wrote under the name Thoré-Bürger in *L'Independence belge*, a newspaper generally critical of the Second Empire. His critical reviews were republished in book form in 1869, the year of his death, with the review of Gérôme featured on pp. 466–68. The young opposition journalist Henry Fouquier (note 21) witnessed Napoléon III's army crush the troops of Garibaldi in 1867. Fouquier later served in the parliament of the Third Republic. Fouquier and Thoré saw in Gérôme's painting the demythologizing of the warrior-hero.

30. *The Absinth Drinker* was rejected at the Salon of 1859; the figure reappeared in *The Old Musician* (1862). Manet's *Philosopher* (1865–66), published in *Journal amusant*, June 29, 1867, n.p., also featured a tall hat. For the relation between Gérôme's painting and Manet's *The Execution of Maximilian*, see Mitchell (note 1), pp. 306–436. See also John House, "Manet's Maximilian: History Painting, Censorship, and Ambiguity," in Juliet Wilson-Bareau, *Manet, The Execution of Maximilian: Painting, Politics, and Censorship*, exh. cat. (London, 1992), pp. 87–111.

31. Ferdinand de Lasteyrie (note 4).

32. "At the supreme hour, the soldier redeemed the citizen" (Claudius Lavergne in *L'Univers*, June 5, 1868, n.p.).

33. E. Palma (Eugénie Chervet), "Le Salon de 1868," *Revue de Paris*, n.s. 11 (June 1, 1868), p. 414, reprinted in Raoul de Navery (Eugénie Chervet), *Le Salon de 1868* (Paris, 1868), p. 21.

34. Jules-Antoine Castagnary, *Salons, 1857–1870*, 2 vols. (Paris, 1892), 1: pp. 261–62; first published in *Le Siècle*. For the relation between Castagnary's position and Third Republic historiography, see Mitchell (note 17), pp. 107–8.

35. Gérôme's "bourgeois" character consolidated the idea of Ney's social ascension and was seen to encapsulate the new social structures of meritocracy or financial success in nineteenth-century France, as when de Lasteyrie categorized Gérôme's Ney as a *propriétaire* (Lasteyrie [note 31]). On this subject, see Louis Bergeron, "Les Classes sociales," chap. 6, in *L'Épisode napoléonien, 1799–1815*, 2 vols. (Paris, 1972), 1: pp. 130–77 and, for Ney in particular, 1: pp. 133–37. Some critics saw Ney's execution as returning him to the lower ranks of the social hierarchy, as when the legitimist paper *La Gazette de France* described Gérôme's Ney as reduced to the rank of "un simple caporal" (Gaston de Varennes, *La Gazette de France*, May 5, 1868, n.p.).

36. Louis de Fourcaud, *François Rude Sculpteur: Ses oeuvres et son temps (1784–1855)* (Paris, 1904), pp. 368–89; for the role of Lamartine in 1848, see pp. 371–73. For Gérôme's contribution to the art program of the Second Republic, see Gerald M. Ackerman, *The Life and Work of*

Jean-Léon Gérôme, with a Catalogue Raisonné (London and New York, 1986), nos. 23–24 (*The Republic* [1848], pp. 188–89).

37. "'Soldiers!' said he, 'aim right at the heart!'" (Lamartine [note 5, *Histoire de la restauration*], 3, bk. 34: p. 330). Lamartine's description became the official version of the event, even though General Rochechouart, who supervised the execution, denied Ney spoke these words (Louis Rochechouart, *Souvenirs sur la revolution, l'empire, et la restauration* [Paris, 1889], p. 442).

38. For example, Louis de Fourcaud, the eminent critic of the 1880s and 1890s, raised the issue (de Fourcaud [note 36], p. 386).

39. T. J. Clark, *The Absolute Bourgeois: Artists and Politics in France, 1848–1851* (London, 1973); see the chapter "The Picture of the Barricade," pp. 9–30.

40. The expression refers to the statement "c'est un bourgeois qu'on va passer par les armes" by Charles Blanc (see note 24). For an analysis of the diverse meanings attached to the term *bourgeois* in the art reviews of 1868, see Mitchell (note 1), pp. 55–59.

41. For historical discussions that informed this chapter, see Alfred Thomas, *L'Histoire socialiste: Le Second Empire* (Paris, 1906); Alain Dalotel, Alain Faure, and Jean-Claude Freiermuth, *Aux Origines de la commune: Le Movement des réunions publiques à Paris* (Paris, 1980); Mitchell (note 1), pp. 60–71, 310–36.

42. In his book, *Art, War, and Revolution in France, 1870–1871: Myth, Reportage, and Reality* (New Haven, 2000), John Milner significantly relates the precedent of Meissonier to the iconography developed in the aftermath of the Franco-Prussian War.

43. Théophile Gautier, "Avec ce siècle infâme il est temps que l'on rompe," sonnet 7, in *Poésies complètes*, vol. 1, *Poésies, 1830–1832* (Paris, 1884), p. 107. The barricades are evoked in line 10 as "les pavés mouvants."

Gérôme and Ethnographic Realism at the Salon of 1857

PETER BENSON MILLER

One of the many roles that Gérôme has been conscripted to play as the foil in the modernist narrative remains perhaps his most infamous incarnation, that of a so-called Orientalist painter. His reputation as a purveyor of an inauthentic, imaginary Orient began to take shape in the nineteenth century. Radical realist critics, chief among them Jules-Antoine Castagnary, denigrated Gérôme's Oriental genre scenes as *retardataire* escapist fantasies. Still alert to Castagnary's scorn, art historians remain offended by Gérôme's stalwart opposition to the realist and Impressionist painters whose struggle in the 1860s against the rigid academic system remains one of the founding sagas of modern art. As a result, Gérôme is understood as the exponent of an obsolete tradition diametrically opposed to and eclipsed by avant-garde realist practice. This, together with Castagnary's dismissal of the Orient as a viable source of the modern, which, as we shall see, was out of sync with the opinions of many contemporary critics, has skewed the retelling of Gérôme's career and the brief heyday of ethnographic realism.

Instead of a frank engagement with the here and now, Gérôme, among others, according to Castagnary, perpetuated the soulless tradition of French academic painting and its preference for literary and historical subjects, including those set in foreign locales. In his review of the Salon of 1857, a xenophobic Castagnary denigrated exotic scenes by "inferior landscapists," who "go off to

search in the Orient, deep in the desert, for a nature that is extraordinary and lacks any relation to our ideas and our temperament."[1] Castagnary was indicting Gérôme specifically. Among the artist's exhibited works in 1857 were several Egyptian landscapes and genre scenes, including *Egyptian Recruits Crossing the Desert* (plate 8), set against an arid expanse of sand. If one discounts the foreign locale, however, *Egyptian Recruits* faithfully conforms to the criteria usually associated with the radical realist aesthetic and its humble subject matter. Based on the artist's extensive travels and exhaustive firsthand research, the painting offers a bleak, unsentimental glimpse of forcefully conscripted soldiers trudging across a blighted, featureless landscape. In its unvarnished depiction of oppressed laborers, it certainly has more in common with realist images of the downtrodden than it does with exotic Orientalist fantasies. Gérôme's pictorial economy, too, visible in the pared-down composition and desolate setting, goes completely against the grain of the anecdotal means and overstuffed detail typically employed to illustrate Oriental customs.

Yet, even in an age of revisionist art history, scholars stop short of reevaluating Gérôme's so-called Orientalist production. One can hardly blame them. In addition to the aesthetic debate launched by Castagnary, they now have to contend with a sociopolitical one unleashed by literary scholar Edward Said in 1978. A Gérôme painting, *The Snake Charmer* (plate 3), appeared on the cover of his *Orientalism*.[2] Said's polemical text and the school of art history it spawned changed how we look at European paintings set in Anatolia, the Middle East, and North Africa. Inevitably *The Snake Charmer* figured prominently in Linda Nochlin's devastating Saidian condemnation of Gérôme's ethnographic pictures as complicit in the naturalization of Western stereotypes of Oriental subjects and their mores.[3] Paintings of the Orient became Orientalist images. The latter no longer constituted simply a category but a campaign of disinformation distorting and even constructing reality rather than representing it truthfully. Gérôme's signature "licked" surfaces and meticulous attention to detail became suspect, synonymous with the misrepresentation of an elusive reality in areas where vaguely defined European powers purportedly projected their shady colonial designs. This version of events has become such an article of faith in Anglo-American art history, despite some significant dissent in France, that when Gérôme pictures are discussed, they are raked over the coals as agents in a vast European conspiracy to enslave, stereotype, and exploit the Orient.

All appearances to the contrary, my aim here is not to take issue with Said's and Nochlin's pioneering texts nor with the use that postcolonial cultural studies following their example have made of images such as those painted by Gérôme. Rather, what interests me is an old-fashioned question of art-historical habit and its

time-honored categories. More specifically, how has it come to pass that Gérôme and his pictures set in the Orient, especially those exhibited in 1857, have come to stand for a hidebound, antinaturalist strain of nineteenth-century painting? I suspect it has less to do with the hegemonic strategies of European colonial powers than with those of nineteenth-century realist critics. In other words, what if we put aside the dichotomy set up by Castagnary when he dismissed Oriental scenes and travel to the Orient as diametrically opposed to the realist focus of his brand of contemporary painting? We are so conditioned by Castagnary's aspersions, and modernist disdain for Orientalism in general, that we have lost sight of how the Orient was a source for the kind of direct engagement with the physical world that Castagnary insisted was only possible by staying home.[4]

This involves overcoming some stubborn art-historical reflexes, including the tendency to link scenes from the Orient more closely to academic tradition than to realist innovation. To a certain extent, the notion of the Orient as a "living antiquity" offered, if not a future, then a postponement of the inevitable, a stay of execution for grand-manner history painting. Many critics in 1857, however, saw Gérôme's studies of Egyptian customs as announcing a new direction in French art rather than prolonging one in need of regeneration. Edmond About, for example, insisted that Gérôme was far more open to new ideas than we had been led to believe: "[Gérôme] knows how to repack his baggage, to increase his resources; he is not afraid of going to seek original ideas, curious types, new landscapes on the banks of the Danube or the Nile."[5]

Across the English Channel, commentators arrived at the same conclusion. To English critics in 1871, confronted by an exhibition of the artist's work in London, Gérôme was a realist and not so much an academic painter. They saw him more interested in contrasting ethnological types and their respective skin colors than he was in painting the classical nude. One reviewer, writing for the *Times*, invoked Charles Darwin in his discussion of *For Sale: Slaves at Cairo* (ca. 1871), which suggests how debates about race and human origins conditioned reactions to Gérôme's work.[6] This is tricky territory to be sure; the machinery of racial inquiry, although initially linked to tracing human ancestry, was equally complicit in generating persistent colonial stereotypes, which gained much of their pseudo-authority through images. My aim is not to exonerate Gérôme or validate his depiction of ethnographic detail but to revisit deeply divisive midcentury aesthetic debates that have left their mark on the retelling of the artist's career. By 1871 Gérôme had already slipped into the formulaic repetition bolstering Orientalism's questionable claims to transparent fact. We might focus instead on Gérôme's shift from a classical mode to an ethnographic realism in the mid-1850s, a transition that English critics, by 1871, acknowledged as virtually complete.

Before considering Gérôme's recourse to the nascent science of physical anthropology, we should situate his embrace of realism in the context of seismic midcentury changes in the French artistic landscape. By the 1850s the evaporating authority of the hierarchy of genres no longer immunized *peinture d'histoire* from the anecdotal inflections of genre painting. In the preface to his review of the 1857 Salon, French critic Théophile Gautier, an early champion of Gérôme and an inveterate traveler himself, testified to the "expanding horizons of art," asserting that art "runs forward in all directions on wings of steam; new lands, unexplored climates, unfamiliar human types, original races offer themselves to art from every angle."[7] Where, in times past, according to Gautier, the heroic human figure had ruled the roost, "recently, art has left this 'ideal homeland [*patrie idéale*]'" in search of concrete contact with the real world. As is clear from the far-flung geographical coordinates built into his language, Gautier's notion of a closer relationship between art and observable reality was inextricably linked to travel, to the experience of places and peoples beyond the frontiers of mainland France. He acknowledges a fundamental change in focus in French art from the realms of history painting to the more prosaic matter-of-factness of genre.[8] Referring back to the 1855 Exposition universelle, Gautier underlined that "exchanges have produced combinations and results that are difficult to classify according to old categories."[9] His comments are striking coming from a critic one would expect to celebrate the Orient more as a destination of exotic fantasy or the re-creation of classical arcadia than as a nexus for realist painting. In fact, Gautier had reservations about the appearance of modern dress in high-minded art, but he accepted a realist scrutiny of contemporary clothing in paintings set abroad. In contrast to realist critics hostile to exoticism, such as Castagnary, Gautier suggests that the shift from classical idealism to a preoccupation with the real was concomitant with an expanded field of vision, one comprising the close investigation of exotic locales and their diverse populations.

Gautier was thinking specifically of Gérôme as he penned these words about a momentous crossroads in French art. The latter owed his early renown to the success of *The Cockfight* (fig. 1) at the Salon of 1847, when he was a standard-bearer for the coterie of Néo-Grec painters. Critics firmly attached to their Davidian principles, foremost among them Étienne-Jean Delécluze, continued to hold out hope that Gérôme would move from the charming but slightly precious classicism of that genre picture to more elevated antique subjects.[10] Catering to Delécluze's constituency in 1855, Gérôme exhibited an ambitious canvas, commissioned by the state and inspired by a passage from Jacques-Bénigne Bossuet's *Discours sur l'histoire universelle* (1681), entitled *The Age of Augustus* (fig. 19). Despite its enormous dimensions, *The Age of Augustus* failed to live up

FIGURE 19
Jean-Léon Gérôme, *The Age of Augustus,* 1855. Oil on canvas, 6.20 × 10.15 m
(20 ft. 4 1/8 in. × 33 ft. 3 5/8 in.). Amiens, Musée de Picardie

to expectations. Its intellectual pretensions produced a dry picture disappointing those who had found the *Cockfight*'s lighthearted naïveté refreshing. Nor was *The Age of Augustus* convincing by Davidian standards. While the enthronement of Roman Emperor Augustus in front of a temple facade recalls the classicism of Ingres' *Apotheosis of Homer* (1827), the representation of the ethnically diverse populations under imperial control gathered around Augustus's dais points to a new direction already gestating in Gérôme's work. This collection of ethnic types was informed by Gérôme's studies of people he encountered during the course of a voyage along the Danube and down the Black Sea coast to Istanbul in 1853. The artist's sketches in the Balkans yielded another, smaller painting exhibited in 1855, *Recreation in a Russian Camp—Memory of Moldavia*, which garnered more praise from critics.[11] Gautier almost certainly had these pictures in mind when he claimed that the expanding horizons of painting were breaking down time-honored distinctions between history painting and genre, and between the ideal and the real. The failure of *The Age of Augustus*, despite its distinguished ancestry, to cement Gérôme's reputation as a *peintre d'histoire* confirmed the shift in Gérôme's art toward realism.

According to art historian Albert Boime, this transition was not as abrupt as it might seem, answering as it did to the institutional pressures exerted by the regime of Napoléon III, whose arts administration persuaded artists, even those initially sympathetic to the extreme left, to collaborate in the molding of public opinion. Here, once again, Gérôme was embroiled in a conspiracy. Rallying to the Second Empire after the coup d'état in 1852, Gérôme and Gautier, along with other artists and what we would now call "embedded" critics, in Boime's analysis, assimilated realism as an official visual style suited to Napoléon III's political aims. Even the tongue-in-cheek attitude of the Néo-Grec painters—which seemed to mock the conventions and erudition of history painting—and their tendency "to depict the ancients in their daily life as if they were Parisian middle class types"[12] anticipated crucial aspects of what would become "official" realism. A lucrative government commission, *The Age of Augustus* represented, in its equation of the Second Empire to the Pax Romana, a transparent attempt to curry imperial favor. For Boime, Gérôme's brand of realism in its more developed form in the 1860s, "verisimilar in its painstaking detail," also endorsed Napoléon III's colonial aspirations. These were laid bare in another commission, *The Reception of the Siamese Ambassadors by Emperor Napoléon III* (1864).[13]

Whether Gérôme took his fee for *The Age of Augustus* and set off for Egypt in 1856 in line with these imperial designs remains a matter of debate. In any case, neither Nochlin's nor Boime's readings of Gérôme's verisimilitude—in *The Snake Charmer* and *The Reception of the Siamese Ambassadors*,

respectively—as a strategy naturalizing political and colonial ideologies, accounts for the harsher realism apparent in the earlier ethnographic pictures. The various conspiracy theories concocted by the social history of art, subtle or otherwise, gloss over the odd matter-of-factness of *Egyptian Recruits*. In that painting Gérôme relinquished Olympian heights to occupy the very down-to-earth territory colonized by the radical realists. At the Salon of 1857, in addition to a group of pictures linked to the artist's voyage in Egypt, which will be discussed in more detail, Gérôme exhibited his *Duel after the Masquerade* (1857), which was, by all accounts, an enormous success with the public, although less so with critics. The influential arbiter Paul Mantz captured the dramatic transition represented by Gérôme's pictures on display:

> But what! As of yesterday, the drama of modern life has yet another historian. M. Gérôme, who, deserting at last his antique idyll, does us the favor of noticing that white tie and tails are equal to the toga, and that, even though the costume has changed, the human heart maintains its eternal affliction. *Duel after the Masquerade* is one of the greatest successes of the Salon: this triumph will come without a doubt as a revelation to M. Gérôme, who, in this composition, as in the other small format paintings that he exhibits, seems finally to have found his calling. Ignoring pure beauty, and inadequate to *grandes machines* of the ancient world, the author of *The Age of Augustus* abandons the sky for the earth, history for anecdote, the past for the present. He is transformed, and an error acknowledged is almost an error pardoned.[14]

Even with the benefit of government support, Gérôme's reinvention of himself as a realist was fraught with "much risk."[15] He was subject to criticism from all fronts: from conservative classisicists, who deplored his abandonment of the beau ideal to cater to the masses, and from radical realists, who saw him as an unwelcome, opportunistic convert to their cause. Alphonse de Calonne, writing for the Orleanist *Revue contemporaine*, felt called to defend history painting against the tyrannical caprice of popular taste. Admonishing Gérôme, Calonne attempted to gather the painter back into the fold.[16] Castagnary, for his part, dismissed the painter's dramatic change in subject matter: "M. Gérôme feels the need to apply his talent to the interpretation of contemporary life." The critic doubted that Gérôme's essays at realism were genuine, following so closely on the heels of *The Age of Augustus*. He was similarly unimpressed by what he calls "landscapes brought back from Egypt," asserting that they "are far, according to those who have traveled in that country, from reproducing the luminous clarity and distant depths found there, in a word, any semblance of intimate and true physiognomy."[17]

Generally speaking, then, critics viewed Gérôme's submissions to the Salon of 1857 as a stab at realism, whether it was manifest in scenes set in contemporary Paris or in Egypt. While Castagnary's reaction to the painter's move was predictably hostile, other critics praised both *Prayer in the House of an Arnaut Chieftain* (fig. 20) and *Egyptian Recruits* for their truthfulness. Of the former, A.-J. Du Pays wrote: "This Oriental page has a truthful aspect, an air of good faith, that commands the attention of the spectator." While Du Pays felt that the heads of the Albanian soldiers in the latter painting were treated with less care for detail than were the firearms and the uniforms, he went on to say "that the ensemble has a truthful character."[18] Jules Verne, discussing *Prayer in the House of an Arnaut Chieftain* in the *Revue des beaux-arts*, exclaimed: "It is with the most absolute simplicity that M. Gérôme has arrived at the most truthful, most penetrating, most successful effect; the Orient, Islam in its entirety, is there."[19] According to Victor Fournel, Gérôme's canvases inspired by his voyage to Egypt rendered "serene gravity, bright light, and infinite horizons [of the Orient], with a breadth, precision, and surprising truth." Fournel qualifies his comments by admitting that "I am well aware that more expert writers than myself, who are happy to have seen this country of light and the cradle of the world, have reproached the painter for his historical and geographical errors; but by truth, I mean artistic and general truth, which is not always the absolute reality of the details."[20] Émile de La Bédollière, in *Le Siècle*, exclaimed with regard to the Egyptian scenes: "And what truth in the character of the physiognomies and the sites, even in the smallest folds of the garments, the chasing of the weapons, and the embroidery of the slippers!"[21]

One critic, Maxime Du Camp, had no doubt about his expertise regarding all things Egyptian. Thanks to his voyage to Cairo and up the Nile with Gustave Flaubert between 1849 and 1851, Du Camp brought an eye steeped in ethnological studies to bear on his commentary in 1857. His clinical efforts to trace racial affiliation through observable traits—including skin color, cranial shape, and facial angle—of human types in Egypt were indebted to the emerging science of what we now call physical anthropology.[22] His review epitomizes the ethnographic and realist standard against which Gérôme's pictures were evaluated. He, like many critics, had reservations about Gérôme's palette, which he found monochromatic.[23] Disappointed, too, by *The Prayer in the House of an Arnaut Chieftain*, Du Camp itemizes the inaccuracies in Gérôme's depiction of the gestures and positions of the men performing their devotions. But if Gérôme failed to render the atmospheric light of the Nile Valley and the movements constituting the Muslim prayer ritual with the necessary exactitude, he excelled at the nuances of Oriental physiognomy. Du Camp asserts: "The best of the paintings

FIGURE 20
Jean-Léon Gérôme, *Prayer in the House of an Arnaut Chieftain*, 1857. Oil on canvas, 66 x 95.2 cm
(26 x 37 ½ in.). Najd Collection, courtesy Mathaf Gallery, London

brought back by M. Gérôme from his recent voyage to Egypt is the one representing the *Egyptian recruits crossing the desert*.... It has remarkable qualities of observation in the diverse types of poor Nubians tied and driven by uncaring Arnauts to the glories of military service in the same way that here we take cattle to the slaughterhouse."[24] It is particularly interesting how Du Camp's comparison of the bound men in Gérôme's painting to livestock reinforces the links discussed earlier between the composition and its subject matter and the gritty domestic topics addressed by the paintings championed by Castagnary.

In analyzing Gérôme's paintings according to strict ethnographic criteria, Du Camp's comments were closely aligned with the more unconditionally enthusiastic observations of Gautier, which were set out in two lengthy articles. When Gérôme returned from Egypt in 1856, he admitted Gautier into his studio. There, as the artist painted, the critic sifted through Gérôme's portfolio of Egyptian studies. These concentrated on the physical features of the various types to be found in Cairo. As Gautier stated in an article published in December 1856: "The artist-traveler has executed many portrait-studies in pencil after different characteristic types; there are Fellahs, Copts, Arabs, Blacks of mixed-blood, men from the Sennaar and the Kordofan, so exactly observed that they could serve as evidence for the anthropological dissertations by M. Serres, so expertly drawn that they will guarantee the success of the painting in which they find a place."[25] Gautier refers here to Étienne Serres, professor of comparative anatomy and curator of an anthropological gallery at the Museum of Natural History in Paris. Since the 1840s Serres provided the hub for a network of artists, surgeons, and scientists who were pioneering the discipline of physical anthropology, the classification of racial types according to morphological patterns and distinctions between skin colors. This entire scientific apparatus later gave rise to the construction of racial inequality, but in mid-nineteenth-century France it seemed to offer a means for artists to represent human types more accurately.

To underscore Gérôme's clinical study of such criteria as the shapes and angles of faces, noses, mouths, cheekbones, eyes, and lips as indices of racial identity, Gautier borrows the descriptive terms that were the staple of reports by Serres and others. Fellahs and Copts, for example, can be identified by their "large flat faces" and their "rounded cheekbones," whereas Arabs are distinguished by the "more Caucasian shape of their head and the openness of their facial angle."[26] And when Gautier published his review of the finished pictures at the Salon of 1857, he made this anthropological inquiry a key aspect of his definition of their exotic content. Regarding *Prayer in the House of an Arnaut Chieftain*, Gautier discusses Gérôme's "ethnographic exactitude," saying that the painter had "satisfied one of the most demanding instincts of the epoch: the desire that people

have to know more about each other than that which is revealed in imaginary portraits [*portraits de fantaisie*]." Above all, Gérôme had "a sense for the exotic, for want of a better term," Gautier writes, "that makes him discover straight away the characteristic differences between one race and another."[27] Gautier was not alone in recognizing in these pictures a new direction in French art. Charles Perrier placed Gérôme at the forefront of a new group of "ethnographic" painters, which included Eugène Fromentin, Théodore Valerio, and others.[28] Another critic, Alexandre Tardieu, maintained that "the translations of human physiognomy that M. Gérôme exhibits this year make him a truly original painter to whom we render justice with infinite pleasure."[29]

As Perrier's review confirmed, the success of Gérôme's Salon entries in 1857 brought greater visibility to a group of artists working in the same vein. Several critics mention the compositional similarity of Gérôme's *Egyptian Recruits* to a drawing of the same subject exhibited at the Salon in 1853 by French artist Alexandre Bida. The latter's *Souvenirs from Egypt*, published in 1851 upon Bida's return from the Orient, offered a catalogue of local types. According to Gautier, writing in 1859, Bida's work, especially its precise details, confirmed the "ethnographic tendency [*tendance ethnographique*]" that characterized the art he championed.[30] Ethnographic studies in watercolor by Théodore Valerio inventoried ethnic types from the Balkans. They were shown at the Exposition universelle in 1855 to great acclaim and discussed at length by Gautier, who praised their "anthropological value." Gautier asserted: "Gérôme has produced an ethnographic series that is as accurate as M. Valerio's studies of the provinces of the Danube."[31]

To understand Gérôme's choice to veer away from classicism to genre and, more specifically, to ethnographic realism, we have to reimagine the possibility, as Gautier clearly did in 1855 and again in 1857, that realism and motifs brought back from a sojourn in Egypt were not incompatible. Just as Gautier insisted that old categories were incapable of doing justice to the transformations generating a more cosmopolitan art, so, too, are the paradigms we have inherited from modernism and the social history of art, inflected by Castagnary's anti-Orientalist bias, unable to accommodate the notion of a realism forged in exotic climes. That the works of artists such as Gérôme were compared to the concrete findings of scientific research promoted by Serres and others aligns the kind of ethnographic painting on display in 1857 with the positivist proclivities of realism rather than with the fantasy long understood as an essential ingredient in Orientalist painting.

I suspect that it was precisely because Gautier's notion of a realism representing racial types studied abroad offered a viable alternative to, not a

continuation of, the faltering classical tradition that Castagnary insisted so vehemently on a home-bred realism of the kind practiced by Castagnary's hero, Gustave Courbet. Indeed, ethnographic realism as a category seems ultimately to have been the casualty of the rival claims to realism pitting the officials of the Second Empire against its opponents on the left. Boime's notion of realism as fiercely contested terrain, a style to be appropriated and its radical political content neutralized, may explain the determination with which Castagnary sought to disqualify Gérôme and the whole school of ethnographic painting as inauthentic, foreign, and ideologically suspect. His campaign gained urgency as a result of Gérôme's triumph as, of all things, a realist at the 1857 Salon. On that occasion, the general consensus held that Gérôme's realist pictures deriving from the artist's trip to Egypt were among the most successful, most original works on display. Paul Mantz underlines how Gérôme's success unsettled the critical landscape. "The conquest is questionable without a doubt, but it is a conquest, and it will not be the least of the singularities of the Salon of 1857 that M. Gérôme, in the final tally of this exhibition, managed to be, if not confused with, then placed among the charming and strong group of genre painters and artists who believe in reality and in life."[32]

Although we are perhaps justified in faulting Gérôme for lapsing later in his career into an endless recycling of similar motifs and seeing those as synonymous with the habits of a formulaic Orientalism or an "official realism," we should reconsider our categorization of the paintings from the 1850s. Gérôme's series of Egyptian pictures, in particular, appeared to most of Castagnary's colleagues as consistent with, not opposed to, the realist aesthetic, albeit one forged in a foreign clime and drawing on the emerging science of physical anthropology. Once we look beyond Castagnary's trumped-up distinction between home and abroad, Gérôme's *Egyptian Recruits* regains some of the unvarnished immediacy that so impressed practically everyone else at the Salon of 1857.

Notes

1. Jules-Antoine Castagnary, "Année 1857," in *Salons*, vol. 1, *1857–1870* (Paris, 1892), p. 31. Unless otherwise noted, all translations are my own.

2. Edward W. Said, *Orientalism* (1978; London, 2003).

3. Linda Nochlin, "The Imaginary Orient" (1983), in *The Politics of Vision: Essays on Nineteenth-Century Art and Society* (New York, 1989), pp. 33–59.

4. Roger Benjamin, *Orientalist Aesthetics: Art, Colonialism, and French North Africa* (Berkeley, 2003), pp. 23–31.

5. Edmond About, *Nos artistes au Salon de 1857* (Paris, 1858), p. 77.

6. Edward Morris, *French Art in Nineteenth-Century Britain* (New Haven, 2005), p. 156. For the reference to Darwin, see *London Times*, April 29, 1871, p. 12.

7. Théophile Gautier, "Salon de 1857. I," *L'Artiste*, June 14, 1857, p. 190.

8. Ibid.

9. Ibid., p. 191.

10. Étienne-Jean Delécluze, "Exposition de 1857," *Journal des débats*, July 2, 1857, n.p.

11. In the catalogue to the Exposition universelle the work is entitled *Récreation du camp (Souvenirs de Moldavie)* and dated 1854. See *Exposition universelle de 1855: Explication des ouvrages de peinture, sculpture, gravure, lithographie, et architecture des artistes vivants étrangers et français, exposés au Palais des beaux-arts, avenue Montaigne, le 1ᵉʳ mai 1855*, exh. cat. (Paris, 1855), no. 3164 bis.

12. Albert Boime, "The Second Empire's Official Realism," in *The European Realist Tradition*, ed. Gabriel P. Weisberg (Bloomington, 1982), pp. 85–86.

13. Ibid., p. 86.

14. Paul Mantz, "Salon de 1857," *Revue française* 10 (1857), p. 54.

15. Théophile Gautier, "Salon de 1857. IV. MM: Gérôme, Mottez," *L'Artiste*, July 5, 1857, p. 245.

16. Alphone de Calonne, "Exposition des beaux-arts de 1857," *Revue contemporaine* 32 (1857), pp. 609–10.

17. Jules Castagnary, *Philosophie du Salon de 1857* (Paris, 1858), p. 85.

18. A.-J. Du Pays, "Salon de 1857," *L'Illustration, journal universel* 30, no. 755 (August 15, 1857), p. 1089.

19. "Jules Verne, "Salon de 1857," *Revue des beaux-arts* 8 (1857), p. 273.

20. Victor Fournel, "Mélanges: Salon de 1857," *Le Correspondant* 5 (August 1857), p. 744.

21. Émile de La Bédollière, "Exposition de 1857," *Le Siècle*, August 23, 1857, n.p.

22. Flaubert considered the physical differences between what he calls "various races of negroes," including one with "a skull narrowed so sharply above the temples that it was almost pyramidal." See his travel notes dated May 18, 1851, in Gustave Flaubert, *Flaubert in Egypt: A Sensibility on Tour*, ed. and trans. Francis Steegmuller (New York, 1972), pp. 187–88.

23. Maxime Du Camp, *Le Salon de 1857: Peinture, sculpture* (Paris, 1857), p. 64.

24. Ibid., p. 61.

25. Théophile Gautier, "Gérôme: Tableaux, études, et croquis de voyage." *L'Artiste*, December 28, 1856, p. 34.

26. Ibid.

27. Gautier (note 15), p. 246.

28. Charles Perrier, *L'Art français au Salon de 1857* (Paris, 1857), p. 92.

29. "Alexandre Tardieu, "Beaux-Arts: Exposition de 1857," *Le Constitutionnel*, June 30, 1857, n.p.

30. Théophile Gautier, "Exposition de 1859. VIII," *Le Moniteur universel: Journal officiel de l'empire français*, June 11, 1859, p. 669.

31. Gautier (note 15), p. 246. On Valerio, see Théophile Gautier, "Aquarelles ethnographiques," *Les Beaux-arts en Europe, 1855*, 2 vols. (Paris, 1855), 2: pp. 287–315.

32. Mantz (note 14), p. 55.

Gérôme in Istanbul

MARY ROBERTS

Jean-Léon Gérôme's *The Snake Charmer* (plate 3) has attained a level of notoriety matched by few Orientalist paintings. Since its inclusion on the front cover of Edward Said's landmark book *Orientalism*, the painting has been imbued with a synoptic function to become a visual shorthand for the Orientalism debate.[1] Through its superb rendering of İznik tile panels from the Topkapı Palace, the mise-en-scène of this painting invokes the cultural heritage of Istanbul, the city that was the center of the modernizing Ottoman state in the nineteenth century. Yet, as Linda Nochlin has so perspicaciously argued, this painting dissimulates any such contemporary cultural connotations in favor of a theatrical rendering of the Orient as a picturesque, eroticized diversion for the delectation of the European viewer.[2]

Since Nochlin's important essay, scholars of Islamic art history have uncovered a mélange of sources and references in this painting and in so doing its surface of seamless realism gives way to a more complex and intriguing aggregation. There is a beguiling accuracy and beauty about the rendition of fabrics, armor, and decorative tilework across this painting, and in their documentary merit some of Gérôme's sources are impeccable. Indeed, one of the photographs of the Topkapı Palace harem precinct, which Gérôme is highly likely to have used in creating the majestic tiled panels in this painting, was by the Abdullah Frères, photographers to the Ottoman court. This was one of few, very rare early photographs of one of the most secluded interior spaces of the Topkapı Palace. Yet this painting sustains both a very precisely observed and a deeply ambiguous inscription of place. The tiles were from two different parts of the palace (the Altın Yol and the Baghdad Pavilion) and have been substantially modified for the painter's purposes.[3] This composite setting is peopled by a motley group that would never have congregated in either of these most proscribed spaces of the palace. One can only imagine how willfully incoherent this composite painting might have appeared to elite nineteenth-century Ottoman viewers familiar with these most interdicted precincts of the Ottoman palace.

While the iconography and ideology of Gérôme's painting have been scrupulously researched and debated, scant attention has been paid to the painter's travels to the Ottoman capital in the decade in which it was produced. In this essay I investigate Gérôme's journey to Istanbul in 1875. This was not his first visit to the Ottoman capital but a journey undertaken when his professional seniority ensured that his pedagogic networks were able to facilitate his access to some of the city's foremost historic and religious sites. Once we shift the lens to examine Gérôme through accounts published in Istanbul's nineteenth-century newspapers and bring into the debate other sources from the Turkish archives, we see that in this period Gérôme was also implicated in the Ottoman palace's acquisition of contemporary European art. Gérôme had a dual role in this process as both a facilitator of the acquisitions and as one of the painters under commission to the palace. Focusing on the circuits of production and reception of Gérôme's paintings destined for Istanbul's elite Ottoman audience enables new ways of understanding his art. For these reasons nineteenth-century Istanbul is a productive place from which to reassess Gérôme's Orientalism.

Gérôme's arrival in the capital of the Ottoman Empire on May 15, 1875, was much vaunted among Istanbul's cosmopolitan expatriate community, and, judging from local newspaper reports, this community was well aware of his reputation both in France and across the Atlantic. Indeed his imminent arrival was announced in three successive articles in the *Levant Herald*, one of Istanbul's local English- and French-language newspapers. The first, a short entry, appeared fourteen days in advance of his arrival.[4] The second, published six days later, was a longer piece announcing that Gérôme had "been commissioned by the Sultan to execute some paintings for the palaces of Dolmabaghtché [Dolmabahçe] and Tcheragan [Çırağan]" and recounting his recent successes in London with the exhibition of *The Sabre Dance* (1875).[5] Yet another article, published four days after that, on May 11, disclosed that Gérôme's host and guide on his excursions around Istanbul was to be his friend the painter Stanislaw Chlebowski. This article further bolstered Gérôme's celebrity status with an extended account of his achievements in both the "old and new worlds."[6]

Once he had arrived in the capital,[7] a succession of articles reported Gérôme's unfolding itinerary to their local readership, praising his industriousness in producing about fifteen studies of mosques in Istanbul, including the New Mosque (Mosque of the Valide Sultan) and Rustem Paşa Mosque, and several mosques in Scutari (Üsküdar) on the Asian shore of the Bosporus, all of which were to appear in subsequent paintings.[8] Later reports specify the painter's two-week visit to Bursa, commencing on June 2, to see the major Ottoman monuments, mosques, and tombs in the former Ottoman capital, again in the

company of Chlebowski and the young French artist Antoine Buttura who had accompanied Gérôme from Paris.[9] From these sites, it is recounted, the painter "has brought back with him a rich harvest of studies," including sketches of the magnificent tiles in the Green Mosque.[10] So too they announced his intention to visit another former capital of the Ottoman Empire, Adrianople (Edirne), famous for Sinan's Selimiye Mosque. Gérôme's sense of heritage also encompassed tracing the footsteps of well-known Orientalists and former residents of Istanbul. As the *Levant Herald* noted, Gérôme visited Baghtchekeui (Bahçeköy) "to paint the picturesque neighbourhood of Belgrade and the great bends so charmingly described in the letters of our English Sevigné, Lady Mary Wortley Montague."[11]

From these articles in the local press we are able to establish a fairly precise sense of Gérôme's itinerary in 1875 of his visits to the sites that gave him material for his Orientalist paintings in the decades ahead. More significantly, however, they provide an insight into the professional networks into which Gérôme was received in Istanbul—incorporating both the European expatriate community and the Ottoman palace. In Istanbul, as elsewhere, Gérôme's international network of former students provided a crucial entrée to the city's cultural elites. In the Ottoman capital it was his friend and former student, the Polish artist Chlebowski, a European expatriate and painter under commission to the Ottoman sultan, who was a crucial conduit.[12]

We have no sources confirming whether or not Gérôme visited the sultan's residence, the Dolmabahçe Palace, during this 1875 trip, but documents in the palace archives reveal that some months later he was instrumental in negotiating the sale of paintings to the sultan through his father-in-law's firm, Goupil et cie.[13] In this enterprise his interlocutor was another former student, Ahmed Ali Bey, one of the foremost Ottoman artists of his generation, who came to be known as Şeker Ahmed Paşa. In the mid-1860s Sultan Abdülaziz sponsored Ahmed Ali's studies in Paris, where he worked in the studios of Gérôme and Gustave Boulanger. Returning to Turkey sometime between 1871 and 1872, he quickly rose in rank and position in the palace bureaucracy.[14]

There are numerous documents in the Dolmabahçe Palace Archive related to the purchase of these paintings between October 1875 and mid-1876. These holdings include invoices from the company addressed to "Sa Majesté Impériale le Sultan," transportation receipts for the delivery of crates of paintings addressed to Ahmed Bey from the Constantinople Agency of the Compagnie de Messageries Maritimes, records of money orders paid through the Crédit Lyonnais to Goupil, and telegrams sent from Paris to Istanbul by Gérôme and Goupil to Ahmed Aly (Ali) Bey, who was addressed as an aide-de-camp to the imperial palace. The telegrams are particularly intriguing. Even though they

are only one side of the correspondence, they give a sense of the liveliness of the protracted negotiations that took place between the Ottoman palace and the Parisian art dealers.[15] They indicate that there was a complicated process involving various intermediaries to secure the purchases and surmount the geographic challenges of aesthetic decision-making at a distance.

That these records are only partial remnants of the negotiations makes the issue as to whose taste this collection reflects a rather complicated matter. Certainly Goupil et cie played an important role in recommending works by Gérôme and others that were available for purchase. The telegrams also convey that Ahmed Ali was a crucial mediator. Did he confer with his former mentor, Gérôme, to initiate this commission a few months earlier when both were in Istanbul? Even if he did not, the palace bureaucrat must have known the work of many of the painters that were being mooted for purchase because of his years as a student in the Parisian art world in the 1860s. It is tempting to conclude that he would have been partial to the landscape paintings that were acquired given his preoccupation with this genre in his own art. Before his deposition in May 1876, Sultan Abdülaziz was in all likelihood also active in these decisions. He was an enthusiastic painter, and in 1867 during a trip to Europe the sultan visited a number of major museums as well as the Paris Exposition universelle.[16]

A comparison of these documents in the Istanbul archives and the company's stock books, held at the Getty Research Institute, has enabled me to identify twenty-nine paintings by twenty-eight different European artists that entered the palace collection through this means.[17] From the stock books, which record both the cost price to Goupil and the sale price to the sultan, it is also evident that in some instances (although not consistently) the firm charged the palace considerably more than their other customers in Europe and America, with a markup that was often around one hundred percent. The record of the company's acquisition and sale dates in these ledgers indicates that some works were drawn from stock that had been in the company's holdings for up to three years (which was a considerable length of time for a company that had a high turnover). Yet by no means was the firm only shifting their old stock. In fact, a number of the paintings purchased in 1875 (such as Charles Chaplin's *Roses de mai* and Giuseppe de Nittis's *Place de la Concorde*) had been exhibited in the Salon that year. The palace was purchasing popular contemporary art.

The palace acquisitions indicate an approach to collecting that favored academic paintings and landscapes by affiliates of the Barbizon school. These acquisitions invite comparison with the collecting practices of the famous Ottoman statesman, Halil Bey (Halil Şerif Paşa), who had amassed his substantial collection of contemporary and old master European paintings in the previous

decade. The Ottoman palace focused solely on contemporary painting, and their selection did not include any of the more *outré* French avant-garde paintings (hardly surprising given the Gérôme-Goupil conduit), but this difference should not be overemphasized. Michèle Haddad's scholarship on the full scope of Halil Bey's acquisitions is a crucial corrective to the tendency to characterize his collection on the basis of a few notorious paintings, especially those by Gustave Courbet.[18] In fact, a number of the same contemporary artists—including Boulanger, Charles Daubigny, Eugène Fromentin, Gérôme, and Constant Troyon—are represented in the two collections.

Halil Bey's collection, Francis Haskell asserted, "could not in essence be distinguished from that of any other rich man living in Paris at the time," and therein lies its potential as a corrective to European Orientalist stereotypes about the Easterner.[19] A similar conclusion might be ventured about the collection accrued in the Ottoman palace in 1875–76. Both Sultan Abdülaziz and Sultan Abdülhamid II understood the strategic value of demonstrating their cultural affiliations with Europe through the display of these collections in the official reception rooms of the palace. Sultan Abdülhamid seems to have been particularly attuned to the way the palace art collection could be utilized as part of contemporary statecraft and international diplomacy. One of his court painters, the Italian Fausto Zonaro, records in his memoirs that the sultan entrusted him with the task of selecting and displaying appropriate paintings from the palace collection for the rooms that German emperor Kaiser Wilhelm II and Kaiserin Augusta Viktoria would see during their state visit in 1898. Zonaro's choices were governed by aesthetic preferences. Among his inclusions were many of the paintings purchased through Goupil (including Gérôme's work). Zonaro was later dismayed to find that his selection was edited by the sultan himself, whose alternative judgments were premised on diplomatic criteria. Abdülhamid vetoed the work by the painter Ivan Aivazovsky on the grounds that his German visitors might be offended to see so many Russian paintings.[20]

It would be misleading to make judgments about the Ottoman palace collecting priorities in the 1870s on the basis of the Gérôme-Goupil acquisitions alone. Rather they should be assessed, as Semra Germaner and Zeynep İnankur argue, alongside the range of artworks that Sultan Abdülaziz commissioned from visiting European painters, Istanbul's expatriates, and contemporary Ottoman artists. This collection continued to be augmented by Sultan Abdülhamid.[21] To cite just one example, Gérôme's former student Chlebowski was commissioned to paint battle scenes commemorating historic Ottoman victories. Sultan Abdülaziz was actively involved in this commission and supplied sketches to the painter to indicate compositional arrangements for the paintings.[22] This example suggests

that some palace acquisitions were motivated by priorities that differed from, and in some cases were at odds with, contemporary European sensibilities.

Gérôme's own work was acquired as part of this collection. As early as April 8, 1875, it was reported in the *Levant Herald* that the French academician had received a painting commission from Sultan Abdülaziz.[23] Telegrams in the Dolmabahçe Palace Archive indicate that by November 1875 two of the three commissioned paintings had entered the palace collection, with the third still under negotiation via Goupil and the painter himself. The three works by Gérôme that were purchased for the sultan are *Lion dans sa grotte, Café égyptien,* and *Bachi-Bouzouk dansant.* Two are listed as lost in Gerald M. Ackerman's revised catalogue raisonné, but, in fact, all three remain in Turkish national collections.[24] As Ackerman notes, two paintings, *Lion dans sa grotte* and *Bachi-Bouzouk dansant,* were exhibited at the Exposition universelle that was held in Paris between May and November 1878. Documents in the Prime Ministers' Archives in Turkey indicate that the French embassy in Istanbul negotiated on Gérôme's behalf with the Ottoman foreign affairs ministry in April 1878 for the loan of these two paintings and that permission was granted by Sultan Abdülhamid for them to travel back to Paris for the duration of this event.[25] Given the extensive effort required to repatriate these paintings for the purposes of this exhibition, one wonders why Gérôme opted for such a complicated loan. It is tempting to speculate that the painter sought to bolster his Orientalist credentials through recognition that his paintings belonged to the sultan. The loan source, however, was not acknowledged in the official catalogue and it was not until the publication of Fanny Hering's monograph in 1892 that the provenance of one of them, *Lion dans sa grotte,* was publicly disclosed.[26] So too one speculates as to the reasons why the Ottoman palace was willing to lend the works. Perhaps Sultan Abdülhamid recognized the benefit of this high-profile recognition of Ottoman participation in the European practices of collecting and lending works of art. This is certainly consistent with the Ottoman state's regular contributions to the international exhibitions held in Europe and America throughout the second half of the nineteenth century.[27]

Two of the three paintings purchased for the Ottoman palace collection also had another life through their circulation as prints. In 1881 *An Egyptian Café* and *Bashi-Bazouks Dancing* were published as photogravures in Edward Strahan (Earl Shinn's) volume on the painter (figs. 21 and 22).[28] This presents us with a fascinating puzzle and prompts questions as to the divergent contemporaneous significance of Gérôme's Orientalism for both the Ottoman palace elite and for European and American audiences. My attention here is focused on the geographically disparate reception histories of one of these two: *Bashi-Bazouks Dancing.*

MARY ROBERTS

FIGURE 21
Jean-Léon Gérôme, *An Egyptian Café*. From *Gérôme: A Collection of the Works of J. L. Gérôme in One Hundred Photogravures*, ed. Edward Strahan [Earl Shinn] (1881), vol. 2: n.p. Los Angeles, Research Library, Getty Research Institute (81-B265)

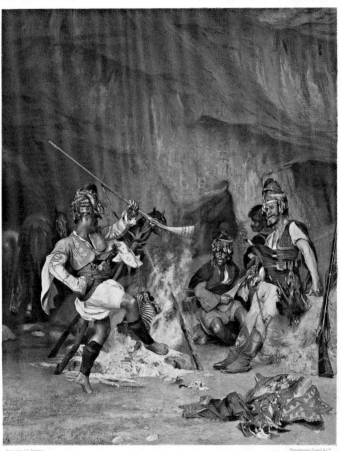

Print par J.L.Gérôme

Photogravure Goupil & Cⁱᵉ

BASHI - BAZOUKS DANCING

New-York : Samuel L. Hall

FIGURE 22
Jean-Léon Gérôme, *Bashi-Bazouks Dancing*. From *Gérôme: A Collection of the Works of J. L. Gérôme in One Hundred Photogravures,* ed. Edward Strahan [Earl Shinn] (1881), vol. 3: n.p. Los Angeles, Research Library, Getty Research Institute (81-B265)

When it was exhibited at the Paris Exposition in 1878, Dubosc de Pesquidoux admired Gérôme's vivid rendering of the picturesque costume of the Bashi-Bazouks, whom he judged to be "less soldiers than bandits."[29] The painting received a more politically charged interpretation when reproduced as a photogravure in Strahan's book. The accompanying text identified Gérôme's figures as "brothers" of the irregular troops that fought alongside the Ottoman army in the 1877–78 Russo-Ottoman War and who had been so controversial in the British accounts of this conflict. Strahan writes:

> [These Bashi-Bazouks are] gathered from the remotest quarters of the Empire in Europe and Asia.... Often with scarcely a pretence of military discipline among them, they imported into a war, professedly carried on under the regulations of the Geneva Convention, such atrocities as before long led the Russians to retaliate in kind. From the letters of the enterprising gentlemen who represented the English press in both armies, may be gathered the fullest details of the manners and customs of these picturesque pillagers, whom Gérôme here represents in a singularly innocent moment.... In the East, men may change, but manners do not, and these dancers and chicken-killers of Gérôme's are the legitimate brothers of the soldiers of the Sultan, so vividly described by those letters from the field.[30]

Strahan endorses the view of this war reported in the British press: a strident critique of the Ottoman Empire because such lawlessness at the hands of the irregular troops was, by implication, sanctioned by the morally corrupt leadership of the Ottoman sultan. Strahan's text assimilated the reported capricious behavior of the Bashi-Bazouks to the larger Ottoman political structures within which the exercise of arbitrary violence was reputedly given license. Such views of the ruthlessness of the Bashi-Bazouks had already been entrenched in the popular imagination. American and British reports about events leading up to the war stirred popular outrage in Britain and ensured that Disraeli's pro-Ottoman policy could no longer be sustained. As Şükrü Hanioğlu has argued, this was a decisive turning point in British foreign relations, signaling "the end of active British support for the Ottoman Empire."[31]

Strahan's characterization of the Bashi-Bazouks as symptomatic of the unchanging nature of "manners" in the East oversimplifies a far more complex and checkered history of the Ottoman state's relationship with the irregular soldiers, who served alongside regular forces during many of the key nineteenth-century battles for the empire's survival.[32] In the context of Strahan's volume, Gérôme's painting performs a certain kind of ideological work, becoming a

vehicle for historicizing these recent events in a way that justifies the shifts in British foreign policy and makes such an unsavory subject palatable to a Western audience by presenting these "bandits" as exotic and picturesque. In Gérôme's painting the threatening implications of their formidable weaponry is muted and the most visible firearm is brandished by the dancer as a benign, picturesque accoutrement to his dance. Although the details of this historic moment are very particular, in essence this is a familiar interpretation of Gérôme's Orientalism, one that accords with Linda Nochlin's and Olivier Richon's insights about the myth of Oriental despotism.[33] Why would the Ottoman sultan have been engaged by such a painting? What alternative connotations might this representation have elicited for the elite Ottoman palace audience in the 1870s?

In the first place, the figures in this painting were identified by a different name, Zeybeks. This is the title by which the painting was referred to in nineteenth-century Ottoman sources and by which it is still known in the Turkish archives. This designation was neither as generic nor in the 1870s did it carry such negative connotations as "Bashi-Bazouks." An Ottoman viewer would immediately have recognized this painting as a representation of the distinctive costume and dance of the Zeybeks, from the mountain region of western Anatolia. The Zeybeks had been part of the irregular Ottoman forces and indeed they had a troubled history with the Ottoman regime, but by the 1870s they were in favor with Sultan Abdülaziz even though the Zeybeks' relationship with the state would continue to wax and wane as the century progressed.[34] The Zeybeks' fierce resistance to any measure to abolish their distinctive dress in 1838 gave them a particular notoriety.[35] These dress reforms were part of the Tanzimat modernization of the Ottoman state. Prior to the reforms (first initiated in the late 1820s) the myriad sartorial distinctions in dress across the empire signaled diverse regional and sectarian allegiances, and the push to homogenize clothing was part of the modernization and increased centralization of the Ottoman state.[36] By the 1870s the official attitude seems to have softened toward the Zeybeks, a change that coincided with shifts in late-Tanzimat state ideology toward "Ottomanism," an ideology that emphasized unity within diversity across the multiethnic, multireligious empire. This shift is evident in the *Elbise-i 'Osmaniyye* (*Les Costumes populaires de la Turquie*), published as part of the Ottoman government's contribution to the World's Fair held in Vienna in 1873. Two Zeïbek (Zeybek) costumes were included in the section on Aïdin (Aydın) (fig. 23). The accompanying ethnographic account noted this fraught recent history of the Zeybeks' relationship to the state but recouped this fiercely proud and sartorially idiosyncratic group as exemplars of successful centralized reform by recounting that the state's representative in the vilayet had recently persuaded

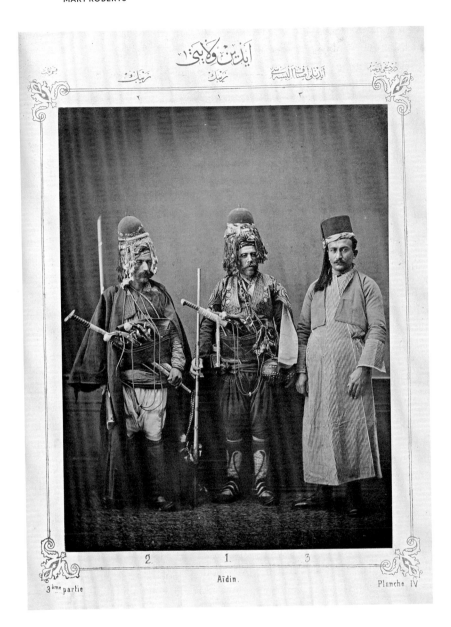

FIGURE 23

Aïdin (figures 1 and 2: Zeïbek [Zeybek]), section 3, plate 4. From **Osman Hamdy Bey and Marie de
Launay,** *Elbise-i 'Osmaniyye (Les Costumes populaires de la Turquie)* (1873). Los Angeles, Research
Library, Getty Research Institute, Box 139, Pierre de Gigord collection of photographs of the Ottoman
Empire and the Republic of Turkey (96.R.14)

the Zeybeks to collaborate with the local police. Instead of profiting from banditry, they reaped financial rewards by providing services as travelers' escorts.[37]

Gérôme's Zeybeks are not situated within an ethnographic classificatory rubric in such a determined way as the Zeybeks in the *Elbise*. As Ahmet Ersoy has argued, the *Elbise* was a project that systematically encompassed each of the Ottoman vilayets (starting with Istanbul, "the heart of the Ottoman Empire")[38] to propose a geographic summary of the empire through costume. A crucial part of what allowed the Ottoman state to define its modernization as distinct from the West was premised on positioning "native culture" as the modernizing state's timeless patrimony. A sartorial definition of this patrimony, Ersoy argues, is evident in the *Elbise*'s framing distinction between the continuity and integrity of local, traditional "costume" and the transience and superficiality of modern (European) "garments."[39] Ussama Makdisi pushes this one step further arguing that the *Elbise* articulates Ottoman Orientalism, "a vision of Ottoman modernity," defined by the Ottoman elite "that was hierarchical and imperial."[40]

In this context the Zeybeks' costume is representative of one element of regional "native culture" within the frame of a book that positions each within a classificatory mode by staging costumed pairs and trios against the same generic background. This and the frontal poses of each model in the *Elbise* contrasts with the anecdotal mise-en-scène of Gérôme's painting and its figures who are entertained by their fireside companion, whose finely wrought costume is so splendidly animated by the movement of his dance. Their tethered horse in the background turns to look, perhaps stirred by the music and dancing of his masters. His presence is a reminder that once the victuals have been consumed and the entertainment finished, the Zeybeks will move on. Here is rendered an itinerant existence that was the antithesis of Ottoman palace life governed by formality and protocol. Despite the differences between the *Elbise* project and the painting, the language of Gérôme's academic realism lends an ethnographic sensibility; and their particular dance was recognized as one of their distinctive practices.[41] It is tempting to think of the range of representations of Ottoman culture within the sultans' art collection as performing something of a visual précis of the empire's diversity for its elite audience, a reminder of cultural patrimony (that which distinguished the Ottoman Empire from Europe), within the contextualizing frame of the modern Ottoman palace. As we track the circulation of Gérôme's painting from Paris to Istanbul to Paris and then back again and incorporate within the account the life of its reprographic double produced in America, the variant names that it accrued as a result of these transitions are indicative of the interpretive distinctions for its divergent audiences.

Reassessing Gérôme's Orientalism through sources that attune us to nineteenth-century Istanbul as a context for the reception of his art, we find ourselves at a considerable geographic and interpretive distance from where this essay commenced and from Nochlin's analysis in which she argues that "the white man, the Westerner, is of course always implicitly present in Orientalist paintings like *Snake Charmer*; his is necessarily the controlling gaze, the gaze which brings the Oriental world into being, the gaze for which it is ultimately intended."[42] My intention here is not, however, to summarily dismiss Nochlin's Saidian analysis of Gérôme's art but rather to suggest that what is required is further cross-cultural interpretive work. An approach that embraces a more contested and geographically encompassing production and reception will augment and nuance our understanding of the cultural politics of Gérôme's Orientalism. So too the impact of Gérôme's pedagogical relations on his Orientalist art and his entrepreneurial activities in the capital of the Ottoman Empire needs to be further investigated to uncover the ways these activities intersected with the shifting parameters of both Ottoman and Orientalist cultural agendas in the nineteenth century.

Notes

My sincere thanks to Nurullah Şenol, Evra Günhan, Agnès Penot-Lejeune, Hannah Williams, Chiara O'Reilly, Gerald M. Ackerman, Holly Clayson, and Rob Linrothe. The research for this essay was supported by the Australian Research Council and fellowships at the Getty Research Institute and the Sterling and Francine Clark Art Institute.

1. Edward Said, *Orientalism* (New York, 1978).

2. Linda Nochlin, "The Imaginary Orient" (1983), in *The Politics of Vision: Essays on Nineteenth-Century Art and Society* (New York, 1989), pp. 33–59.

3. In note 7 of her essay "The Imaginary Orient" Linda Nochlin reported a conversation with Edward Said in which he said that "most of the so-called writing on the back wall of the *Snake Charmer* is in fact unreadable," to refute Richard Ettinghausen's statement that the various inscriptions in Arabic "can be easily read" (Richard Ettinghausen, "Jean-Léon Gérôme as a Painter of Near Eastern Life," in Gerald M. Ackerman, *Jean-Léon Gérôme [1824–1904]*, exh. cat. [Dayton, 1972], p. 18). Walter Denny weighed in to the discussion by identifying the lower panels as being, in Gérôme's time, from the Altın Yol (1574) and the upper panel from the Baghdad Kiosk (1637) (Walter B. Denny, "Quotations in and out of Context: Ottoman Turkish Art and European Orientalist Painting," *Muqarnas* 10 [1993], p. 221). Adding a further complication to the identification, Barry Flood (in correspondence with Sarah Lees, curator at the Clark Art Institute) has identified the long inscription at the top as an amalgamation of two sources — one of which is a verse from the Qur'an (2: 256) — and he proposes the following about the differing interpretations: "Ettinghausen claimed... that the inscriptions were legible, Edward Said denied this. The truth lies somewhere in between and is more interesting — the inscriptions have been deformed/transformed through copying, and Gérôme's combination of disparate sources also complicates any sense of 'simple' reading" (email correspondence between Finbarr Barry Flood and Sarah Lees, Clark Art Institute file notes on *The Snake Charmer*).

4. "M. Gérôme, the distinguished French historical painter, has, we understand, received a special invitation from the Sultan to paint a series of pictures for the Palace, and is expected to arrive here towards the middle of the present month" (*Levant Herald*, May 1, 1875, p. 330). A shorter notice in French appears on page 331 of the same paper.

5. *Levant Herald*, May 7, 1875, p. 346.

6. "Le Peintre Gérôme," *Levant Herald*, May 11, 1875, p. 359. A slightly extended version of the same article was published the following day under the same title, *Levant Herald*, May 12, 1875, pp. 158–59.

7. His arrival on the Messageries Maritimes vessel *La Bourdonnais* was announced in a short entry in *La Turquie*, May 15, 1875, p. 1.

8. Again the newspaper is highly conscious of art-world events in the French capital, noting that "despite the crises that have occurred, Paris has once again become, with remarkable speed, the great centre of the arts," where the "English and particularly the Americans come and pay amazing prices for canvases by Gérôme, Baudry, and Meissonier" ("Le Peintre Gérôme," *Levant Herald*, May 28, 1875, p. 403).

9. *Levant Herald* (June 2, 1875, p. 189) reports his departure for Bursa, as well as his return to Istanbul (June 17, 1875, p. 458). This same trip to Bursa is again reported (June 23, 1875, p. 219).

10. *Levant Herald*, June 17, 1875, p. 458. A version of the same report is published in French on page 459.

11. Ibid.

12. Opinions differ as to which artist hosted Gérôme's 1875 visit. The Goncourt *Journal* recounts a dinner-party conversation with the artist on the eve of his trip that year. In this source it is indicated that Gérôme will be hosted by an (unnamed) court painter who had painted the sultan's portrait (Edmond de Goncourt and Jules de Goncourt, *Journal mémoires de la vie littéraire*, 6 vols. [Paris, 1935–36], 5: pp. 154–55). Vasıf Kortun disputed Gerald M. Ackerman and Semra Germaner's assumption that it was "Abdullah Siriez" (a misnomer for the Abdullah Frères) and contended instead that it was Pierre Désiré Guillemet (Vasıf K. Kortun, "Gérôme ve İstanbul'daki Dostları," *Tarih ve Toplum* [August 1988], pp. 40–41). Both Guillemet and Chlebowski were court painters to Sultan Abdülaziz, and portraits were commissioned from both of them, so either could fit the description. Given the extensive reports in the *Levant Herald* of Chlebowski's role in hosting Gérôme's visit and the fact that he was also a former student, in my view it seems more likely that he is the unnamed painter referred to in the *Journal*.

13. I am grateful to Cemal Öztaş, M. Erdal Eren, and Gülsen Sevinç Kaya for facilitating my access to study and photograph these documents and the paintings in the Dolmabahçe Palace Archive and Museum in 2004.

14. *Şeker Ahmed Paşa, 1841–1907*, ed. Ömer Faruk Şerifoğlu and İlona Baytar (Istanbul, 2008). The third important contact for the painter was the Abdullah Frères, the Ottoman-Armenian photographers. This firm was an important source of photographs for Gérôme's paintings. A letter to the artist dated November 14, 1878, demonstrates that they remained in contact well after Gérôme's visit (Gérôme correspondence, Masson Collection, Paris). (My thanks to Gerald M. Ackerman for generously providing a transcription of this letter.) I discovered further evidence of their ongoing contact in a newspaper article published in the previous year. This report indicates that Gérôme had sent a painting of a bullfight to the Abdullah Frères studio in Istanbul. The same report notes that the delivery also contained a landscape by Buttura and some Gérôme and Fortuny photogravures published by Goupil (*Levant Herald*, November 9, 1877, pp. 846–47). The Gérôme painting is *Taureau et picador* and is inscribed, "Souvenir à MMrs Abdullah." This painting is number 178 in the French edition of Gerald M. Ackerman, *Jean-Léon Gérôme: Monographie révisée, catalogue raisonné mis à jour* (Courbevoie, 2000), p. 268.

15. This correspondence even includes some works that Goupil sought to acquire at auction

on behalf of the sultan but failed to obtain at a suitable price, such as the *Florentine Poet* (1861), most likely the painting of the poet Dante by Alexandre Cabanel.

16. Sema Öner, "The Role of the Ottoman Palace in the Development of Turkish Painting following the Reforms of 1839," in *National Palaces*, no. 4 (Istanbul, 1992), pp. 58–77; and Gülsen Sevinç Kaya, "Dolmabahçe Sarayı İçin Goupil Galerisi'nden Alınan Resimler / The Paintings Purchased from Goupil's Art Gallery for the Dolmabahçe Palace," in *Osmanlı Sarayı'nda Oryantalistler / Orientalists at the Ottoman Palace* (Istanbul, 2006), pp. 71–91.

17. *Goupil & Cie / Boussod, Valadon & Cie Stock Books* [electronic resource], 1846–1919 (Research Library, Getty Research Institute, Los Angeles). A more extended comparative analysis of these two sources will be part of my forthcoming book, *Artistic Exchanges in Nineteenth-Century Istanbul.*

18. Michèle Haddad, *Khalil-Bey: Un Homme, une collection* (Paris, 2000).

19. As Haskell demonstrates, Halil's reception in the popular press in Paris often reiterated superficial stereotypes of the "Turk" as a spendthrift and philanderer (Francis Haskell, "A Turk and His Pictures in Nineteenth-Century Paris," in *Past and Present in Art and Taste: Selected Essays* [New Haven, 1987], pp. 175–85). For an account of the role of Halil as an Ottoman statesman and advocate for political reform, see Roderic H. Davison, "Halil Şerif Paşa: The Influence of Paris and the West on an Ottoman Diplomat," *Osmanlı Araştırmaları* 6 (1986), pp. 47–65; Davison, "Halil Şerif Paşa, Ottoman Diplomat and Statesman," *Osmanlı Araştırmaları* 2 (1981), pp. 203–21.

20. Fausto Zonaro, "Venti anni del regno di Abdulhamid: memorie e opere di Fausto Zonaro," typed manuscript, pp. 249–54 (Collection of Erol Makzume, Istanbul). My thanks to Erol Makzume for providing access to Zonaro's memoirs. For commentaries on the collection by other foreign visitors to the palace, see Semra Germaner and Zeynep İnankur, "The Ottoman Imperial Art Collection," *Constantinople and the Orientalists*, trans. Joyce Matthews (Istanbul, 2002), p. 118. Sultan Abdülhamid's deployment of photography and public ceremony as instruments of statecraft and international diplomacy has been extensively analyzed; see, for example, Selim Deringil, *Well-Protected Domains: Ideology and the Legitimation of Power in the Ottoman Empire, 1876–1909* (London, 1998), p. 16.

21. Germaner and İnankur (note 20), pp. 117–19.

22. A large folio of Sultan Abdülaziz's drawings presented to Chlebowski (one of which is a drawing by the painter that has corrections on it by the sultan) is collated in a commemorative album held in the National Museum of Cracow (inv. no. III–r.a.10.296–10.366). See *War and Peace: Ottoman-Polish Relations in the Fifteenth–Nineteenth Centuries*, exh. cat., ed. Selmin Kangal, trans. Bartłomiej Świetlik (Istanbul, 1999), p. 432.

23. "We also learn that MM. Gérôme and Boulanger, the celebrated French painters, have received commissions from the Sultan for several of their works" (*Levant Herald*, April 8, 1875, p. 266).

24. *Café égyptien* is held in the Dolmabahçe Palace collection. *Lion dans sa grotte* and *Bachi-Bouzouk dansant* are held in the Cumhurbaşkanlığı Atatürk Müze Köşk Koleksiyonu.

25. Başbakanlık Osmanlı Arşivi, Foreign Affairs Decrees, no. 16850. The document in Ottoman is reprinted in Mustafa Cezar, *Sanatta Batı'ya açılış ve Osman Hamdi*, 2 vols. (1971; Istanbul, 1995), 2: pp. 629–30, and is reprinted and transliterated into Turkish by Sema Öner, *Tanzimat Sonrası Osmanlı Saray Çevresinde Resim Etkinliği (1839–1923)* (PhD diss., Mimar Sinan Güzel Sanatlar Üniversitesi, 1991), pp. 361–63.

26. Fanny Field Hering, *The Life and Works of Jean Léon Gérôme* (New York, 1892), p. 225. Hering notes that the alternative title for this painting is *The Lion with the Phosphorescent Eyes*. In the 1878 official catalogue of the Exposition universelle the painting is just listed as *Un lion*. I am indebted to Holly Clayson for her suggestion about Gérôme's possible motivation for the inclusion of these specific paintings.

27. See Zeynep Çelik, *Displaying the Orient: Architecture of Islam at Nineteenth-Century World's Fairs* (Berkeley, 1992).

28. *Gérôme: A Collection of the Works of J. L. Gérôme in One Hundred Photogravures*, ed. Edward Strahan [Earl Shinn], 4 vols. (New York, 1881). *An Egyptian Café* is in vol. 2 and *Bashi-Bazouks Dancing* is in vol. 3, both accompanied by extended descriptive text. In Strahan's book the title of the latter work is in the plural in the illustration's caption, i.e., *Bashi-Bazouks Dancing*, but is expressed in the singular form in the heading for the work's text entry, i.e., *Bashi-Bazouk Dancing*.

29. Jean Clément Léonce Dubosc de Pesquidoux, *L'Art dans les deux mondes: Peinture et sculpture*, 2 vols. (Paris, 1881), 1: p. 136.

30. "Bashi-Bazouks Dancing," in Strahan (note 28), vol. 3: n.p.

31. For further explication of these historical events and the political implications in Britain and the Ottoman Empire, see M Şükrü Hanioğlu, *A Brief History of the Late Ottoman Empire* (Princeton, 2008), p. 131.

32. The term *Başıbozuk* was used to describe the irregular troops that served alongside regular Ottoman forces during times of war. The majority were of Kurdish, Albanian, and Circassian origins (*Encyclopaedia of Islam* [Leiden, 1960], 1: p. 1077). During the Crimean War there was an unsuccessful attempt to subject them to military discipline. The Bashi-Bozouks were so controversial during the Russo-Ottoman War that they were subsequently no longer employed by the Ottoman state (*Türk ansiklopedisi* [Istanbul, 1967], 5: p. 383).

33. See Nochlin (note 2), pp. 52–53; and Olivier Richon, "Representation, the Despot, and the Harem: Some Questions around an Academic Orientalist Painting by Lecomte-du-Nouy (1885)," in *Europe and Its Others: Proceedings of the Essex Conference on the Sociology of Literature*, ed. Francis Barker et al., 2 vols. (Colchester, 1985), 1: pp. 1–13.

34. For an analysis of the shifting perceptions of the Ottoman state toward the Zeybeks, as reflected in documents in the Ottoman archives, see Atilla Çetin, "Osmanlı Arşiv belgelerinde Zeybekler hakkında Bilgiler," in *Zeybek kültürü sempozyumu*, ed. Nâmık Açıkgöz and Mehmet Naci Önal (Muğla, 2004), pp. 69–70; Haydar A. Avcı, *Zeybeklik ve zeybekler: Bir başkaldırı geleneğinin toplumsal ve kültürel boyutları* (Hückelhoven, 2001); Onur Akdoğu, *Bir başkaldırı öyküsü: Zeybekler: Tarihi, ezgileri, dansları*, 3 vols. (İzmir, 2004).

35. For an account of the suppression of the Zeybek uprising in 1838 that resulted from attempts to forbid their dress and other, later equally ineffective attempts at Zeybek dress reform in 1894 and 1905, see G. Leiser, "Zeybek," in *Encyclopaedia of Islam* (Leiden, 2002), 9: pp. 493–94.

36. Donald Quataert, "Clothing Laws, State, and Society in the Ottoman Empire, 1720–1829," *International Journal of Middle East Studies* 29 (August 1997), pp. 403–25.

37. Osman Hamdy Bey and Marie de Launay, *Elbise-i 'Osmaniyye / Les Costumes populaires de la Turquie en 1873 ouvrage publié sous le patronage de la commission impériale Ottomane pour l'exposition universelle de Vienne* (Istanbul, 1873), p. 141.

38. Ibid., p. 7; Ahmet Ersoy, "A Sartorial Tribute to Late *Tanzimat* Ottomanism: The *Elbise-i Osmaniyye* Album," in *Ottoman Costumes: From Textiles to Identity*, ed. Suraiya Faroqhi and Christoph K. Neumann (Istanbul, 2004), pp. 253–70.

39. Hamdy Bey and de Launay (note 37), p. 5; Ersoy (note 38), p. 261.

40. Ussama Makdisi, "Ottoman Orientalism," *American Historical Review* 107, no. 3 (June 2002), p. 786. For an analysis of Osman Hamdi Bey's paintings in terms of Ottoman Orientalism, see Edhem Eldem, "Osman Hamdi Bey ve Oryantalizm," *Dipnot* (Kış-Bahar [Winter–Spring] 2004), pp. 39–67.

41. Leiser (note 35), 9: p. 494.

42. Nochlin (note 2), p. 37.

An Artistic Enmity
Gérôme and Moreau

PETER COOKE

The archives of the Musée Gustave Moreau in Paris contain three brief, undated letters from Jean-Léon Gérôme to Gustave Moreau. Two of them address Moreau with a playfully exaggerated display of love and respect as "my beloved and venerated colleague," indicating that they were written after Moreau's election in November 1888 to the Institut de France, where Gérôme had been a member since 1865. One of these two relates to an essay prize, the Prix Bordin, for which Gérôme and Moreau served on the jury in 1891.[1] The other refers with irony and disgust to the banquet that was to be held on January 16, 1895, to celebrate the seventieth birthday of Puvis de Chavannes, a painter whose idealistic, flat, anti-naturalistic style Gérôme detested.[2] The third letter, in which Gérôme addresses Moreau in frank and affectionate terms as "Very dear friend," appears to be a reply to a letter of condolence.[3] Yet, beneath the cordial surface of their relationship as colleagues, how did the two painters relate to each other's art? Friendships, associations, and influences have been much studied in art history, but enmities can also be revealing. Aversion may exert aesthetic influence of another kind, for artists may define themselves in opposition to an alien art. Whereas Gérôme, who enjoyed a much more precocious official career than Moreau, probably took little notice of the latter's controversial and relatively marginal art, he epitomized the type of art that Moreau abhorred.[4]

Both artists had to contend with the prolonged crisis of history painting (traditionally the most prestigious of the genres) that came to a head during the mid-nineteenth century. After a vast but less than entirely successful official commission—*The Age of Augustus* (fig. 19) exhibited at the Exposition universelle of 1855—Gérôme abandoned attempts at achieving the grand manner, for which his training in the studio of Paul Delaroche, one of the foremost proponents of *genre historique* (anecdotal history painting), had ill prepared him. After exhibiting, in the 1850s and 1860s, a few experimental and highly controversial realist history

paintings, which subverted central tenets of the academic tradition, he subsequently abandoned history painting altogether in favor of more digestible and salable, meticulously rendered genre paintings, representing scenes from everyday life situated either in antiquity or in the contemporary Middle East. Moreau, on the other hand, who was trained in the studio of the neoclassical history painter François Édouard Picot, pursued a highly ambitious and difficult career at the Salon as an uncompromising, but unorthodox, history painter, devoted to the renewal of *le grand art* through an idealist, symbolic, semi-archaizing treatment of mythological and biblical subjects.[5]

It is instructive to compare the two paintings with which Gérôme and Moreau first gained recognition. Gérôme made a name for himself with *The Cockfight* (fig. 1), exhibited at the Salon of 1847, when he was still a student of Charles Gleyre, who had taken over Delaroche's studio. On that occasion the veteran critic Théophile Gautier predicted his fame and consecrated him the leader of a new school that he christened the Néo-Grecs.[6] The painting depicts an action from everyday life; it is a genre scene, bereft of serious meaning, but situated in the ancient world, which traditionally had been the site of the solemnities of grand-manner history painting. In contrast, Moreau's *Oedipus and the Sphinx* (fig. 24), exhibited at the Salon of 1864, where it attracted enormous attention, presents a symbolic, subtly moralizing interpretation of a Greek myth, a kind of pagan Temptation of Saint Anthony.[7] Moreau went to great pains to create an idealized style, based on an eclectic study of the art of the past, while Gérôme in his painting drew primarily on the scrupulous observation of nature and refused to idealize the nudes (especially the male figure) in accordance with academic expectations. Whereas the austere yet decorative style of Moreau's *Oedipus and the Sphinx* was inspired by quattrocento painting, Gérôme's naturalism is resolutely of its time. The *Cockfight* could be interpreted either as a bold and skillful rejuvenation of a tired antiquity or as an impertinent degradation of the ideals of *le grand art. Oedipus and the Sphinx* was instantly recognized as a valiant, and in many ways successful, attempt to breathe new life into idealist history painting by a blend of intellectual and moral investment and a return to the aesthetic principles of the early Renaissance.

At the same Salon, in 1864, at which Moreau made his name with *Oedipus and the Sphinx*, Gérôme exhibited *Dance of the Almeh* (fig. 25), representing an Egyptian belly dancer ogled by off-duty soldiers dressed in exotic costume, in a naturalistic genre scene offering the male viewer titillation in the guise of ethnographic reportage. While Moreau, in a bid to relaunch his career, sought aesthetic glory by an uncompromising devotion to the highest principles of *le grand art*, the veteran Gérôme, already loaded with official honors, appealed

PETER COOKE

FIGURE 24
Gustave Moreau (1826–1898), *Oedipus and the Sphinx*, 1864. Oil on canvas, 206.4 x 104.8 cm
(81¼ x 41¼ in.). New York, The Metropolitan Museum of Art. Bequest of William H. Herriman,
1920 (21.134.1)

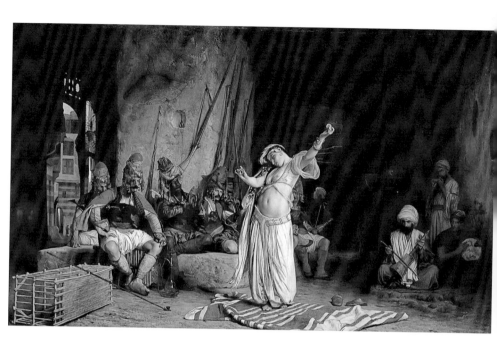

FIGURE 25
Jean-Léon Gérôme, *Dance of the Almeh*, 1863. Oil on wood panel, 50.2 x 81.3 cm (19 ¾ x 32 in.).
The Dayton Art Institute. Gift of Mr. Robert Badenhop (1951.15)

not to the connoisseur or high-minded critic but to the buying public, with a modish subject and shameless eroticism (for which he did not escape censure by indignant Salon critics). There can be little doubt that, in the eyes of Moreau, Gérôme had forsaken the authentic ideals of high art in favor of commercial success, a success greatly aided by his close and lucrative association with the art dealer Adolphe Goupil.[8] An insight into Moreau's opinion of Gérôme's art is afforded by a peevish note, probably written in the 1860s, in which he attacks the contemporary vogue for "ethnographic painting":

> And what can these so-called conscientious people do? A journey that allows them to see and note with more or less material exactitude a scene, a costume, a foreign, exotic figure.
>
> In figure painting people have come to understand only ethnographic painting.
>
> They represent a woman drawn in France, after a Frenchwoman, covered in flashy rags brought back from the Orient, and they call that the belly dance!
>
> No truly original physiognomy; false types. Complete absence of life, etc., etc., and they do not stop to think that the Flemish, who were condemned by nature to a humble and familiar spirit, lived all their lives in the midst of their models, which they still managed, in their great experience and their great feeling for art, to find a way to transform.[9]

Moreau is certainly referring to Gérôme's *Dance of the Almeh*, which was also known as the *Danse du ventre* (Belly Dance). In his eyes there was a world of difference between the authentic art of the Flemish genre painters, the art of a Metsu or a Terborch, with their "love of artistic matter," their "care," their "taste in the choice of tones and values," and their "imagination in color" and the "modern, vulgar, and nauseous imitations" of a Meissonier, a Cabanel, or a Gérôme.[10]

When, in the 1870s, Moreau came to represent an exotic dance, the result belonged to a different aesthetic universe than Gérôme's *Almeh*. Exhibited at the Salon of 1876 and Exposition universelle of 1878, *Salome Dancing before Herod* (fig. 26) was Moreau's answer to contemporary Orientalism.[11] To ethnographic realism he preferred impassive, hieratic figures, clad in sumptuous, imaginary garments, involved in a tragic episode in sacred history. The extraordinary decor, resembling a fantastical temple more than the banqueting hall of the New Testament story, is an eclectic assemblage drawn from a wide variety of Western, Middle-Eastern, and Asian architectural sources, entirely justifying Moreau's description of himself as an "ouvrier assembleur de rêves" (craftsman assembler

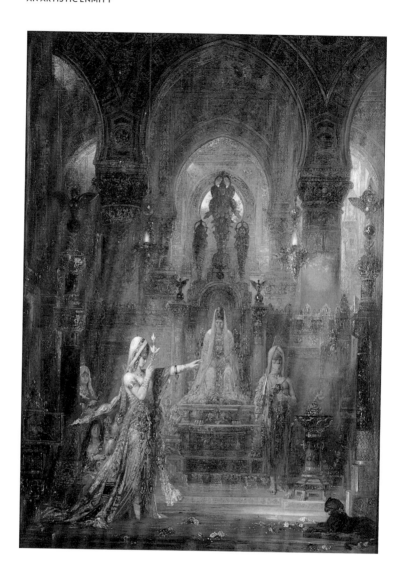

FIGURE 26
Gustave Moreau (1826–1898), *Salome Dancing before Herod*, 1876. Oil on canvas,
144 × 103.5 cm (56 ⅝ × 40 ¾ in.). Los Angeles, Hammer Museum. The Armand Hammer Collection,
Gift of the Armand Hammer Foundation

cement

141

PET

of dreams).[12] Salome's hieratic performance evokes, more than a dance, some strange, mysterious ritual. To the reportage of Orientalist genre painting, Moreau opposes aesthetic enthrallment, semiotic saturation, and polysemous mystery.

Fourteen years after exhibiting *Salome*, Moreau seized the opportunity of making public his contempt for the art of Gérôme and his emulators. Elected in 1888 to the fine arts section of the Institut, in place of Gustave Boulanger, who had died in the same year, Moreau was bound by convention to deliver a speech in honor of his deceased predecessor.[13] But Boulanger, a painter of Néo-Grec and Orientalist genre scenes heavily influenced by Gérôme, represented aesthetic tendencies deplored by Moreau. He therefore chose to perform the delicate task of praising the man while demolishing his art. The terms chosen to define the nature of Boulanger's talent immediately connote a second-class artist: "habileté" (skill) and "facilité" (facility).[14] Judging Boulanger—and by implication his mentor Gérôme—from the point of view of a history painter, Moreau posed the difficult problem of classifying his art in terms of genre categories: "At a time when everything in art is on the brink of confusion, when the limits of the genres are suppressed... one is very embarrassed when it comes to classifying the producers and works of art, in the hierarchical or special order that they seemed to occupy formerly, under the designations of History Painters and genre Painters.... Was Boulanger a history painter or was he a genre painter? It would be difficult to decide."[15] Boulanger had contributed, Moreau implied, to the confusion of the genres that he saw as one of the aesthetic evils of his times. While his "serious classical studies" would seem to predispose him toward history painting, rather than genre, his choice of subjects suggests that he was drawn toward "intimate, familiar painting, rather than toward the art of history and pure imagination." For he liked "what is called character, the exterior physiognomy of beings and things," and his way of feeling and expressing himself was "subtle and ingenious rather than grave and severe. Curiosity, rather than meditation and sensibility of the soul, was revealed in all things in him, and so his artistic nature was drawn in preference toward picturesque and ethnographic painting."[16] It should be noted that at that period the word *curiosité*—a term repeatedly used in Salon criticism to characterize and denigrate the art of Gérôme—was loaded with negative connotations of unhealthy superficiality, often of a prurient nature, as opposed to a thirst for true knowledge.[17] Moreau then proceeded to launch an attack on Orientalism, the "modern taste for the exotic," which, in his eyes, had "brought new elements into painting," rejuvenating it but "only from the point of view of the picturesque and color," since, in his opinion, "a Western soul, mind, and temperament" could only "express themselves surely and completely on condition that they remain in the milieu for which they were created."[18]

Having invalidated the aesthetic premises of Orientalism, Moreau now turned his attention to Boulanger's Néo-Grec subjects, purporting to admire "the facility and the grace of these canvases" but stating that "in the restitution of distant epochs, it would seem perhaps that Boulanger did not altogether take into enough account the difference between civilizations, concerning both moral habits and the basis of mores, representing, for example, a scene from the Rome of the Caesars as he could have treated a subject closer to us, and that in spite of the scrupulous and erudite exactitude of his archaeology."[19] Lacking the artistic imagination of the true history painter, Boulanger stands accused, once more, of superficiality, and, paradoxically, the archaeological precision of the Néo-Grec genre painter is discredited as unhistorical, not founded on a deep understanding of the civilization that it purports to represent. In contrast, Moreau went on to outline his own, neoromantic, aesthetic vision of the way in which antique subjects should be treated, supporting his claim with the antiacademic authority of Rembrandt:

> And yet, it might seem simple enough and natural enough, on the face of it, that historical periods which have become almost legendary through their distance in time could only be expressed on condition that poetic feeling alone reconstitutes them and gives them a new lease on life.
> This archaeology of feeling, of the imagination, was that of Rembrandt, very little in conformity with tradition, one has to admit, inadequate, no doubt, but, despite that, so profoundly true, so Oriental and so biblical.[20]

At one point, as if unable to contain his scorn any longer, Moreau stated, bluntly, that "Boulanger also liked wit in painting, anecdotes, subjects.... It is in anecdotal subjects that he showed all the ingenuity of his mind, that is how he could please and interest; it is in these qualities that he asserted himself, as also in a great conscientiousness of execution, neglecting no part whatever of his work, which he brought to conclusion unfailingly."[21]

Here, Moreau is drawing an implied contrast with his own experimental, varied, and often hesitant execution. Should one blame Boulanger for his preference for genre painting, Moreau asked disingenuously? Surely not: "Indeed, there seems to be nothing to regret in his infidelities toward the austere tradition, for one feels that the nature of the traveler and the seeker of novelty would not have been so fully satisfied and expressed in traditional works, born only of the profound study of the philosophy of history, pure poetry, and the inflamed contact with the immortal masters."[22] By slyly criticizing the art of Boulanger and, through Boulanger, that of Gérôme, Moreau was able to attack the positivism of his age while formulating, in the negative, his own artistic ideals.

Moreau can have made few friends at the Institut with his poisoned encomium, and his thinly disguised contempt for some of the prevalent trends in "academic" art helps explain why he was, according to his favorite pupil, Georges Rouault, "very bitterly and slyly attacked, at the École [des beaux-arts] and elsewhere."[23] From a remarkable eyewitness account we know that one of the professors who attacked Moreau at the École was none other than Gérôme. In a letter to his father, Moreau's pupil Henri Évenepoel recounts that one day in July 1896, while Moreau was correcting a student drawing from the antique, in the company of two or three other pupils from Moreau's atelier, Gérôme approached Moreau, shook his hand, and said to him bluntly: "Savez-vous, mon ami, que vous foutez vos élèves là-dedans?" (Do you know, my friend, that you are screwing your pupils up?).[24] Évenepoel informs us that Moreau smiled without replying. On one level, Gérôme was doubtlessly teasing his colleague in a spirit of camaraderie, but, on another, he probably did believe that Moreau was damaging his students. The reason for this belief lies, no doubt, as Cristina Scassellati Cooke has suggested, in the heterodox aspects of Moreau's aesthetic and style and notably his archaism, a quality diametrically opposed to Gérôme's scrupulous naturalism.[25] Indeed, according to another of Moreau's students, Arthur Guéniot, pupils of rival ateliers nicknamed Moreau's students "the Botticellis." Guéniot narrates a revealing anecdote: "Some of [Moreau's] colleagues at the Institut used to tease him about it as well and so, one day, in the chapel of the École, which is a copy of the Sistine Chapel and a museum of early Renaissance art, he impulsively took into his arms the bust of Donatello's Saint John to make Gérôme and Frémiet admit the qualities of this quattrocento master."[26] Moreover, whereas in his teaching Gérôme insisted on the traditional academic primacy of drawing, Moreau encouraged his pupils, from an early stage, to cultivate color as well as drawing.[27] At a time when he was becoming increasingly exasperated by the rise of antinaturalistic and antiacademic practices in French art, Gérôme, who had been teaching at the École for more than thirty years, must have felt that the newcomer Moreau was compromising the academic integrity of the institution on which he himself had left such a lasting mark.[28]

In a sense, as Scassellati Cooke has pointed out, Gérôme was right to accuse Moreau of "screwing [his] pupils up," for the unorthodox aesthetic doctrine that he passed on to them, making his studio "the refuge of militant originality," as the critic Roger Marx put it, effectively debarred them from winning the prestigious Prix de Rome, where Gérôme's pupils often succeeded.[29] Instead, to his best pupils, such as Henri Matisse, Georges Rouault, Henri Évenepoel, Albert Marquet, Charles Camouin, and Henri Manguin, Moreau transmitted his faith in the transformative power of art in the face of the prevailing naturalism,

FIGURE 27
Gustave Moreau (1826–1898), *Orpheus at the Tomb of Eurydice*, ca. 1890–91. Oil on canvas, 173 × 128 cm (68 × 30⅜ in.). Paris, Musée Gustave Moreau

in "feeling," and in "the imagination of color," a faith that was to help produce the fauves in the first decade of the twentieth century.[30] In retrospect it can be seen that Gérôme's teaching, on the other hand, with its unswerving naturalism and insistence on "correct" drawing, while preparing his pupils effectively for the Prix de Rome, offered them an aesthetic dead-end as far as the twentieth-century avant-garde was concerned.

The essential differences between the art of Gérôme and that of Moreau may be exemplified by two self-representations of the 1890s. In *Working in Marble* (fig. 2), Gérôme has portrayed himself in a quasi-photographic style, at work in his studio executing a naturalistic marble sculpture from a live female model. With its muted colors and refusal to idealize the human form, the painting epitomizes the scrupulous naturalism of Gérôme's art. Moreau's *Orpheus at the Tomb of Eurydice* (fig. 27), painted in homage to his deceased companion, Alexandrine Dureux, who had died in 1890, is a self-representation of the painter-poet in the mythological guise of the poet Orpheus, mourning his wife Eurydice, whom he had failed to rescue from the Underworld. In its daring, antinaturalistic, saturated colors, in which Orpheus's cold blue drape contrasts with blood-red trees and putrescent green and brown earth, and in its bold, violent paint application, it employs painterly means to express the intensity of the artist's grief.[31] The two works of art belong to radically different aesthetic worlds, which is why, whatever their professional relationship may have been, Moreau and Gérôme could never be anything but artistic enemies.

Notes

1. "Je prie mon bien aimé et vénéré confrère de ne pas oublier en venant samedi à la commission de peinture, les petites notes que je lui ai remises avant mon départ pour Cannes. / Ces quelques lignes me remettront en mémoire ceux [sic] que j'ai lu il y a longtemps déjà. / Ce Pascal nous donne bien de l'embêtement! Quel dommage qu'il ait écrit cette pensée d'ailleurs stupide! / Moi je pense à vous, c'est moins bête et plus affectueux" (undated letter, archives, Musée Gustave Moreau, Paris). On the Prix Bordin in 1891, see Gustave Moreau, *Écrits sur l'art par Gustave Moreau*, ed. Peter Cooke, 2 vols. (Fontfroide, 2002), 2: pp. 358–67. The candidates were asked to "demonstrate the error or the truth contained in the following exclamation by Pascal: 'How vain is painting which attracts admiration by the resemblance to things whose originals one does not admire.'" Unless otherwise noted, all translations are my own.

2. "Mon bien aimé et vénéré confrère, j'ai rencontré votre médecin qui m'a dit que dans l'état actuel de votre santé, vous aviez besoin d'un fort vomitif. Lisez les articles ci-joints sur Mr Puvis de Chavannes, et sur le futur banquet, et l'effet demandé sera produit" (undated letter, archives, Musée Gustave Moreau, Paris).

3. "Très cher ami, je suis bien sensible à la très bonne et très excellente lettre que vous m'avez envoyée—vous êtes de ceux que j'affectionne, et cette dernière preuve de sympathie m'est tout particulièrement précieuse dans les circonstances douloureuses où je me trouve aujourd'hui" (undated letter, archives, Musée Gustave Moreau, Paris).

4. Born in 1824, Gérôme won a third-class medal at the Salon of 1847. Favored by the government of the Second Empire, he was made a chevalier of the Légion d'honneur in 1855, at the occasion of the Exposition universelle, appointed a professor at the newly reformed École des beaux-arts in 1864, elected to the Institut de France in the following year, and appointed *officier* of the Légion d'honneur in 1867, the year of the second Exposition universelle, where he obtained a medal of honor. Born in 1826, Moreau had no success until the Salon of 1864, at which he obtained his first medal. In 1875 he was made a chevalier of the Légion d'honneur and in 1878 he had considerable success at the Exposition universelle. In 1882 he was made an *officier* of the Légion d'honneur; he was elected to the Institut de France in 1888 and was made a professor at the École des beaux-arts in 1892.

5. On Moreau's reinvention of history painting, see Scott C. Allan, *Gustave Moreau (1826–1898) and the Afterlife of French History Painting* (Ann Arbor, 2007); and Peter Cooke, "Gustave Moreau and the Reinvention of History Painting," *Art Bulletin* 90, no. 3 (September 2008), pp. 395–417.

6. See Gerald M. Ackerman, *La Vie et l'oeuvre de Jean-Léon Gérôme* (Paris, 1986), pp. 30–31, 186.

7. On the archaism and the iconography of temptation in this painting, see Peter Cooke, "Gustave Moreau's *Oedipus and the Sphinx*: Archaism, Temptation, and the Nude at the Salon of 1864," *Burlington Magazine* 146, no. 1218 (September 2004), pp. 609–15.

8. See *Gérôme et Goupil: Art et entreprise*, exh. cat. (Paris, 2000).

9. Moreau (note 1) 2: p. 319.

10. Ibid., 2: pp. 319–20.

11. On the iconography of *Salome*, see Julius Kaplan, *The Art of Gustave Moreau: Theory, Style, and Content* (Ann Arbor, 1982), pp. 55–67. On its engagement with Orientalism, see Peter Cooke, "Gustave Moreau's *Salome*: The Poetics and Politics of History Painting," *Burlington Magazine* 149 (August 2007), pp. 528–36.

12. Moreau (note 1), 1: p. 118.

13. *Notice sur M. Gustave Boulanger par M. Gustave Moreau, membre de l'Académie, lue dans la séance du 22 novembre 1890*, reprinted in Moreau (note 1), 2: pp. 339–48.

14. Ibid., 2: p. 340.

15. Ibid., 2: p. 342.

16. Ibid., 2: pp. 342–43.

17. On Gérôme's critical reception, in relation to the expectations of history painting, see John House, "History without Values? Gérôme's History Paintings," *Journal of the Warburg and Courtauld Institutes* 71 (December 2008), pp. 261–76. For the connotations of the word *curiosité* in Moreau's time, see House, "*Curiosité*," in *Impressions of French Modernity: Art and Literature in France 1850–1900*, ed. Richard Hobbs (Manchester, 1998), pp. 33–57.

18. Moreau (note 1), 2: p. 343.

19. Ibid., 2: p. 344.

20. Ibid.

21. Ibid., 2: p. 345.

22. Ibid., 2: p. 346.

23. Georges Rouault, *Souvenirs intimes* (Paris, 1926), p. 47.

24. Henri Évenepoel, *Lettres à mon père, 1892–1899*, ed. Danielle Derrey-Capon, 2 vols. (Brussels, 1994), 2: p. 66.

25. Cristina Scassellati Cooke, "The Ideal of History Painting: Georges Rouault and Other Students of Gustave Moreau at the Ecole des beaux-arts, Paris, 1892–1895," *Burlington Magazine* 148 (May 2006), pp. 332–39.

26. Anne Prache, "Souvenirs d'Arthur Guéniot sur G. Moreau et sur son enseignement à

l'Ecole des beaux-arts" (1966), quoted in Scassellati Cooke (note 25), p. 336. Emmanuel Frémiet (1824–1910) was a renowned naturalistic sculptor.

27. According to Charles Moreau-Vauthier, Gérôme urged his pupils "to study nature scrupulously, especially in drawing" (*Gérôme, peintre et sculpteur, l'homme et l'artiste, d'après sa correspondance, ses notes, les souvenirs de ses élèves et de ses amis* [1906], quoted in Ackerman [note 6], p. 160).

28. On Gérôme's theory of art and bitter reaction to contemporary trends in the 1890s, see Ackerman (note 6), pp. 160–61, and on his career as a professor at the École des beaux-arts, see pp. 168–77.

29. Roger Marx, "Les Salons de 1895" (1895), quoted in Scassellati Cooke (note 25), p. 332.

30. Letter of July 27, 1893, quoting a remark by Moreau, in Évenepoel (note 24), 1: p. 197.

31. On this painting, see Peter Cooke, "L'Image et le texte: L'*Orphée* (vers 1890–1891) de Gustave Moreau, la peinture et sa 'notice,'" *Revue du Louvre: La Revue des musées de France*, no. 3 (June 1995), pp. 66–72.

Plates

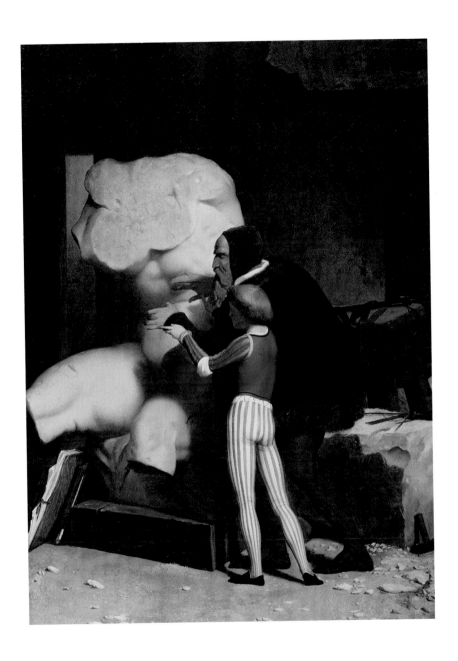

PLATE 1
Jean-Léon Gérôme, *Michelangelo Showing a Student the Belvedere Torso*, 1849.
Oil on canvas, 51.4 x 37.5 cm (20 ¼ x 14 ¾ in.). New York, Dahesh Museum of Art (1999.8)

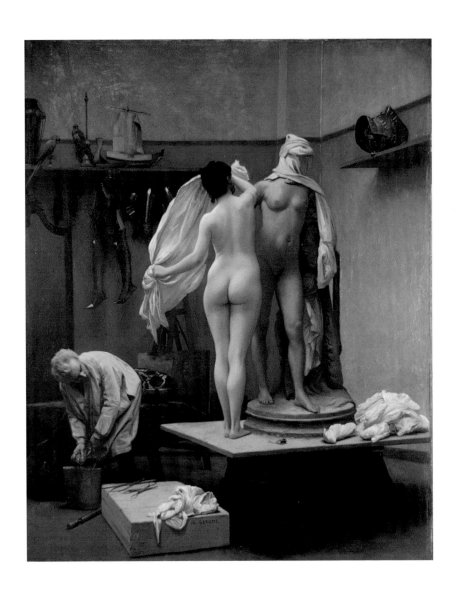

PLATE 2
Jean-Léon Gérôme, *The End of the Session*, 1886. Oil on canvas, 48.3 x 40.6 cm (19 x 15 $\frac{7}{8}$ in.).
Frankel Family Trust

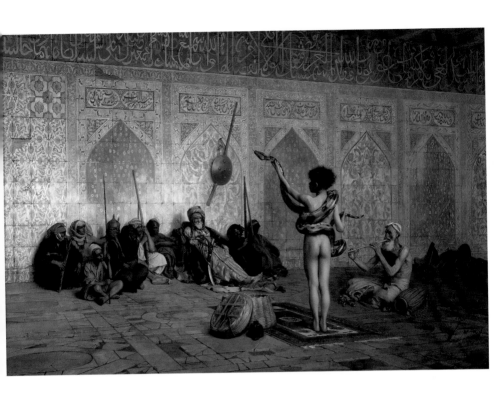

PLATE 3
Jean-Léon Gérôme, *The Snake Charmer*, ca. 1870. Oil on canvas, 83.8 x 122.1 cm (33 x 48 in.).
Williamstown, Massachusetts, Sterling and Francine Clark Art Institute (1955.51)

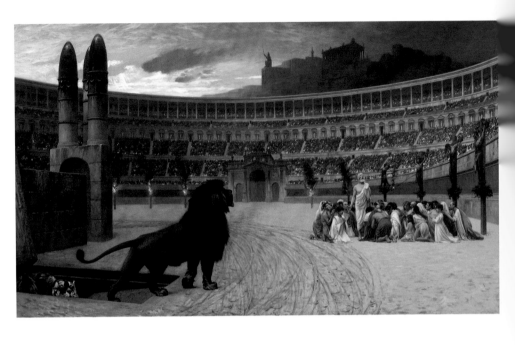

PLATE 4
Jean-Léon Gérôme, *The Christian Martyrs' Last Prayer*, 1863–83. Oil on canvas, 87.9 x 150.1 cm (34 ⅝ x 59 ⅛ in.). Baltimore, The Walters Art Museum. Acquired by William T. Walters (37.113)

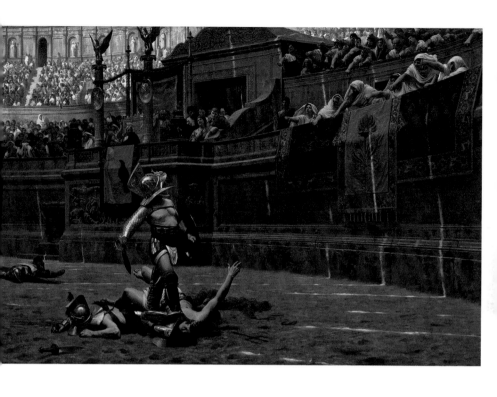

PLATE 5
Jean-Léon Gérôme, *Pollice Verso*, 1872. Oil on canvas, 39.5 × 58.6 cm (15½ × 23 in.). Phoenix Art Museum. Museum purchase

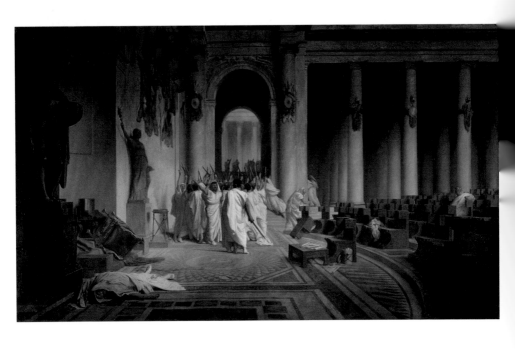

PLATE 6
Jean-Léon Gérôme, *The Death of Caesar*, 1859. Oil on canvas, 85.5 x 145.5 cm (33 ¹¹/₁₆ x 57 ⁵/₁₆ in).
Baltimore, The Walters Art Museum. Acquired by Henry Walters, 1917 (37.884)

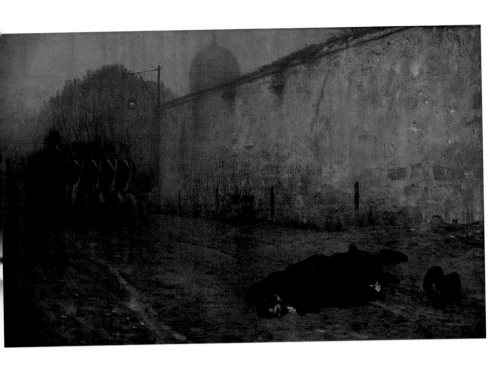

PLATE 7
Jean-Léon Gérôme, *December 7, 1815, 9 o'clock in the Morning*, 1868. Oil on canvas, 64.1 × 103.5 cm
(25 ¼ × 40 ¾ in.). Sheffield, England, Graves Gallery, Museums Sheffield

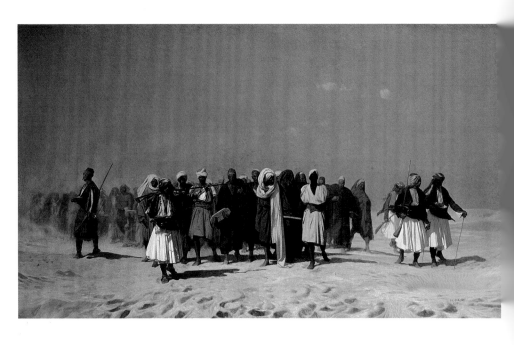

PLATE 8
**Jean-Léon Gérôme, *Egyptian Recruits Crossing the Desert*, 1857. Oil on panel, 64 × 109.8 cm
(25 ⅛ × 43 ⅛ in.). Najd Collection, courtesy Mathaf Gallery, London

Index

Contributors

Scott Allan is assistant curator of paintings at the J. Paul Getty Museum.

Emily Beeny is a Ph.D. candidate in the Department of Art History and Archaeology, Columbia University, New York.

Emerson Bowyer is a Ph.D. candidate in the Department of Art History and Archaeology, Columbia University, New York.

Peter Cooke is Senior Lecturer in French Studies, University of Manchester, England.

Gülru Çakmak is a Ph.D. candidate at Johns Hopkins University, Baltimore.

Allan Doyle is a Ph.D. candidate in the Department of Art and Archaeology, Princeton University, New Jersey.

Marc Gotlieb is the Class of 1955 Memorial Professor of Art at Williams College and the Director of the Williams College Graduate Program in the History of Art, Williamstown, Massachusetts.

Nina Lübbren is Senior Lecturer in the Department of English, Communication, Film and Media, Anglia Ruskin University, Cambridge, England.

Peter Benson Miller is an independent art historian based in Rome.

Claudine Mitchell is Honorary Fellow, School of Fine Art, History of Art and Cultural Studies, University of Leeds, England.

Mary Morton, former associate curator of paintings at the J. Paul Getty Museum, is curator of French painting at the National Gallery of Art, Washington, D.C.

Mary Roberts is Associate Professor in the Department of Art History and Film Studies, University of Sydney, Australia.

Acknowledgments

This volume was first conceived in the summer of 2009, and in order for it to materialize in time for the opening of *The Spectacular Art of Gérôme* at the J. Paul Getty Museum in June 2010, extraordinary efforts were required of many people. First and foremost, we offer heartfelt thanks to all the contributors for preparing their essays on such short notice and being so cooperative during the editing process. Second, in Getty Publications we are extremely grateful to publisher Gregory M. Britton for his enthusiastic support from the outset, editor Edward Weisberger, who shepherded the book with admirable efficiency and attention to detail, and others committed to the project, including managing editor Ann Lucke, freelance editor Kathleen Preciado, production manager Karen Schmidt, senior production coordinator Suzanne Watson, design manager Deenie Yudell, senior graphic designer Stuart Smith, sales and marketing manager Rob Flynn, and marketing coordinator Melissa Crowley. Thanks are also extended to senior contract administrator Karen Campbell and especially Emily Beeny, contributing author and graduate intern in the Paintings Department of the Getty Museum, for her invaluable editorial assistance. We would like to acknowledge the instrumental support and encouragement at the Museum of former director Michael Brand, acting director David Bomford, associate director of exhibitions Quincy Houghton, and senior curator of paintings Scott Schaefer. Most warmly, we are grateful to Gerald Ackerman, whose pioneering scholarship on Jean-Léon Gérôme remains the necessary starting point for any serious student of the artist's work.

— Scott Allan and Mary Morton